The Image of the Indian
and the Black Man
in American Art
1590-1900

D0845601

The Image of
THE INDIAN
and the
BLACK MAN
in American Art

1590-1900

ELLWOOD PARRY

George Braziller

NEW YORK

For information address the publisher:
George Braziller, Inc., One Park Avenue, New York, N.Y. 10016

Library of Congress Catalog Card Number: 73-79606
Standard Book Number: 0-8076-0706-1, cloth
0-8076-0707-x, paper

Printed in the U.S.A.
First Printing
DESIGNED BY RONALD FARBER

Acknowledgments

First of all, I would sincerely like to thank those private collectors who have graciously allowed me to use photographs of works in their possession. I am particularly grateful to Mr. and Mrs. H. John Heinz III, Professor and Mrs. Julius S. Held, Mr. and Mrs. Paul Mellon, and Mr. Erwin Swann.

Furthermore, to those curators of American art, librarians of Rare Book Departments, and keepers of American history collections at various public and private institutions, I am also deeply indebted for prompt answers to my many requests for photographs or information, for appointments to see specific works of art, and for access to archival materials in their care. My special thanks are due to Philip A. Bellefleur, Headmaster, The Pennsylvania School for the Deaf, Philadelphia; Georgia B. Bumgardner, Curator of Maps and Prints, American Antiquarian Society, Worcester, Massachusetts; Beverly Carter, Secretary, Paul Mellon Collection; Christine Huber, The Pennsylvania Academy of the Fine Arts, Philadelphia; James K. Kettlewell, Curator, The Hyde Collection, Glens Falls, New York; Abram Lerner, Curator, and Cynthia McCabe, Associate Curator, Joseph H. Hirshhorn Museum and Sculpture Garden, Smithsonian Institution; Edward J. Nygren, Assistant Curator of Paintings, The Paul Mellon Center for British Art and British Studies, Yale University; Dale Roylance, Curator, Arts of the Book Collection, Yale University Library; Elizabeth Roth, Curator, Prints Division, New York Public Library; and Neda M. Westlake, Curator, Rare Book Collection, Van Pelt Library, University of Pennsylvania.

This book, like other projects of mine, has benefited considerably from discussions with several of my former teachers at Yale, namely Professors Jules D. Prown, Robert L. Herbert, and Robert F. Thompson. And this is not to mention more recent conversations with colleagues in the Department of Art History and Archaeology at Columbia, particularly Professor Douglas Fraser and Dr. Seymour H. Koenig. I am grateful to them for suggestions and references.

It is an added pleasure to keep a promise by mentioning the names of a number of students—Black and White, male and female, graduate and undergraduate—who, in taking courses of mine over the past three years, have worked on themes and image-traditions in American art that turn out to be related directly or indirectly to the contents of this book. It seems only fair, after their hours of initial leg-work, tracking down basic information, to list their names here in gratitude. On the other hand, no one on this list is responsible for any errors of fact or interpretation in the text that follows. The students I would like to thank are Annette Adams, James Alexander, Claudio Balloffet, Jocelyn Blackwell, Maria Chamberlin-Hellman, Beverly Copeland, William Dailey, Marilyn Drucker, Rosalia Ennis, Wendy Gifford, Peter Gow III, Sybil Kantor, Peggy Kaye, Charles Laughinghouse, Tony Marquez, Arlene Glassman Miller, Tom Murrell, Rhoma Phillips, Brice Rhyne, Carol Robbins, Karla Spurlock, Jan Taradash, and Jonathan Waller.

Lastly, it must also be clearly and gratefully acknowledged that this project was made possible, from the initial purchase of numberless photographs to the typing of the final draft, by two summer research grants awarded to the author in 1971 and 1972 by the Columbia University Council for Research in the Humanities.

FOR PAMELA

Contents

Introduction

THIS IS A BOOK about images and image-making. The plates assembled here constitute a visual anthology culled from dozens of different sources. Although some of these images may look familiar to the reader, while others seem more unusual, as a group they represent only a tiny fraction of the myriad representations of Indians and Black men available to the art historian. No attempt has been made to be encyclopedic, except, perhaps, in the matter of artistic materials and techniques. Since the means of creation can have such an overwhelming effect on the visual results, a wide range of image-making methods has been included. Among the illustrations the reader will find etchings, lithographs, color lithographs, and several types of engraving on metal plates, not to mention paintings on plaster, panel, and canvas, pieces of sculpture in sheet metal, wood, marble, and bronze, and a variety of photographic images from daguerreotypes and stereographs to positive prints made from glass-plate negatives.

Above these basic technical considerations there arises the larger question of thematic content. By juxtaposing comparable images wherever possible and by examining in detail those few works in which Blacks and Indians appear together, we can see more clearly the prejudices and preconceptions at work in the minds of the predominantly *White male* artists who created these visual statements at different moments in the history of American art. Long-term changes in racial attitudes are brought into sharper focus by means of the comparisons that are central to each of the following chapters.

No apology needs to be made for the exclusion of other minorities in modern American society from the title and text of this book. The fact is that no other races or racial groups ever came to symbolize the North American continent in the same way that Indians, who were discovered here, and, to a lesser extent, the Black slaves, who were brought here to work the fields, *defined* the land that is now the United States. Images of Indians and Black men have been standard elements in the iconography of the New World for several centuries, and it is on this level of traditional imagery

and changing conceptions within a given tradition that the plates will be discussed.

The time-span limitation for this study should be self-explanatory. The year 1590 was the publication date for the first part of Theodore De Bry's *America,* which contained engravings after comparatively authentic views of people and places along the coast of North America. Because they were presented as first-hand information, available to large numbers of readers one century after the initial voyage of Columbus, De Bry's engravings of the 1590s had an important influence on later artists. The year 1900, on the other hand, represents a convenient cut-off point, separating what is historical fact, seen in perspective, from what remains in living memory as part of the continuum of current events. Because of the passionate feelings involved, modern history can hardly be treated with the same mixture of detachment, concern, and serious interest applied to the past. This discussion will end, therefore, on the threshold of the twentieth century, leaving to later writers the task of describing and explaining the rapid changes that are taking place in contemporary image-traditions.

Since a great variety of images will be discussed within the 310 year span from 1590 to 1900, a sliding definition of "American art" is necessary. For Chapter One, dealing with European portrayals of New World Indians, "American" refers to American subject matter. This meaning holds true for some of the other works by foreign artists scattered throughout the text. In subsequent chapters the definition of the word "art" has been expanded to admit all sorts of visual materials rarely discussed in surveys of the "fine arts." Included are broadsides, wood engravings from the popular press, sheet music covers, folk art, moving panoramas, and several types of photographs that once saw active service in the no-man's-land between the self-conscious aesthetics of well-trained artists and the American public's lack of sophistication in such matters in the past. Many of these cruder images provide the clearest demonstration of the racial stereotypes embedded in the popular mind, while some of the better portrait photos present the faces of Black men and Indians with an impartiality beyond the abilities of even the most sympathetic artists. When placed next to major paintings or works of sculpture, these popular images can aid the modern eye in comprehending what the leading American artists of the past *were or were not* able to see and understand in their own time.

In 1889–1890, when Jacob A. Riis was writing about the "Color Line" in New York City housing (see Plate 109), he pointed out that a ghetto boundary "line may not be wholly effaced while the name of the negro, alone among the world's races, is spelled with a small n."[1] In the interests of impartiality, all terms, whether adjectives or nouns, that refer to a particular racial group will be treated uniformly in this book; that is, they will be capitalized, because the use of the upper case helps to emphasize the conceptual nature of the materials under discussion, and it remains consistent with many of the original pre-twentieth-century sources quoted in the text.

On the issue of equal representation, parity is not easily achieved, however.

It would require a conscious distortion of historical facts to reproduce an equal number of pictures of Indians and Blacks, implying an equal interest in each group on the part of the artists involved over three centuries. No complete statistics on this question have ever been compiled, but for the period 1590–1900 there can be no doubt that images of Indians far outnumbered all representations of Blacks as slaves or freemen in American art. Within the collection of plates reproduced here, this overall imbalance has been reduced to a ratio of 60 to 40 or 3 to 2 in favor of Indian interests. This has been done by concentrating attention on the nineteenth century; compared to the earlier times under discussion, the last one hundred years witnessed the most dramatic changes in racial attitudes and relationships on a national scale—and it is from the last century that the greatest number of images have survived.

The changing image of the American Indian can be traced through the following chapters as it evolved through history—beginning as the object of European intellectual curiosity, serving a political or symbolic function at times, becoming the natural model for the Romantic notion of the noble savage, occasionally being pictured as a fearsome, fiendlike enemy of White settlers along the moving frontier, and then finally descending into the melancholy twilight of near extinction, a disappearing race falling victim to the inevitable progress of the woodman's ax, the great iron horse, or the United States Cavalry.

The more domesticated image of the Black man in American society serves as a fitting counterpoint to the dominant position held by Indian images and pictorial traditions. During the seventeenth century, for example, pictures of Black slaves or servants in America were virtually nonexistent, save for a very minor figure or two in the lower corner of a decorative European map of the New World. Among colonial images the single appearance of a Black king as one of the three Magi in a unique religious painting (Plate 16) was completely offset by dozens of pictures and even historical portraits of Indian kings and orators; the only Blacks in colonial portraiture were household servants, endlessly waiting at the feet or at the elbow of their White masters (Plate 22). At the end of the eighteenth century, a few American painters, working in London, managed to incorporate Black figures into semiheroic compositions or history paintings (Plates 28, 29, and 34); otherwise, Negroes were usually forced to play comic parts in American genre scenes and political cartoons well into the 1800s. Obviously, for most artists, the common and familiar aspects of Black servitude or slavery held relatively little interest compared to the foreign and more fascinating appeal of Indian subject matter.

It was not until the height of the Abolition movement in the 1850s, followed by the Civil War era and then Reconstruction, that images of Black men began to change drastically in content as they multiplied rapidly in number. Burgeoning interest in the legal end of slavery and the new life of the Negro thereafter resulted in a major reversal of roles. In the course of the nineteenth century, fiercely proud Indian warriors, once admired and feared, were transformed into dying chiefs and paupers by American artists

and by historical events as well (compare Plates 36 and 89). At the same time, the once humble and devoted slave could be portrayed in the act of throwing off his chains to emerge as a free man, bursting with new-found pride and eager to improve his lot, mainly through education (see Plates 38, 90, and 120).

The Image of the Indian
and the Black Man
in American Art
1590-1900

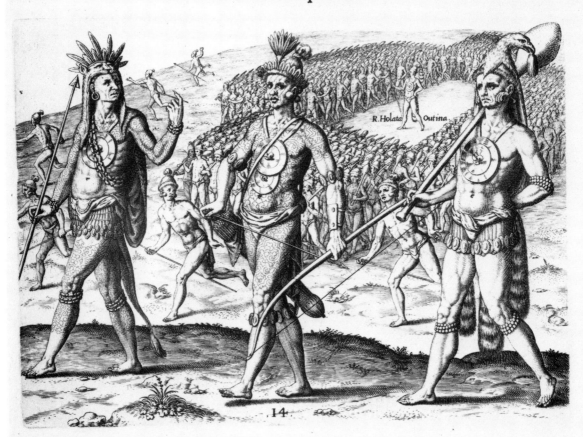

REGE Saturioua *ad bellum proficiscente, ejus milites nullum ordinem servant, sed sparsi hinc inde discurrunt alij alios sequentes. Contra ejus hostis Holata Outina, cujus jam memini, quod multorum Regum Regem significat, longè eò potentior subditorum numero & divitijs, progreditur servatis ordinibus veluti instructa acie, solus in medio agmine consistens, rubro colore pictus: agminis alæ sive cornua ex adolescentibus constant, quorum maximè agiles, rubro etiam colore picti cursorum & exploratorum munere funguntur, ad hostium copias explorandas: nam horum vestigia perinde naribus percipiunt, atque canis feræ alicujus, & cognitis hostium vestigijs statim ad exercitum significatum recurrunt. Porro ut tubis & tympanis nostri homines in exercitu utuntur ad significandum quid facto opus sit: sic apud eos præcones sunt, qui certis clamoribus indicant quando subsistendum aut progrediendum, hosti obviam eundum, aut aliquod militare munus obeundum. Post Solis occasum subsistunt, nec unquam pugnare solent. Castra autem ponere volentes per decurias distribuuntur, maximè strenuos ab alijs segregantes: delecto à Rege Castrorum loco in agris vel syluis ad noctem traducendam, & illo jam cænato & solo sedente, castrorum metatores decem strenuiorum decurias in orbem circum Regem collocant: circiter decem inde passus aliæ viginti decuriæ etiam in orbem eos claudunt: viginti verò ab illis passus, aliæ quadraginta decuriæ collocantur, & ita deinceps decuriarum & passuum numerum augendo pro exercitus copia & magnitudine.*

C 3

1. Theodore De Bry (c. 1528–1598), *Outina's Order of March*. Engraving after an original design by Jacques Le Moyne de Morgues, 6 x 8⁵⁄₁₆ inches. From De Bry, *Florida*, Frankfurt-am-Main, 1591.

I

European Interest in the New World

THE FIRST EUROPEANS to visit the New World were adventurers, not artists. Daring and sometimes ruthless in their conduct, these early navigators, soldiers, and explorers came in search of easy profit— profit in terms of unclaimed land and mineral wealth as well as national or personal prestige. Creative artists were not needed on these initial voyages because the only images to be made were simple maps, outlines of the newly discovered coasts, showing the mouths of navigable rivers and the site or plan of an occasional fort. If an explorer wanted to illustrate his findings in America, he could, like Columbus, collect extensive samples of the flora and fauna—even to the point of abducting a few Indians who might be lured out to his ship. Captives of this sort were used frequently as translators or guides on one side of the Atlantic and as fascinating trophies of conquest on the other—if they survived the ocean crossing.

In sixteenth-century Europe, the image of America fit neatly into a well-established figural tradition, one that can be traced back to classical antiquity. Representing the welcome fourth corner of an expanding Renaissance world, America was personified as a symbolic female figure with appropriate Indian attributes. She was usually pictured in popular prints, books, statues, and political parades wearing a feather skirt and headdress, holding a club or a bow and arrow, and standing in the midst of exotic vegetation with some characteristic animal (such as a parrot, a sloth, an armadillo, or a crocodile) as her companion. The tropical flavor of this image was clearly derived from Spanish reports of Central and South America, but even after the North American continent had been colonized and new facts about aboriginal life were known, this tropical personification of the New World was so well fixed in the public imagination that it survived largely unchanged until the time of the American Revolution (see Plate 3).

By contrast, first-hand visual documents, said to depict actual conditions in North America with the authority of personal experience, were not widely available in Europe before the 1590s when Theodore De Bry, a Flemish gold-

smith and engraver, began to publish a series of illustrated books on historic voyages. To embellish each volume with engravings after the most authentic pictures available, De Bry sought out those few artists who actually had been to America. In 1588–1589, for example, he bought from the widow of Jacques Le Moyne de Morgues both a series of watercolors that Le Moyne had painted of American Indians and a narrative account of the short-lived Huguenot settlement on the coast of Florida. Originally, Le Moyne had been one of three hundred Protestant colonists who sailed to Florida in 1564, with the hope of leaving constant warfare and religious strife behind. During the following year, however, he was lucky to escape the attack that drove these French intruders from the territory claimed by Spain. It was in London that Le Moyne later prepared the manuscript of his story along with the pictures based on his experiences.

As a form of visual evidence recorded long after the event, the watercolors by Le Moyne, of which only one survives (New York Public Library), and the De Bry engravings after the entire set can hardly be trusted as literal truth. Confronted with unfamiliar facts, it was quite natural and even inevitable that the artist and the engraver should translate this new wealth of information into preexistant patterns of thought and vision. In terms of style alone, for instance, it is obvious that the seminude Indians have all been cast in the same Mannerist mold (Plate 1). In every engraving by De Bry the human figures—both male and female—are large and powerful, rendered with a Michelangesque attention to musculature, but with no interest at all in the problem of more individualized portraits. These Indians are conceived and then presented in terms of their place or function in society, while the landscapes they inhabit are little more than abstract stages on which a certain action is performed.

No matter what reservations one may have about their style or their ultimate truthfulness, it is important to realize that Le Moyne's designs, as published by De Bry, did provide important patterns for other artists to follow. As in the case of the first explorers, there was no moral or written law to prevent a later engraver from lifting Indian figures out of their original context and forcing them, however uncomfortably, into decorative European settings. This was clearly done in the case of the triumphal arch, replete with Renaissance swags and festoons, that De Bry employed as a title page in 1591 (compare Plates 1 and 2); and the same process was still at work almost a century later as seen in an exuberant Baroque cartouche, taken from a French map of North America (Plate 3), which actually borders on grotesquerie—note the Indian feathers emerging from a human nose at the base of the motif.

In terms of content, on the other hand, De Bry's engravings after Le Moyne may serve as a perfect index to the range of European interests imposed on the facts of native life in foreign lands. Each image or group of images seems to mirror some fundamental concern of the age. Fully one-third of the forty-two illustrations in De Bry's *Brevis Narratio eorum quae in Florida . . .* deal with the major theme of war and death. *Outina's Order of March* (Plate 1), to take a prominent example, shows the most powerful Indian chieftain in the area of the French colony going to war in the center of a phalanx of well-disciplined

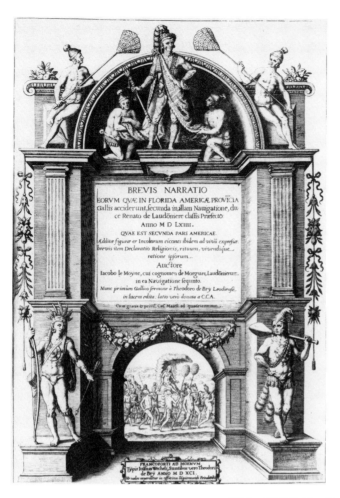

2. Theodore De Bry, From *Brevis Narratio eorum quae in Florida . . .*, Frankfurt-am-Main, 1591. Engraving, 12³⁄₁₆ x 8⁵⁄₁₆ inches.

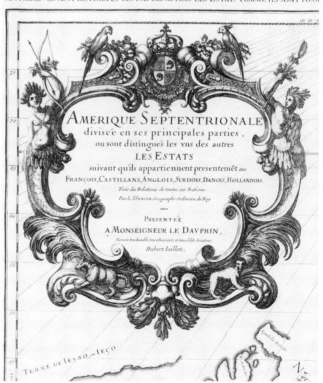

3. Alexis Hubert Jaillot (c. 1632–1712), *L'Amérique Septentrionale,* 1674. Detail of engraved map, cartouche 9¼ inches high. Historical Map Collection, Columbia University Libraries, New York.

warriors. This picture of a startlingly European military formation and the Latin text describing its highly efficient operation imply considerable respect and admiration on the part of the outnumbered Huguenots who were allied in 1564–1565 with Outina's weaker rival, Saturiba.

Another important theme was the natural supply of food and its preparation. Indian women can be seen in several of De Bry's plates doing the planting, gathering, and cooking, while the men perform the more athletic and dangerous tasks of hunting deer or killing crocodiles. In the engraving of a deer hunt (Plate 4), one is reminded of those sixteenth-century European landscape paintings in which a hunter firing his musket at a deer was a familiar foreground detail. Without sophisticated weapons, though, the native hunters of the New World had to use ingenuity and stealth in a way that fascinated more civilized men. As an image of perfect adaptation to nature, the Indians' use of animal disguises in stalking their prey with bow and arrow must have seemed just as marvelous to De Bry's readers in the 1590s as it did to George Catlin's audience two hundred and fifty years later (Plate 5).

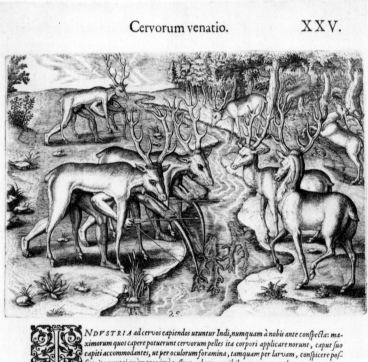

Cervorum venatio. XXV.

INDVSTRIA ad cervos capiendos utuntur Indi, numquam à nobis ante conspecta: maximorum quos capere potuerunt cervorum pelles ita corpori applicare norunt, caput suo capiti accommodantes, ut per oculorum foramina, tamquam per larvam, conspicere possint; ita compti quàm proximè possunt, ad cervos nihil metuentes accedunt; prius tempore observato, quo cervi ad flumen bibendi causa eunt: eos, arcum & sagittam manu tenentes, facilè figere possunt, cùm frequentes sint admodum in ea regione: arboris tamen cortice sinistrum brachium muniunt, ne ab arcus nervo laedantur à natura ita edocti. Pelles verò cervis detractas, non chalybe, sed conchis adeo accuratè parare norunt, ut mirum sit, nec quemquam in universa Europa inveniri existimo, qui tanta arte eas parare queat.

E 2

4. Theodore De Bry, *Indians Hunting Deer.* Engraving after an original design by Jacques Le Moyne de Morgues, 6³⁄₁₆ x 8⁵⁄₈ inches. From De Bry, *Florida,* Frankfurt-am-Main, 1591.

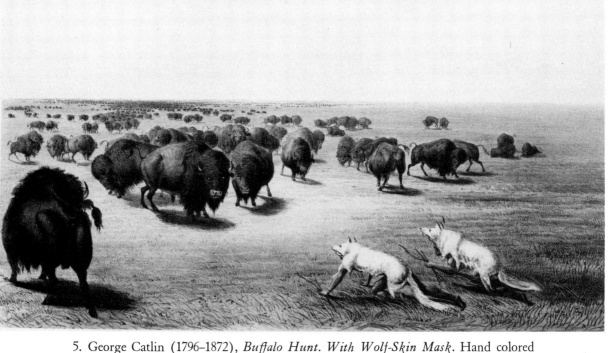

5. George Catlin (1796–1872), *Buffalo Hunt. With Wolf-Skin Mask.* Hand colored lithograph, 12 x 17¾ inches. From Catlin's *North American Indian Portfolio,* London, 1844.

Another artist whose watercolors came into Theodore De Bry's possession was John White, an Englishman who made several voyages to Roanoke Island, Virginia, including one as governor of this English colony authorized by Sir Walter Raleigh under a patent from Queen Elizabeth. The set of watercolors painted by White between 1585 and 1587 (British Museum, London) show a wide range of interests—wider than Le Moyne's, in fact, since they include detailed studies of New World birds, fishes, reptiles, and insects. In the end, however, only the more conventional, travel-book images of Indian life, depicting their settlements, costumes, and principal occupations, were used by De Bry in 1590 as illustrations for his first volume on America, an edition of Thomas Hariot's *A Brief and True Report of the New Found Land of Virginia* (published in English, French, and German, as well as Latin).

Of the twenty-three finished engravings that appeared in this book, one of the most unusual and instructive was the view of *The Town of Secota* (Plate 6). By drastically tilting up the ground plane in his original watercolor, even to the point of cutting off the horizon and severely distorting the perspective of the bark huts, John White was able to communicate a maximum amount of information about this small farming village, where "these people live happily together without envy or greed." In De Bry's engraving the conceptual content of the image is made even clearer by the use of a letter key (A through L). In the upper corner of the engraved plate bowmen are chasing deer in the

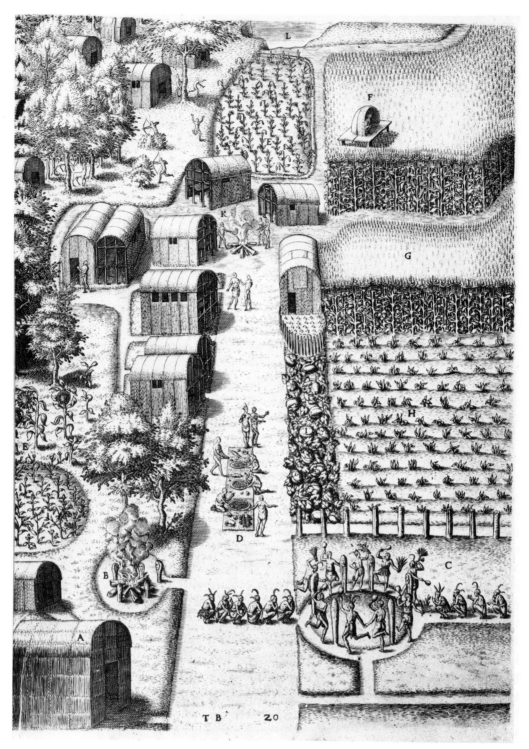

6. Theodore De Bry, *The Town of Secota*. Engraving after an original watercolor by John White, 12⅛ x 9³⁄₁₆ inches. From De Bry, *Virginia,* Frankfurt-am-Main, 1590. The Indian crops include tobacco and sunflowers (E), and three plantings of corn with a patch for pumpkins (I). The cornfields are arranged in a natural progression from new shoots (H) to green corn (G), to ripe corn in full tassel (F). While other villagers are celebrating a solemn ritual (C), before attending a great feast (D), a single Indian watchman is left to guard the crops from his solitary platform (F).

forest, but the greater portion of the picture is given over to an explanation of native agriculture—especially those plants new to European eyes—and the representation of a few religious ceremonies. The end impression of what life was actually like in this peaceful village, built without the usual protective palisade, is surprisingly rich in detail.

One important type of American Indian image that did not exist before 1600 and then found only limited currency in the seventeenth century was the individual portrait, showing the sitter close-up in a half-length or bust-length view. Even in those plates by De Bry where native kings or queens in Florida or Virginia are identified by name, they are still portrayed as full-length figures, distinguished from their subjects more by royal panoply and position than by any visible traits of personality. Needless to say, no successful European painter of the time would rationally choose to cross the Atlantic to search for portrait commissions in the wilderness. Instead, it was the Indians who went abroad. From the 1580s on, a number of Indians from the coast of North America were taken back to Europe not as captive curiosities or slaves, but as welcome emissaries from a foreign country. In this capacity they were generally well received at court and their portraits were occasionally painted or engraved by competent hands.

The English attempts to colonize Virginia provide an interesting example of this new climate of exchange and the opportunity for portraiture. The first expedition sent out by Sir Walter Raleigh in 1584 returned with two savages on board, Wanchese and Manteo, chosen for their strength and endurance. The ostensible purpose of their visit was twofold: (1) to promote better relations with the native tribes along the Virginia coast—as a sign of good faith Manteo was made "Lord of Roanoke" in return for his loyalty—and (2) to prevent hostile attacks by convincing these savages of the inevitable superiority of the English in numbers and weapons, even if their fortified settlements in Virginia seemed small and extremely vulnerable.

The presence of these two Indians in London during 1584 and 1585—a notable event recorded in words, but not in pictures of any kind—had an important side effect. Probably as a result of the added publicity, large numbers of colonists, including John White, were willing to sail for Roanoke Island in 1585 and again in 1587. This first colony failed ultimately for want of resupply during the national crisis in England caused by the Spanish Armada (1588), but the seed of colonization had been well-planted. The publication of De Bry's engravings after John White and the memory of the Indian visitors must have helped to keep the idea alive in English minds.

The next settlement in Virginia, established by the London Company at Jamestown in 1607, was more successful even though its early years were marked by extreme hardships, particularly during the first winters when the ill-prepared and ill-equipped settlers suffered from exposure and starvation. At the same time the value of effective propaganda at home in support of this precarious venture in the wilderness was thoroughly understood. The London

Company itself issued governing laws and pamphlets of instructions, while Captain John Smith, one of the leaders of the new colony at Jamestown, became a major spokesman for English efforts in the New World through his several publications.

In the spring of 1616, in order to make a strong impression in favor of the struggling colony in Virginia of which he was governor, Sir Thomas Dale decided to take an Indian delegation to England. He arrived in London on June 22, 1616, according to an official record, bringing with him "some ten or twelve old and younge of that Countrie, among whom the most remarquable person is Pocahuntas."[1] Pocahontas, whose real name appears to have been Matowaka, was truly remarkable for several reasons. As the daughter of Powhatan, the native "Emperour" of Virginia, she was considered to be royalty by the English—an authentic Indian princess. Secondly, as a political hostage for a time in Jamestown, she had been befriended by Reverend Whitaker, Governor Dale, and John Rolfe, the successful tobacco planter; under their influence she became the first convert to Christianity in Virginia, taking the name Rebecca at her baptism. And thirdly, once she had been baptized, she and John Rolfe were married (April 5, 1614), thereby tending to ensure the survival of the colony through the protection of an approving God and peaceful cooperation with neighboring tribes.

In strictly human terms, therefore, no more appropriate or convincing image of the taming of the American forests could be imagined than the arrival of Rebecca Rolfe in England. Carefully groomed for her visit, she even learned to speak a little English and to wear conventional garments, although she never learned to like the staring crowds, the noise, or the smells in the streets of London. When Simon van de Passe engraved her likeness in 1616 (Plate 7), listing her age at 21 as part of a complete inscription, he created what may have been the first English and perhaps the first European posed-for portrait of an American Indian. In style, of course, this image belongs to the stiff and rather formal tradition of Tudor-Stuart portraiture that survived from Elizabethan times into the reign of James I. When compared to contemporary portraits of fashionable English ladies, a few details in the van de Passe engraving (the unusually prominent cheekbones and the conspicuous feather fan) seem to suggest the savage origins of this elegant and aristocratic woman.

It is a very different image of Pocahontas that appears in the lower right-hand corner of Robert Vaughan's engraving of "Ould Virginia" (Plate 8). This composite plate, published in John Smith's *Generall Historie of Virginia, New-England and the Summer Isles* (London, 1624), is named for the map of the Virginia coast, conceived from a European standpoint, looking from east to west, from across the Atlantic onto the new continent. More importantly, the narrative scenes gathered around this map, though they vary in size and chronological order, were meant to provide "A description of part of the adventures of Cap. Smith in Virginia."

Taken as a group, these small pictures speak of extremely hostile relations between the Indians and the first English settlers at Jamestown from 1607 to 1609. There were attacks and counter-attacks, with numerous casualties and

7. Simon van de Passe (c. 1595–1647), *Pocahontas* (Matoaks al[ia]s Rebecka, daughter of the mighty Prince Powhatan, Emperour of Attanougskomouck, al[ia]s Virginia), 1616. Engraving, 6⅝ x 4⅝ inches. Print Room, British Museum, London. Courtesy: Trustees of the British Museum.

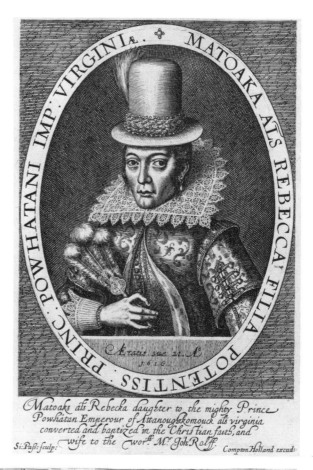

8. Robert Vaughan (English engraver), *Ould Virginia,* 1624. Engraving (4th state), 10¹¹⁄₁₆ x 13¹⁵⁄₁₆ inches. Published in John Smith, *Generall Historie of Virginia,* London, 1624.

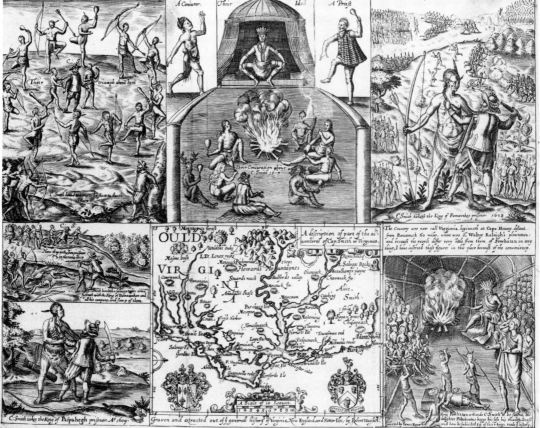

prisoners taken on both sides. Captain Smith is actually represented in the act of shooting three Indians (center, left) before he was taken prisoner himself and almost executed in 1607. The climactic and now legendary scene in which Pocahontas steps forward and saves the life of the English soldier is placed in a key position on the right, while the abbreviated caption inserted beneath the figures invites the reader to follow the rest of these thrilling adventures in the text.

In the process of extracting certain episodes from Smith's self-laudatory book and then giving them visual form, Robert Vaughan was obviously more interested in dramatic effect than in factual truth. There can be no question of direct portraiture of persons or events since no artists were active at Jamestown in recording its early history. Instead, this engraver at work in London simply drew on an established source—the 1590 engravings after John White's watercolors of Virginia. This debt is openly acknowledged by Vaughan on the map itself, and his words imply that new visual evidence was not necessary since all savages looked alike: "The Country wee now call Virginia beginneth at Cape Henry distant from Roanoke 60 miles, where was Sr. Walter Raleigh's plantation: and because the people differ little from them of Powhatan in any thing, I have inserted the figures in this place because of the conveniency."

Convenience was undoubtedly a primary factor. Compared to the difficulties of reaching the New World safely and then returning with fresh images, it was infinitely easier for art to follow art. Robert Vaughan's figure of Pocahontas was adapted, with minor adjustments, from De Bry's engraving of "An Old Man in his Winter Clothes." This model was chosen, presumably, because of the appropriate pointing gesture and the modesty afforded by his ample garment.

In January of 1617, when Rebecca Rolfe attended a performance of Ben Jonson's Christmas masque at Whitehall Palace, she was described as being different from the other women in court dresses because of the noble way she held her shoulders, the lightness with which she walked, and the indescribable grace with which she waved her feather fan. In 1624, on the other hand, the details of her personal appearance were far from essential. She appears in Vaughan's engraving as something of an Amazon, devoid of courtly graces. Hieratic in scale, she towers over the tiny Englishman about to be cruelly murdered. In this pictorial version of the story, as in later retellings, her act of mercy was made larger than life.

Towards the end of the seventeenth century, while English colonists controlled but a narrow strip of land along the eastern edge of North America, the French had established their claim to all of Canada or La Nouvelle France. Two book illustrations that give some idea of official French interests in the New World are reproduced here (Plates 9 and 10). Both were meant to be encyclopedic images, recording in one frame a considerable variety of Indian activities on a given theme (one male and hostile, the other female and domestic), as described in each text. At first glance, these supposedly American

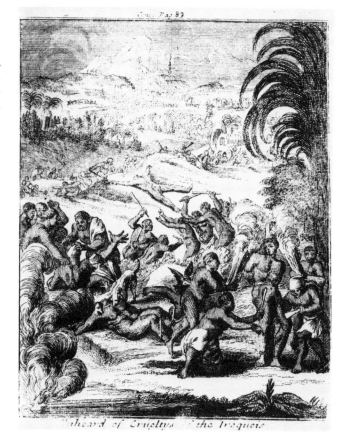

9. Anonymous (English engraver?), *Unheard of Crueltys of the Iroquois.* Engraving, 6⅛ x 4¾ inches. Published in Louis Hennepin, *A Continuation of the New Discovery of a Vast Country in America,* London, 1698.

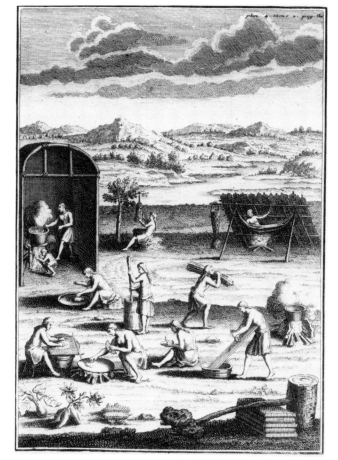

10. Anonymous (French engraver), *Manière de préparer la nourriture.* Engraving, 7⅝ x 5½ inches. Published in J. F. Lafitau, *Moeurs des Sauvages Amériquains, comparés aux moeurs des premiers temps,* Paris, 1724, volume II. On the right, a cutaway view of a "Carib" Indian lean-to. Four Carib women across the middleground are making cassava bread, a staple food in the tropics. On the left, an Iroquois matron and her child. Outside the hut, three more Iroquois women prepare and store cornmeal, an essential food for northern tribes.

landscapes may appear somewhat more convincing—in terms of spatial continuity, at least—than John White's view of Secota (Plate 6), but the settings are just as arbitrary as the figure-groups assembled in them. Neither plate was drawn or engraved from personal experience.

The *Unheard of Crueltys of the Iroquois* (Plate 9), created by someone who believed that palm trees grew everywhere in the New World, appeared in Louis Hennepin's *A Continuation of the New Discovery of a Vast Country in America* (London, 1698). In visual effect, the multiple tortures being inflicted by bands of Indians on their captives in this plate represent a partial rehearsal of Counter-Reformation iconography. Some of the specific details described by Hennepin may have been "unheard of," but to anyone familiar with Baroque paintings, showing Catholic saints being martyred for the church, this pictorial catalogue of Indian cruelties would have seemed quite familiar. The transplanting of European religious imagery in American soil was perfectly natural since Father Hennepin, a Recollect missionary who accompanied La Salle to Canada in 1675, hinted at these parallels in his text.

The main issue involved in this illustration, however, was political not religious. Ever since 1609, when an exploring party under Samuel de Champlain encountered a number of Iroquois warriors and killed many of them with firearms, the powerful Iroquois Confederacy of what is now New York State fiercely resisted any further incursions by French colonists and their Indian allies. As implacable enemies, the Iroquois were automatically characterized as barbarous fiends by the French. According to Hennepin, they were the most savage people of North America, and the most inhuman tortures are ascribed to them in the text and the accompanying illustration:

> When the *Iroquois* have kill'd a Man, they tear off the Skin of his Skull, and carry it home with them as a certain Mark of their Victory. When they take a Slave, they tie him, and make him run after them; if he is unable to follow them, they stick their Hatchet into his Head, and there leave him, after they have torn off Skin and Hair together. They don't spare suckling Infants: If the Slave can march after them, they tie him every Night to a piece of Wood made in the form of a St. *Andrew's* Cross, and leave him expos'd to be stung by the *Maringoins,* and other Flies, in Summer-time, and use him as cruelly as may be.
>
> Sometimes they fix four Pegs into the Ground, to which they fasten their Slaves by the Feet and Hands, and so leave them all Night long upon the Ground in the sharpest weather. . . . When they are near their Villages, they set up loud cries, whereby their Nation knows that their Warriours are return'd with Slaves. . . . But 'tis a lamentable Reception for these poor People: The Rabble fall upon them like Dogs or Wolves upon their Prey, and begin to torment them, whilst the Warriours march on in a File, mightily puff'd up with their own Exploits.[2]

A still later example (Plate 10), taken from Joseph François Lafitau's *Moeurs des Sauvages Amériquains, comparés aux moeurs des premiers temps* (Paris, 1724), belongs to the continuing tradition of intellectual interest in the

manners and customs of foreign peoples, expressed (as in this instance) without moral judgment or political censure. This particular illustration, portraying the Indian manner of preparing basic foods, was inserted in the section of Lafitau's treatise dealing with the occupations of women. Compared to French Rococo paintings of precisely the same period, especially those by Lancret and Pater in which doll-like women seem to have endless amorous encounters in one pleasure garden after another, this engraving of 1724 looks sparse and almost empty. The female figures are equally small in relation to the frame— a general characteristic of Rococo images—but here they are arranged diagrammatically in an open landscape, and their function is serious and didactic, rather than playful and diverting.

At the core of Lafitau's book was his contention that most New World Indians were descendants of the race that originally inhabited the Greek peninsula and its islands. To prove such a speculative theory, visual as well as documentary evidence had to be stretched and sometimes distorted. Even in the case of seemingly straightforward descriptive images, ethnographic facts had to be arranged in usable patterns. From Lafitau's own explanation, for example, one learns that the illustration of food-making contains both North and South American women in one improbable scene.

Ignoring tribal and geographical differences—perhaps out of real ignorance or possibly just for the sake of convenience—the anonymous engraver of this plate made all of these Indian women look and dress exactly alike. Their tasks were the important thing in this instance, not their costumes or personal characteristics. As a result, the educational value of the illustration rests not on the figures, but on the types of architecture depicted and on the key foods (a sweet potato, a manioc or cassava plant, and several ears of corn), placed in a well-lit corner of the foreground where they could hardly be overlooked.

2

Colonial Images

WITHOUT A DOUBT, the dominant form of art practiced in the American Colonies before the Revolution was portraiture, but alongside the myriad likenesses of wealthy colonials, their wives and children, only a few portraits of individual Indians were produced between 1675 and 1775. And if Negro slaves appeared at all in colonial portraits, it was invariably as servants, waiting on their masters—never as objects of interest in themselves. Only by turning to other types of pictures and other forms of visual art can this meager repertory be increased. The following illustrations, showing Black and Indian kings as well as servants or subjects, include a religious painting, a mural, and an early landscape painting in addition to several engravings, a woodcut, and a piece of sculpture. Although still few in number, these key images are interesting for the basic issues they raise about colonial life and racial interaction.

The attitudes of early Puritan settlers towards the native tribes of New England offer a fascinating case in point—a case that involves an emblematic image of an Indian with strong religious and political overtones (Plate 11). Operating under a royal charter, the original New England Company for the establishment of a plantation in Massachusetts Bay was permitted to have its own official seal in 1629. Two hand seals, needed to stamp important documents and correspondence, were immediately ordered from a London silversmith, Richard Trott. One was sent to the New World on the very next ship, and the duplicate was brought over by the new governor, John Winthrop, when he arrived with more colonists the following year.

From the beginning, the image on this seal consisted of two standard elements: a Latin inscription around the outside and an Indian figure in the center, holding a bow in one hand and an arrow in the other, while speaking the words, "COME OVER AND HELP US." Since the London silversmith in 1629 was unlikely to have had a living Indian model, he probably turned to printed sources such as the engravings by Theodore De Bry (compare Plates 2 and 11). For the purposes of a small seal, less than 1½ inches high,

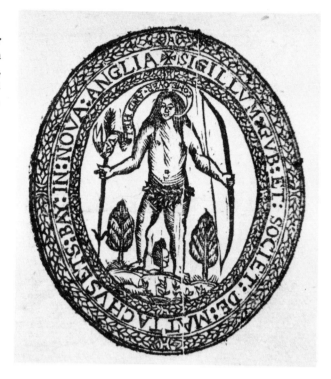

11. John Foster (1648–1681), *Seal of the Massachusetts Bay Colony,* carved in 1675 and in use until 1690. Woodcut, 2½ x 2¼ inches. American Antiquarian Society, Worcester, Mass.

however, the life-like, three-dimensional quality of the best engravings had to be sacrificed for a simple, two-dimensional, emblematic design that would be completely legible when stamped in wax.

This basic design, which remained relatively unchanged through the seventeenth century, was copied by John Foster about 1675 (Plate 11). At that time Foster, a former schoolmaster in Dorchester, was setting up a printing shop in Boston with the hope of cutting into the monopoly of Samuel Green, the Cambridge printer. Significantly, Green had been using another woodcut of the colony's seal since 1672; but this version, showing a rather stocky female figure holding the standard attributes, was probably imported from England. Foster's woodcut, the first version of the seal to be carved in America, was undoubtedly made in response to this foreign rival. And having such a seal on hand was mandatory if he wanted any of the colony's business for printing laws and public proclamations.

Looking closely at Foster's seal and considering his lack of artistic training, it is not surprising that he made mistakes in the anatomy of the figure or that he occasionally misplaced a row of parallel lines meant to represent shading. But taking a more positive view, the smiling expression on the face of this long-haired "savage" seems charming enough to make up for any shortcomings in the overall draftsmanship.

In keeping with the earlier versions of this seal, Foster was careful to include the ribbon-like pennant emerging from the Indian's mouth. As a form of visible speech, this pennant belongs to a long tradition. It may remind one of Medieval and Early Renaissance paintings of *The Annunciation* in which the Virgin Mary's answer to the angel appears as a phylactery beside her head —with the words printed upside down so that God could read them. On the seals of the Massachusetts Bay Company, however, the Indian's invitation to

"COME OVER AND HELP US" was not addressed to God, although the phrase was taken from the Bible. According to Acts 16, verse ix, the Apostle Paul was traveling in Asia Minor when a vision appeared to him in the night. A man of Macedonia stood before him, beseeching him and saying, "Come over to Macedonia and help us." On the spot Paul decided to go on to Macedonia, convinced that God had called him to preach the Gospel there.

Clearly, the Indian on the first silver seal in 1629 was intended to be an evangelical vision, imploring Englishmen to spread the Gospel among the savages of North America. Ironically, after John Foster carved his version of the seal in 1675, it was first printed on government orders concerning King Philip's War (1675–1676), the bloodiest and most costly Indian war in southern New England. With the aid of Christianized Indians, who lived in their own "praying towns," the English colonists were able to defeat the Wampanoag warriors and their allies (the Narragansetts, Nipmucs, and Pocumtucks). When the war was over, all the territory of what is now Massachusetts, Connecticut, and Rhode Island was opened to further missionary and colonizing efforts without interference. In this context the phrase "COME OVER AND HELP US" has the ring of a land development offer—a call from the English settlers to their fellow countrymen, imploring them to come over and help first with the military defense and then with the inevitable economic and territorial expansion of the colony.

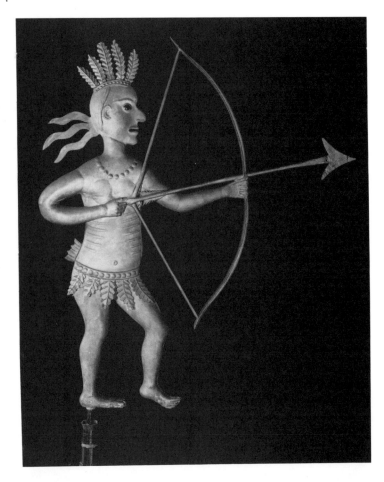

12. Shem Drowne (1683–1774), *Indian Archer Weathervane,* early 18th century. Sheet copper, gilded, 54¼ inches high. Massachusetts Historical Society, Boston.

On a larger scale, one of the most familiar landmarks in colonial Boston was another Indian image, serving as a weathervane on top of the Province House (Plate 12). Where the majority of early weathervanes in America tended to be simple profile shapes, cut from flat pieces of wood or metal, the body of this Indian archer was carefully formed in low relief from two slightly convex sheets of hammered copper (maximum thickness—3½ inches) which were joined at the edges and then gilded. This weathervane was created by Shem Drowne, also called Deacon Drowne because of his position in the church, who worked as a carver in Boston for most of his long life. Primarily, he created figureheads for ships sailing out of Boston harbor, but it is reported that he also carved a variety of ornaments for more stationary objects, such as pumpheads, gateposts, and mantelpieces.

The most unusual account of Drowne's work, offering a glimpse of artistic life in eighteenth-century Boston, was a short story by Nathaniel Hawthorne, called "Drowne's Wooden Image," that appeared in *Mosses from an Old Manse* (New York, 1846). At the center of this fictional tale was the issue of artistic ability and inspiration. Though he gave Shem Drowne credit for "no inconsiderable skill' in the mechanics of carving figures and giving them every appropriate attribute, Hawthorne admitted to his reader that these figures had a heavy wooden sameness about them. As an example of extended family resemblances, he pointed out that Drowne's figurehead of Miss Peggy Hobart, the daughter of a wealthy merchant, bore a remarkable similitude to Britannia, Victory, America, and other ladies of the allegoric sisterhood who emerged from unshaped blocks of timber in the carver's workshop.

As a foil to Shem Drowne's inability to give convincing life to his wooden figures, Hawthorne introduced into the story "Copley, the celebrated painter, then a young man and a resident of Boston." On one supposed visit to the carver's shop, Hawthorne had Copley pretend to admire some of the figures for their life-like, portrait qualities. In reply to this mocking praise Drowne openly admitted that there was the same difference between his carvings and the works of an inspired sculptor, as there was between a sign-post daub and one of Copley's better pictures.

At the end of this fictional account, Hawthorne mentioned a few works by Drowne that actually were famous sights in Boston. A reduced likeness of Captain Hunnewell, holding a telescope and quadrant, stood at the corner of Broad and State Streets, identifying the shop of a nautical instrument maker. And, more importantly, one of Drowne's finest productions, "an Indian Chief, gilded all over, stood during the better part of a century on the cupola of the Province House, bedazzling the eyes of those who looked upward, like an angel of the sun."[1]

This literary reference to a golden angel of the sun seems farfetched today, but there was a popular legend, supposedly drawing a crowd of curious boys each midday, that if the archer were ever to fire his arrow it would have to be at high noon. In style, of course, Drowne's weathervane belongs to a more earthly, less magical tribe of images produced with an untrained artist's naive imagination. While some colonial painters, such as Gustavus Hesselius

or John Singleton Copley, created close-up intimate portraits of the faces before them (see Plates 18 and 28), Drowne had no need of a living model. His Indian archer met all the requirements for an effective weathervane: it had a bold (if oversimplified) silhouette, easily recognizable from a great distance; it indicated the wind direction with considerable drama; and it may have been intended to act as a specific symbol for the building it surmounted.

In crowded English and American cities like London or Boston, it is possible that weathervanes served as aerial markers, identifying particular public buildings or building types which might otherwise have been extremely hard to find when traveling on foot through narrow, twisting streets. Vigilant weathercocks, for example, were traditional for church steeples on both sides of the Atlantic. Another well known work by Shem Drowne was the gilded grasshopper weathervane (dated 1742) on Faneuil Hall, the gathering place for Boston merchants. This four-foot long insect with a green glass eye was a copy of the famous grasshopper atop the Royal Exchange in London. By direct association, therefore, when foreign traders arrived with their precious cargoes in the port of Boston and looked out over the roofs of the town, the grasshopper alone could tell them immediately where to find the shipping agents and potential buyers they sought.

At the same time, since an Indian holding a bow and arrow had always been an integral part of the colony's seal, Drowne's weathervane atop the Province House, built in 1716 as the new residence of the governors of the Massachusetts Bay Colony, could have been commissioned as a deliberate reference to the administrative authority housed in the building below. Without a quotation emerging from his mouth, however, this outdoor image has shed any evangelical or political meanings. The pose with the drawn bow seems more comic than threatening, since the possibility of a hostile Indian attack on Boston was extremely remote. What remains is a hollow symbol of the New England "savage," whose wisdom and instinctive knowledge of nature have been tamed and pressed into service for the public good. For a century Drowne's Indian stood, aiming his arrow endlessly into the wind, while keeping his dark glass eye alert to changes in the weather.

In 1710, Colonel Peter Schuyler of Albany took a delegation of Mohawk chieftains to London to see Queen Anne. From the English point of view, the purpose of this state visit was to secure the friendship and loyalty of the entire Iroquois Confederacy, thereby establishing an effective buffer zone between the unprotected colonies in New England and New York and the hostile French in control of Canada. For their part, the Indian sachems declared their willingness to accept further instruction in the Bible in return for English soldiers, firearms, and cannon to help them fight off their northern enemies.

The visit of these four American kings—*Te Yee Neen Ho Ga Row* and *Sa Ga Yean Qua Pieth Tow*, Kings of the Maquas, *Etow Oh Koam*, King of the River Nation, and *Ho Nee Yeath Tow No Row*, King of the Genereth-garich (John of Canajoharie)—became an important public event. They were

presented at court, where they made speeches; they appeared at public entertainments, such as Punch's Theatre; and they offered to run down a deer in one of the Queen's parks and to capture it without injury. The Archbishop of Canterbury gave each of them a Bible, and the Queen herself commissioned John Verelst to paint full length portraits, showing each one with his clan totem and his favorite weapon (against a forest setting in which that weapon is being used). When the portraits of these noble visitors were finished, the London engraver, John Simon, quickly prepared mezzotint copies to be sold in the streets, hoping to capitalize on the Indians' celebrity (Plates 13 and 14).

In short order these prints were also available in America, providing a source of inspiration for at least one artist that we know of. When Archibald Macphaedris built an imposing brick mansion for his wife in Portsmouth, New Hampshire (completed about 1723), he apparently wanted it to be as fashionable and sumptuous as a house could be in the Colonies. New furnishings were ordered directly from England, while the interior was being finished by the best local craftsmen. More importantly, Macphaedris also hired an unnamed artist to paint a mural on the window wall of the main stairwell of the house, opposite the front door (Plate 15).

The subject of this mural, which must have set a new standard of elegance for Portsmouth, if not for other towns in New England, was a pair of princely personages borrowed from the John Simon mezzotints of 1710. Behind this choice of subject matter there may have been a strong element of colonial pride. The sachems who visited Queen Anne were, after all, the closest thing to an American royalty, coequal with the British crown. Admittedly, the two Indian kings in this wall painting in New Hampshire were not copied as historical portraits of identifiable chiefs; instead, they were separated from their forest backdrops, generalized, and then transferred somewhat awkwardly onto the plaster in dominant reds and browns.

Nevertheless, despite the crudeness of certain passages, there is a touch of sophistication in the overall design. Capped by draperies drawn back to either side and a canopy over the window, the entire wall has an impressive formal impact, surprising for its time and for its place in a private dwelling. The decorative use of large Indian figures, carefully chosen in terms of left- and right-hand gestures to flank a central opening, may remind one of Theodore De Bry's triumphal arch motif (Plate 2). At the same time, these life-size American princes retain their regal bearing in spite of the decorative, domestic setting. In the final analysis it may be that these Indian images were being used as emblems by the White colonists for their own sense of pride and growing self-confidence in a new land, apart from the mother country.

Far more rare in American Colonial Art was the representation of a Black king. Only one image comes to hand, and it, too, depended heavily on a European print as a basic source. Some time during the first quarter of the eighteenth century, one of the anonymous artists active among the wealthy Dutch patroons of the upper Hudson Valley painted an *Adoration of the Magi*

13. John Simon (1675–c. 1755), *Etow Oh Koam, King of the River Nation*, 1710. Mezzotint engraving after a painting by John Verelst (3rd State), 15¾ x 10¼ inches. Library of Congress, Washington, D.C.

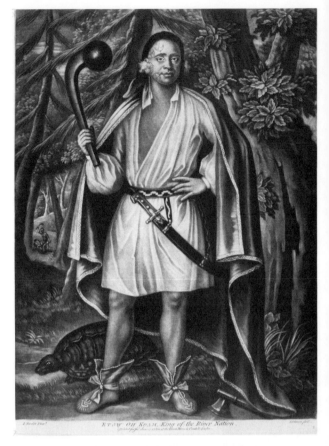

14. John Simon, *Ho Nee Yeath Taw No Row, King of the Generethgarich*, 1710. Mezzotint engraving after a painting by John Verelst (3rd state), 15⅜ x 9¾ inches. Library of Congress, Washington, D.C.

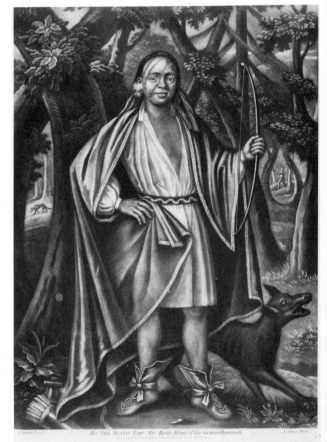

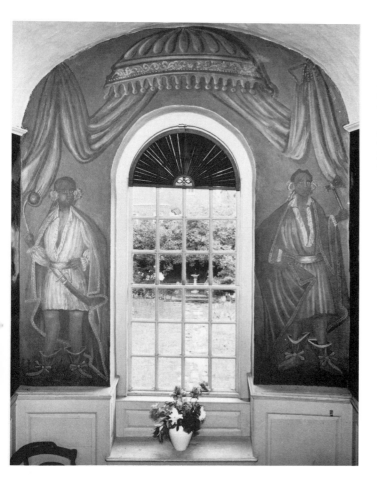

15. Anonymous (Colonial painter), *American Indian Kings*, c. 1716–1720. Mural painting in the main stairwell of the Macphaedris-Warner House, Portsmouth, New Hampshire.

(Plate 16). As this picture was undoubtedly based on an illustration from a Dutch Bible, it naturally follows the Netherlandish tradition of showing one of the Magi as a Black man. Regrettably, there was never any serious demand for religious paintings in the Protestant Colonies, so this imported image tradition—for all its psychological charm and implied equality among the Magi—never took root in American soil.

Another anonymous painting from the Albany area (Plate 17) offers a colorful view of Dutch country life along the Hudson in the 1730s. Posed in front of their yellow house with its red tile roof and dressed in their finest clothes, Marten van Bergen and his wife stand near the center of this long overmantel, acting the part of the wealthy country gentleman and his lady. In spite of the hints of Old World elegance, however, one can instantly tell that this is a New World scene. Like other wealthy landowners in that region, Marten van Bergen undoubtedly owned several slaves; four can be counted in this picture. And inasmuch as the van Bergen house was built (1729) near the site of an Indian burial ground, not far from the village of Catskill, it was probably common to see groups of Indians crossing their property.

Whoever he may have been, the itinerant artist who created this idyllic view was not well trained (as the distorted perspective of the descending road and the fence on the left will show). Invited into the van Bergen house, his task was to produce a decorative portrait of his host's estate, and this had to be done directly upon two cherry-wood planks, 7'3" long, that were built into

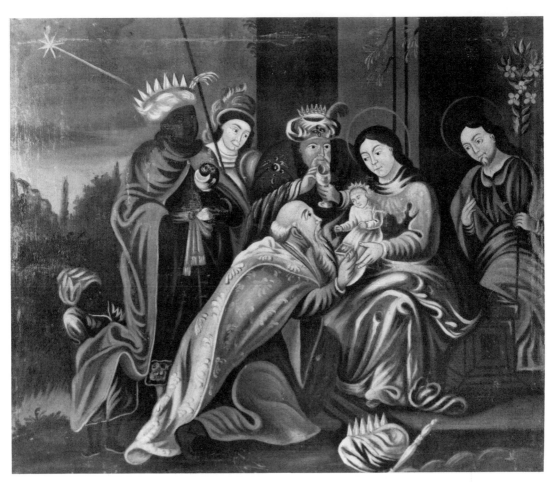

16. Anonymous (Hudson Valley painter), *Adoration of the Magi,* c. 1700–1725. Oil on canvas, 29¼ x 36⅝ inches. Collection Albany Institute of History and Art, New York. Melchior kneels before the Christ Child. Balthazar leans forward. Behind him stands Gaspar, the youngest of the three Wise Men, usually portrayed as a Moor or a Negro, signifying with his gift the tribute of Africa in addition to the homage of Asia and Europe.

17. Anonymous (Itinerant painter), *Marten van Bergen Overmantel,* c. 1735. Oil on panel, 18 x 87 inches. New York State Historical Association, Cooperstown. Marten van Bergen and his wife gesture graciously in either direction, indicating the fruits of their domain.

the paneling above the fireplace in the main room. Seen against a panorama of low hills and then the Catskill Mountains in the background, the house itself in the finished painting is very carefully rendered, down to individual bricks and the large panes of glass typical of Dutch windows. In sharp contrast, however, the tiny human figures were drawn in a very rudimentary way. Differentiated only by their garments and by the colors (pink, reddish brown, and dark brown) of their simple, round, featureless faces, they remain *staffage* elements, incidental details in this pictorial inventory of Marten van Bergen's holdings. No two elements are allowed to overlap, hiding something interesting from view.

What this anonymous artist was able to create was a naive vision of a world of peace and plenty. Evenly spread out across the horizontal landscape, all the living creatures seem to live in perfect harmony with nature and with each other—under the watchful supervision, to be sure, of the wealthy colonial farmer who commissioned the painting.

In other colonies, especially in those that prided themselves on their fair and enlightened treatment of the Indians, historical relations between races appeared equally idyllic in the 1730s—if only on the surface. To lay the groundwork for the purchase of more land, a conference was held on May 9th, 1735, between a delegation of Lenni Lenape or Delaware Indians and the new Proprietor of Pennsylvania, Thomas Penn. Present, besides the colonial officials, were Nuntimus, Tishcohan, Lesbeconk, and other Indians in addition to Lapowinsa, the principal orator. Perhaps as a record of this occasion, Penn commissioned portraits of Tishcohan and Lapowinsa (Plate 18). A note in an official cashbook, dated "Philadelphia, 6th month, 12th day, 1735," mentions the sum of £16 to be paid to the order of Hesselius, the Swedish painter.

Unlike the four American "kings" who visited Queen Anne twenty-five years earlier, these Delaware chiefs did not have to travel anywhere near that far in 1735 to have their portraits painted. In point of fact, these two pictures by Gustavus Hesselius (now in the Pennsylvania Historical Society) represent the dawning of a new age. They are considered the first *true* portraits of American Indians produced on this side of the Atlantic—*true* in the sense of recording

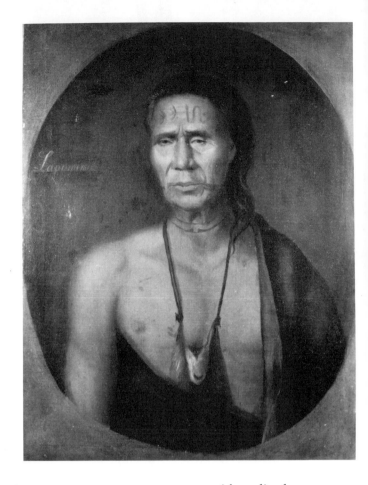

18. Gustavus Hesselius (1682–1755), *Lapowinsa,* 1735. Oil on canvas, 33 x 25 inches. Historical Society of Pennsylvania, Philadelphia.

individuals, rather than illustrating savage manners or customs with stylized figures. That they were commissioned at all suggests a new attitude on the part of the colonists, an attitude of growing scientific and technological interest in a once totally alien environment. Moreover, the fact that they were commissioned during a diplomatic visit suggests a sense of history in the making. It seems plausible that Penn may have been thinking in terms of an Indian gallery, to be filled with a series of portraits of historical interest, each one painted by the same artist on a canvas of the same size. Similar portraits-in-series by the court painters, Sir Peter Lely and Sir Godfrey Kneller, were among the best-known works of the late Baroque period in England. And Kneller's famous series of forty-two portraits of the members of the Kit Cat Club (1702–1717) established a semistandard size (36 x 28 inches) for half-length pictures.

In his painting of Lapowinsa (33 x 25 inches) there are echoes of fashionable European work, but Hesselius, who first came to the Swedish colony on the Delaware in 1712, was a less proficient artist. Although he employed the traditional portrait device of an oval frame-within-a-frame (compare Plates 7 and 18), it is not very convincing as a dramatic opening into the space inhabited by the Indian sitter. Hesselius was clearly a better painter of surfaces than a draftsman able to describe the human form in great detail. Lapowinsa's head is well-modeled, but his chest and arm seem to be flattened out and his left shoulder has strangely disappeared under his cloak.

Balanced off against these shortcomings is the advantage that Hesselius

did not have to flatter a rich colonial patron. He was free to look at this Delaware chief and to record exactly what he saw, including the squirrel skin pouch and the distinctive black marking on his face and neck. Fifty-three years old himself, the artist obviously took special care in showing every sign of age, every wrinkle, every strand of gray hair on his subject's head. The portrait as a whole is dark and somber, and this mood is sustained by Lapowinsa's expression. As the leader of a peaceful people, confronting the White colonial world, he seems at once both wise and pained, sympathetic and suspicious. If he was suspicious, there was good reason. In 1737, by means of the infamous "Walking Purchase," Lapowinsa and the other Delaware representatives who signed the treaty were cheated out of some of their best lands, and their protests went unheeded.

Benjamin West was born in 1738, not far from Philadelphia. An unusual Quaker child, fascinated by the finer arts of any kind, he decided on the unlikely career of trying to become a professional painter: in the colonies this meant being able to capture an acceptable likeness in oils or in miniature. Even though his early work does not reflect it, he had also absorbed along the way a great deal of information about American Indians, and this knowledge proved very useful when he went abroad in 1760. During his sojourn in Italy, for example, the topic came up in several different contexts.

It is said that when the young artist from Pennsylvania arrived in Rome on the 10th of July, 1760 his presence caused a sensation. Hearing that he had just come from the New World to study Italian Art, the curious turned out to see for themselves if he really were an Indian. And reportedly, when West was presented to Cardinal Albani, the blind prelate immediately asked about the color of his skin and was surprised to hear that it was as fair as an Englishman's.

The most famous and oft-repeated story about West in Italy concerns a visit to see the *Apollo Belvedere* in the company of a number of connoisseurs. When the keeper of the collection threw open the doors, West supposedly exclaimed, "My God, how like it is to a young Mohawk warrior." On translation the Italians in the party were mortified that the statue they adored for its godlike beauty should be compared to a mere savage. In reply the American was induced to give a full account of the Indians, describing their education, their dexterity with the bow and arrow, the admirable elasticity of their limbs, and the other physical benefits of a vigorous outdoor life which he found so nobly depicted in the Apollo. "I have seen them often," he claimed, "standing in that very attitude, and pursuing, with an intense eye, the arrow which they had just discharged from the bow."[2] With this fresh and unusual critique the Italians were thoroughly delighted.

Though he was interested primarily in Renaissance and Baroque painting, not to mention the arts of Greek and Roman antiquity, West was also intrigued by the Egyptian obelisks to be seen at various points in Rome. The hierogylphics on these monuments reminded him instantly of the pictographs

that American Indians painted on trees and rocks or placed on their belts of wampum. In fact, according to his later biographer, John Galt, West remembered seeing young braves being taught the art of picture writing: "He had also noticed among the Indians who annually visited Philadelphia, that there were certain old chiefs who occasionally instructed young warriors to draw red and black figures."[3] Inevitably, the equation of Indian and Egyptian hieroglyphics fostered serious speculations in West's mind about the Egyptian origin of the American savages, but in this respect he was being no more fanciful than those who were convinced that the Indians of the New World were descendants of the original Greeks or of the ten lost tribes of Israel.

Because of his origins, his ability, and his first-hand experience of the subject, there was a certain demand for West's services as an Indian painter. For instance, while recovering from an illness in September of 1760, West received a commission from Joseph Shippen, a Philadelphia merchant traveling in Italy, for a "Drawing of an Indian warriour in his proper Dress & accoutrements & his Squaw." This design was to be a present for the English Consul in Venice, who wanted a painting that would represent the four parts of the world, but this project could not be finished in Shippen's words "for want of knowing the particular Dress of our Indians to distinguish America." No such design is known, but this is hardly proof that West never filled this order according to Shippen's very specific instructions: "If the circumstances of your Disorder will permit . . . it would be best that each Figure be at least 18 inches high [so] that the particularities of the Dress may be plainly distinguished. The Warriour's Face should be painted, & Feathers in his Head; he ought to have his

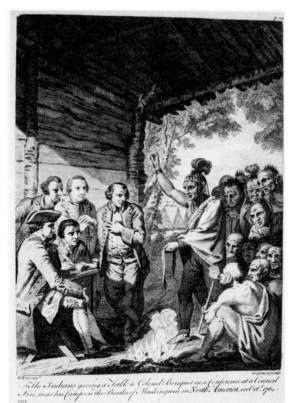

19. Benjamin West (1738–1820), "The Indians giving a Talk to Colonel Bouquet in a Conference at a Council Fire, near his Camp on the Banks of the Muskingum in North America, in Octr. 1764." Engraving by Grignion, 8¾ x 6⅜ inches. Published in William Smith, *An Historical Account of the Expedition Against the Ohio Indians,* London, 1766.

Gun, Tomahawk & Spear but no dog with him as he is supposed going out to war."[4]

On leaving Italy, Benjamin West did not return to Pennsylvania. Instead he established himself in London in 1763, beginning a long and celebrated career as a portrait and history painter in the center of the English art world, but he never forgot about American subjects. On the contrary, it seems that topics from American history were his by a kind of birthright. His two illustrations for a book by his friend, William Smith, *An Historical Account of the Expedition against the Ohio Indians, in the Year 1764* (Plates 19 and 20), are an interesting and quite early example of this connection. When Smith's book was first published in Philadelphia in 1765, it contained maps and diagrams of the military campaign, but no illustrations. For the London edition in 1766, the publishers (perhaps at Smith's suggestion) turned to West as the most logical choice, since the narrative required images of Indians.

Smith's book provided a colorful account of very recent history on the colonial frontier, and enjoyed considerable popularity. After the end of the French and Indian War (1755–1763), the Indians of what is now western Pennsylvania and Ohio continued to attack the White settlements, and for a time in 1763 Fort Pitt, on the site of present-day Pittsburgh, was under constant siege. In order to chastise the Shawnee, Delaware, and Ohio Indians for their repeated and unprovoked "barbarities and depredations" along the western frontier, a company of 1,500 men under Colonel Henry Bouquet left Fort Pitt

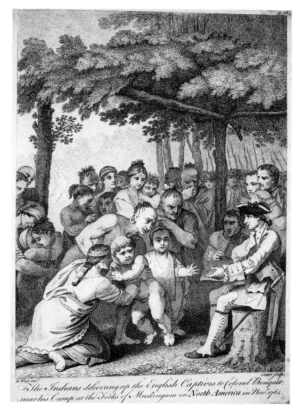

20. Benjamin West, "The Indians delivering up the English Captives to Colonel Bouquet, near his Camp at the Forks of the Muskingum in North America in Novr. 1764." Engraving by Canot, 8⅞ x 6⅜ inches. Published in William Smith, *An Historical Account of the Expedition Against the Ohio Indians,* London, 1766.

on October 3rd, 1764, and marched westward into the heart of Indian country. They camped near the banks of the Muskingum River, well within striking distance of the main Indian villages. Impressed by this show of force, the Indians were then willing to negotiate and quickly agreed to the English terms for peace, including the return of all captives.

Far from an eyewitness, Benjamin West had to invent these two illustrations partly from his own imagination and partly based on the famous engravings by Gravelot for Rollin's *Ancient History*. In so doing, he gave visual form to the most dramatic moments in the story. In the first picture engraved from West's design (Plate 19), the Indians have just arrived to confer with Colonel Bouquet (identified by his hat). After smoking the peace pipe, or calumet, according to their custom, the Indian orators opened their pouches and took out the strings or belts of wampum to hold in one hand as they spoke. According to Smith's text, "the general substance of what they had to offer, consisted in excuses for their late treachery and misconduct, throwing the blame on the rashness of their young men and the nations living to the westward of them, suing for peace in the most abject manner, and promising severally to deliver up all their prisoners."[5]

As the intelligentsia and then the general public of the mid-eighteenth century rediscovered the art and literature of classical antiquity, the one aspect of American Indian life that drew the most admiring praise was oratory. Writer after writer referred to this tribe or that as the "Romans of the New World." In William Smith's opinion, however, the speeches made by the Indian spokesmen to Colonel Bouquet in 1764 contained little "of that strong and ferocious eloquence, which their inflexible spirit of independency" had inspired at other times. In Benjamin West's design, on the other hand, the orator holding a strip of wampum is given uncommon dignity, and his words seem to be having a marked effect on the listeners. To make this figure as effective as possible, West actually borrowed a familiar pose from Etruscan and Roman portrait statues of political leaders. Like the *Augustus of Primaporta,* the speaker in West's design raises his right hand in a forceful *ad locutio* gesture, commanding attention as he begins to address his audience. Behind him West included a cascade of Indian faces, each one exhibiting a different expression, as if he were imitating sheets of caricatures like those engraved by Hogarth.

Historically, the real Colonel Bouquet was unimpressed by the orators' excuses. He demanded the return, without any exception, of all "Englishmen, Frenchmen, women and children; whether adopted in your tribes, married, or living amongst you under any denomination or pretense whatsoever, together with all negroes."[6] The second engraving after a drawing by West (Plate 20) shows the emotionally charged scene as the Indians returned their captives several weeks later. The repatriation of 206 people is reduced to a small group of White children, some tearfully embraced by their relatives, while others have to be wrenched unwillingly from the arms of their Indian mothers.

By the end of November, 1764, the entire company of English regular and Provincial volunteer soldiers, together with all the former prisoners (except for those women who escaped to go back to their Indian husbands), had returned

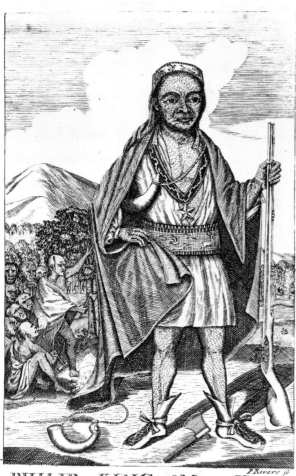

21. Paul Revere (1735–1818), *Philip, King of Mount Hope.* Engraving, 6¼ x 3¹⁵⁄₁₆ inches. Published in Thomas Church, *An Entertaining History of King Philip's War,* 2nd edition, Newport, 1772.

PHILIP. *KING* of Mount Hope.

to Fort Pitt and to civilization, ending the expedition against the Ohio Indians without bloodshed.

 As an amusing aside, one may compare Benjamin West's design (Plate 19) with Paul Revere's engraving of *Philip, King of Mount Hope* (Plate 21). Employed to provide illustrations for a new edition of *The Entertaining History of King Philip's War* (Newport, 1772) by Thomas Church, Revere, the silversmith, patriot, and part-time engraver, looked around *as usual* for appropriate sources to copy or to improve upon. And here, again, it was a question of art imitating art because of the enormous convenience and predictable effect.

 Since no Boston limner of 1675 would have dreamed of trying to reach the Wampanoag stronghold at Mount Hope (Bristol, Rhode Island) with his painting materials in hand, since no artist recorded the death of King Philip as he was shot from ambush by Alderman, a Christianized Indian in the service of Captain Benjamin Church, and since no one later bothered to record the appearance of Philip's severed head as it was displayed for years on a pole in the Plymouth Colony as an act of final revenge and a public reminder to other Indian leaders, there was no accurate portrait for Revere to follow. Instead, he

borrowed the costume and general pose of his King Philip from the 1710 mezzotints after John Verelst (compare with Plates 13 and 14). The important thing was to invoke a sense of Indian Kingship, but in the translation process from the softer tones of the mezzotints to the hard lines of the copper plate engraving, the king's head and eyes grew larger and his skin acquired a measled rather than a weathered look.

In the background of this image, furthermore, a paraphrase of West's "Indians Giving a Talk to Colonel Bouquet" was squeezed into the narrow space between Philip's cape and the edge of the picture. Other than the natural reversal of the figures when the plate was printed, there is one significant change in this depiction of Indian eloquence. In this case the orator is clearly discussing war, judging by the tomahawk in place of a strip of wampum in his hand.

One last comparison, juxtaposing two major portrait paintings of the colonial era, illustrates the fundamental differences between the role and hence the image of the slave in colonial society and the less easily defined position of the Indian. At the same time, these two pictures offer a fascinating study in changing tastes. Although one was painted on a plantation in Maryland in 1761 (Plate 22), it relied heavily on English stylistic precedents; the other was painted in London (Plate 23), but its subject matter was thoroughly American.

When Gustavus Hesselius died a relatively wealthy man in 1755, he left his "Negroe Woman Pegg" and his "Negroe Man Tom" to his daughter Lydia, while his "Chamber Organ, Books, Paints, Oyls, Colours" and all other painting materials, including unfinished canvases, went to his son John. By 1755 John Hesselius had already taken over the fashionable portrait business from his father, who was also his first teacher. However, the paintings he produced on frequent trips to Maryland and Virginia also show the influence of John Wollaston, an English painter active in the middle Colonies in the 1750s. It may have been from Wollaston's work that the younger Hesselius learned certain mannerisms of pose and expression, particularly the convention of faintly smiling faces with almond-shaped, heavily-lidded eyes.

At some point in 1761, John Hesselius was working at "Mount Airy," the estate of Benedict Calvert in Prince George's County, Maryland. There he was commissioned to paint portraits of the four Calvert children—Elizabeth and Ellinor, twins, age 8; Ann, age 6; and Charles, the youngest, at age 5 (Plate 22). Each of the three daughters was pictured in half-length on a canvas measuring 30 x 25 inches. But the more important full-length portrait of the male heir, named after his grandfather, Charles Calvert, the fifth Lord Baltimore, was painted on a considerably larger scale (50 x 40 inches)—undoubtedly by parental request. On the back of the canvas appears the original inscription, "Charles Calvert, AE 5/John Hesselius, Pinx, Maryland./1761."[7]

Rococo is the right term to describe the flavor of this portrait. The blond-haired boy fits the part of an aristocratic child, born with a sense of authority and position. Yet greater attention is given to the play of light over his pink costume, with its flowing blue drapery, than to the rendering of his face which

seems oddly distorted. The same stylized shape was used for the head of the Black servant who also inhabits the foreground stage, and both figures are clearly set off against the pastoral landscape backdrop on the right. Since the Calvert family undoubtedly owned many slaves, one may guess that this Black boy, who seems somewhat taller and older than Charles, was a personal servant, perhaps even a childhood playmate, included in this formal portrait of his young master as a reward for his love and loyalty. Everything about the Black's appearance is made to enhance the dignity and presence of the White child. His clothes are golden tan with dark trim, complementing the other's pink and blue; he kneels obediently to pick up the drum on which Charles had just been playing with the drumsticks; and he is made to look up at his owner with an open and trusting expression that is almost adoring.

The presence of a Black servant in this type of painting was not unusual at all for the period. Numerous European portraits and conversation pieces of the early eighteenth century show similar figures in elegant livery, attending their masters in park-like settings. From an artist's point of view, no matter where he worked, the inclusion of a dark-skinned figure must have added a welcome touch of exoticism, setting off the main figure more effectively. From a modern viewpoint, however, it is regrettable that these personal servants, who were often extremely well-painted, always remain anonymous. In the case of Hesselius's portrait, for example, only the name of Charles Calvert was inscribed on the back of the canvas. In addition, it is known that Charles died when he was only 17, while attending school at Eton College in England. What may have happened to his childhood servant was never recorded at all.

In 1774 Colonel Guy Johnson succeeded his uncle, Sir William Johnson, as the Superintendent of Indian Affairs in the Northern Colonies, an appointment warmly favored by the Iroquois. Like other Loyalists during the early months of the Revolution, he hurriedly left his home in New York State for Canada, and from there he returned to London for further instructions. Accompanying him on this trip was his Indian friend and secretary, Joseph Brant (Thayendanegea), a Mohawk chief. Like Omai, the Polynesian "prince" who arrived in England a year earlier, the educated and impressive Brant also became the object of considerable popular interest. Where Omai was painted by Sir Joshua Reynolds, Joseph Brant posed for a portrait by George Romney—and his presence was evoked in Benjamin West's painting of *Colonel Guy Johnson* (Plate 23).

For West, working in London, the chance to do an official portrait of Colonel Johnson meant another opportunity to deal with an American subject involving noble savages. In the final painting, the English officer poses calmly in the foreground, dressed in a mixture of European and Indian clothing. The moccasins, the beadwork, and the blanket tell of his intimacy with Indian ways on the frontier in western New York, while his red coat and long rifle serve as reminders of his military power and position. The shadowy Indian standing behind him is usually taken to be a generalized portrait of Joseph Brant, but the figure's individual identity seems less important than the dignity of his presence. He waits on the White man as an advisor, not as a servant. And he

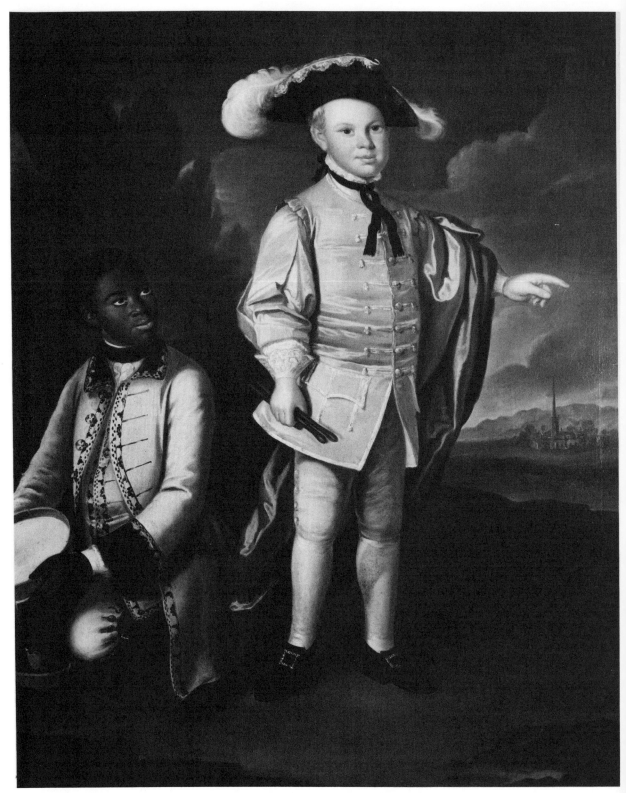

22. John Hesselius (1728–1778), *Portrait of Charles Calvert,* 1761. Oil on canvas, 50¼ x 40¼ inches. Baltimore Museum of Art, Gift of Alfred R. and Henry G. Riggs in memory of General Lawrason Riggs.

23. Benjamin West (1738–1820), *Colonel Guy Johnson,* 1776. Oil on canvas, 79¾ x 54½ inches. National Gallery of Art, Washington, D.C., Andrew W. Mellon Collection.

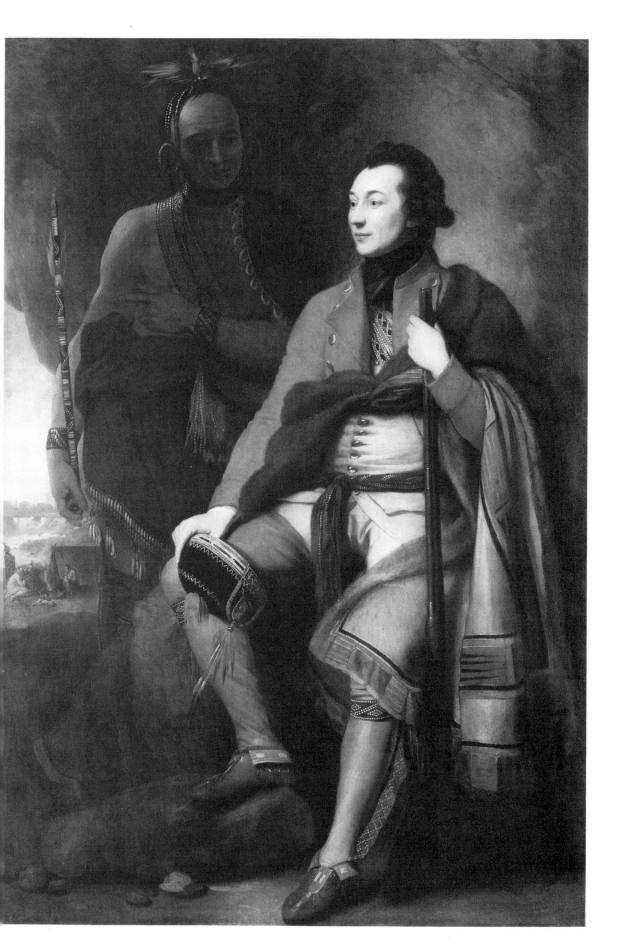

points to the peace pipe in his right hand as if offering his sound counsel with a single gesture.

Compared to the painting of *Charles Calvert,* everything about West's portrait of *Colonel Johnson* appears more noble and more dramatic. The presence of an Indian also adds a welcome touch of exoticism, but it is exoticism of a foreign rather than a domestic sort. Even the imaginary landscapes in these two works are entirely opposite in mood. In the picture by Hesselius the two boys are playing in a calm, rather soft setting, with a pleasant village in the distance; nothing about the scene is symbolic of the New World at all. In West's painting, however, the two men are resting in a cave-like scene, and through the opening on the left the viewer can see both an Indian encampment and a version of Niagara Falls in the distance—the two most characteristic features of the North American continent.

3

Romantic Thoughts and Feelings

URING THE ROMANTIC PERIOD, first in Europe (1750–1850) and then in America (1780–1880), other categories of painting began to challenge the primacy of portraiture. History pictures and landscape subjects in particular began to find a wider popular audience because they satisfied, at least in part, some of the basic longings of the age. As western cities grew more crowded and more industrial, as the elegant refinements of civilization seemed increasingly artificial, and as political unrest directed against the old order became more violent, the need for escape took firmer hold on the Romantic imagination.

By painting exotic scenes or historical events that were far removed from the present time and place, the Romantic artist offered his contemporaries endless hours of enjoyment. For those who attended public exhibitions or collected prints after famous paintings, everyday cares could be quickly forgotten in the face of intriguing images that were sometimes soothing and peaceful, but more often turbulent and highly-charged. In addition to providing visual pleasure, however, artists of the late eighteenth and early nineteenth century felt a duty to instruct their audiences as well. For this reason, the moral lessons of ancient history and the stoical, yet child-like example of the noble savage became standard vehicles of expression.

For the English-speaking world, the idealized concept of the noble savage referred primarily to the Indian tribes of North America and secondarily to the Polynesians publicized by Captain Cook's voyages to the South Seas in the 1770s. Only by later extension was this same concept applied to the natives of the Congo and West Africa who were being transported to the New World as slaves on English and American ships. For those Romantic artists, from Benjamin West (Plate 24) to George Catlin (Plate 63), who painted American Indians, it was no longer a question of idle intellectual curiosity concerning the manners and customs of a more primitive people. Many of the illustrations in this chapter suggest a fundamental wish to identify with the less compli-

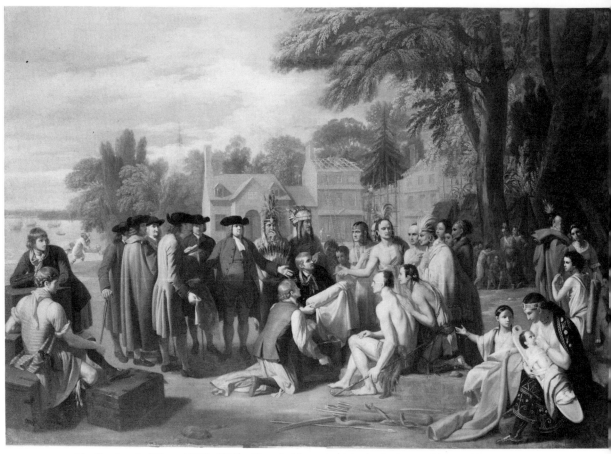

24. Benjamin West (1738–1820), *Penn's Treaty with the Indians,* 1771. Oil on canvas, 75½ x 108¾ inches. Pennsylvania Academy of the Fine Arts, Philadelphia.

cated, less pretentious existence of uncivilized men who lived closer to nature —and therefore closer to God. Some representations of the American Indian were highly commercial (Plate 54) and others mildly erotic (Plate 57), but in the more serious political images, individual chiefs were almost always portrayed on completely equal terms with their "White fathers." And even in thrilling narrative scenes, depicting the most inhuman barbarities (from the colonists' point of view, that is), the blood-thirsty savages involved were usually treated with the awe and respect granted to powerful enemies (Plate 44).

Conversely, the Black man was rarely heroized in this age of heroes and hero-worship. Negro servants continued to appear beside their masters in a few Romantic portraits, such as *The Washington Family* by Edward Savage (Plate 38), despite a rising interest in the independent existence of freed slaves and free-born Blacks. Nevertheless, even when an occasional Black figure was inserted into a history or genre painting, affording an extra touch of drama or humor, his presence was never threatening and his stature never larger than life. Furthermore, in the context of the slave trade and the heated emotional propaganda against it—social issues that did not attract the finest artists in America—images of Black men, women, and children tended to be small, crudely stylized figures (Plates 30–33) bordering on the emblematic and call-

ing for preconditioned responses to the question of racial inferiority or racial justice.

As a public image involving noble savages and even nobler Englishmen, Benjamin West's painting of *William Penn's Treaty with the Indians, when he founded the Province of Pennsylvania in North America* (Plate 24), first exhibited at the Royal Academy, London, in 1772, operated on several levels at once —touching on colonial history, contemporary politics, and Quaker theology. To begin with, modern historians have discovered that Penn's supposed conference and treaty with the Indians in 1682 never took place, but the legend was so firmly established and West pictured the storied event with such convincing power that image and myth have remained inseparable ever since—aided, of course, by countless reproductions. Moreover, in a period of serious turmoil in the American Colonies, caused by excessive taxation imposed from London, this peaceful image may have been intended as a subtle reminder to George III and his ministers that Penn's fair and considerate treatment of the Delaware Indians was the best policy for dealing with all the inhabitants of the New World under British rule.

Simultaneously, this stately vision of honorable and Godly men beginning their "Holy Experiment" in the wilderness was also a testament to the fundamental Quaker principles of Peace and Universal Love. This is not surprising, certainly, since Benjamin West was born a Quaker—and so was the man who commissioned this work, Thomas Penn (1702–1775), the same son of William Penn and heir to the proprietary rights in the colony of Pennsylvania who commissioned the two Indian portraits from Gustavus Hesselius in 1735. What *is* remarkable about West's painting, however, is the fact that engravings after it found their way into Quaker households on both sides of the Atlantic, even though the Society of Friends as a body distrusted the fine arts in any form and ridiculed the purchase of fancy pictures as a gaudy and self-indulgent display of wealth.

In retrospect, it seems that West's design initiated a kind of Quaker iconography—a small store of acceptable black and white images that embodied the sect's most treasured beliefs. In his book, *A Portraiture of Quakerism* (1806), Thomas Clarkson described the few prints that one might sometimes find in Quaker homes in England. One, showing the Ackworth School, was indicative of Quaker interest in the benefits of public education. Concerning the other two images, Clarkson's own comments were worth quoting in full:

> One of the prints, to which I allude, contained a representation of the conclusion of the famous treaty between William Penn and the Indians of America. This transaction every body knows, afforded, in all its circumstances, a proof to the world, of the singular honor and uprightness of those ancestors of the Quakers who were concerned in it. The Indians too entertained an opinion no less favourable of their character, for they handed down the memory of the event under such impressive circumstances, that

their descendants have a particular love for the character, and a particular reliance on the word, of a Quaker at the present day. The print alluded to was therefore probably hung up as the pleasing record of a transaction, so highly honourable to the principles of the society; where knowledge took no advantage of ignorance, but where she associated herself with justice, that she might preserve the balance equal. . . .

The second was a print of a slave-ship [see Plate 32], published a few years ago, when the circumstances of the slave-trade became a subject of national inquiry. In this [engraving] the oppressed Africans are represented, as stowed in different parts according to the number transported and to the scale of the dimensions of the vessel. This subject could not be indifferent to those, who had exerted themselves as a body for the annihilation of this inhuman traffic. The print, however, was not hung up by Quakers, either as a monument to what they had done themselves, or a stimulus to farther exertion on the same subject, but, I believe, from the pure motive of exciting benevolence; of exciting the attention of those, who should come into their houses, to the cause of the injured Africans, and of procuring sympathy in their favour.[1]

The matter of Quaker involvement in the antislavery movement will be taken up shortly—but here it is important to note that what was true for Quaker homes in England at the start of the nineteenth century undoubtedly applied to rural Quaker houses in the state of Pennsylvania two or three decades later. In this way, Edward Hicks, the Quaker preacher and sign painter in Newton, Pennsylvania, naturally inherited the iconographic theme of *Penn's Treaty with the Indians,* taken from an available print which reversed the image. In the background of many of his naive, but charming pictures, offering their messianic message of universal love, Hicks introduced the figures of William Penn and a few Indians existing in perfect harmony (Plate 27).

For the equally symbolic group in the foreground of his *Peaceable Kingdoms,* it is known that Hicks found an important source in Richard Westall's design for "The Peaceable Kingdom of the Branch" (Plate 26), first published in an English Bible in 1815 and then reengraved for American Bibles and prayer books in the 1820s. In turn, it appears that Westall was inspired, not by an image of Adam naming all the animals in Paradise or Orpheus taming the wild beasts with the magic of his music, but by the *Amor vincit omnia* tradition, illustrated here in a seventeenth-century painting by a follower of Nicholas Poussin (Plate 25). The major theme shared in common by this sequence of three images is the triumph of spiritual love over bestial appetite or desire. This important victory for the higher instincts of the human mind is represented, in the school of Poussin picture, by the figure of Cupid who grabs the beard of goat-legged Pan to prevent him from assaulting Venus. Westall transformed this little figure into a small, Christ-like child, who carries a branch of the Tree of Jesse, while putting his arm around the neck of a once voracious lion. Lastly, in Edward Hicks' mind, the Westall image of Christian love, subduing even the fiercest animals on earth, must have dropped perfectly into place next to a print after Benjamin West's idea of the famous Quaker leader taming the wild inhabitants of the New World.

25. Circle of Nicolas Poussin, *Landscape with Nymphs and Satyrs,* c. 1630–1635. Oil on canvas, 38¼ x 50⅛ inches. The Cleveland Museum of Art, J. H. Wade Collection.

26. Richard Westall (1765–1836), *The Peaceable Kingdom of the Branch*. Engraving by Charles Heath. Published in Westall's *The Holy Bible,* London, 1815, volume III.

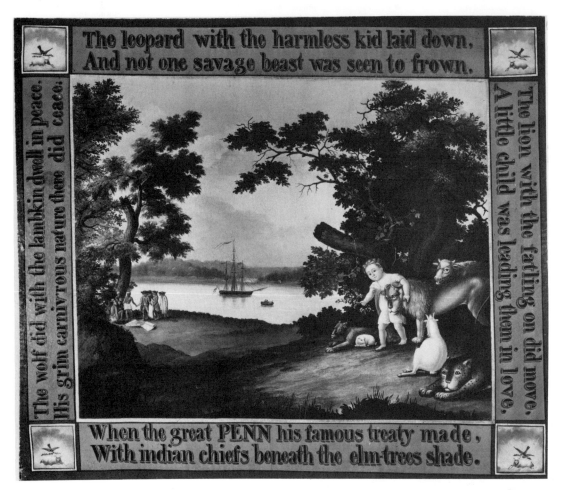

27. Edward Hicks (1780–1849), *The Peaceable Kingdom,* c. 1830–1835. Oil on canvas, 30¼ x 36¼ inches. New York State Historical Association, Cooperstown.

This final equation—so patently unflattering to the Indians—is spelled out around the border of Hicks' painting (Plate 27) in a personal paraphrase of Isaiah 11, verses vi–viii:

> The Wolf did with the lambkin dwell in peace,
> His grim carnivorous nature there did cease;
> The leopard with the harmless kid laid down,
> And not one savage beast was seen to frown,
> The lion with the fatling on did move,
> A little child was leading them in love,
> When the great PENN his famous treaty made,
> With Indian chiefs beneath the elm-trees shade.

Benjamin West's success with history paintings such as *The Death of General Wolfe,* 1771 (National Gallery, Ottawa) and *Penn's Treaty with the Indians*—both of which contained historical figures in their proper costumes as well as American Indians in impressive poses—established a new pattern for

others to follow. For artists like Copley and Trumbull, any attempt to emulate West's example meant traveling to Europe, especially to London, where paintings of contemporary history would be received by a larger and more appreciative audience than they could possibly hope to find at home.

When John Singleton Copley left Boston in the early summer of 1774, he was giving up his career as the most prolific and successful painter in the Colonies. Apparently, he had two major reasons for this decision to leave America. On one hand, his position of political neutrality was becoming increasingly untenable. Although he was sympathetic to the liberal leaders who were calling for open rebellion against British rule, he was also a man of property. Members of his wife's family were rich merchants, responsible for the shipment of tea that was thrown into Boston Harbor by a band of radicals, *disguised as Indians,* on the night of December 16th, 1773. And many of his wealthier friends and patrons were Tories, still loyal to George III.

On the other hand, Copley had been thinking of going to Europe for many years. In the back of his mind was the undying dream of becoming a famous history painter, even though in reality all that his American patrons ever wanted for their money was a convincing likeness, not a useless historical scene. By traveling abroad, Copley hoped to avoid offending either faction of his Boston clientele, while pursuing a new course that might ultimately satisfy his greatest ambitions.

Once settled in London after a tour of Italy, Copley began to send single and group portraits to public exhibitions, but it was not until 1778 that he made his first major impression on the English art world. His large exhibition piece, *Watson and the Shark,* was considered one of the best paintings at the Royal Academy that year. A reviewer for the *Morning Post* admired "the softness of the colouring, the animation which is displayed in the countenances of the sailors, the efforts of the drowning boy, and the frightened appearance of the man assaulting the shark." And the *Morning Chronicle,* in praising all of the fearful expressions, called special attention to the face of the Negro at the top of the composition as "a fine index of concern and horror."[2]

Significantly, no Black man appeared in the initial drawings for this stirring, if not particularly edifying, picture of Brook Watson as a boy being attacked by a shark in Havana Harbor. It must have been at an advanced stage in his preparations that Copley suddenly decided to include a Black figure at a key position in the painting. His reasons for doing this are not known, but presumably he felt (quite correctly) that this added touch of the unfamiliar would appeal to the general public. At the same time, free Black men, working as sailors, were undoubtedly a common sight on ships sailing to and from the Caribbean; in this sense, it was perfectly logical to show a Black sailor in a Cuban port.

As an oil study for this exotic figure, Copley painted his magnificent *Head of a Negro* (Plate 28) now in Detroit. When this strikingly lifelike portrait sketch was sold in 1864—along with other paintings in the collection of Copley's son—it was listed as "Head of a Favourite Negro. Very Fine. Introduced into the picture of 'The Boy saved from the Shark.' "[3] The phrase "Favourite

28. John Singleton Copley (1738–1815), *Head of a Negro (Study for Watson and the Shark)*, c. 1777–1778. Oil on canvas, 21 x 16¼ inches. Detroit Institute of Arts, Michigan, Purchase, The Gibbs-Williams Fund.

Negro" implies that this athletic-looking young man may have been a domestic servant in the Copley household, but there is no positive proof that he was not a free man, perhaps even a sailor visiting London, who was asked or even paid to pose for this sketch. Clearly, this was not a formal portrait commissioned by the sitter; more in the tradition of spontaneous portraits of Black men by Baroque artists such as Rubens and Rembrandt over a century earlier, this study of a Negro face, frankly rendered without prejudice or distortion, was one that the artist wanted for himself. What Copley learned about Negro facial characteristics in the process, he used in the final painting—while this more intimate, but unfinished sketch remained in his studio, unexhibited.

Also painted in London was John Trumbull's spirited sketch of *Second Lieutenant Thomas Grosvenor, Third Connecticut Regiment, and his Negro Servant, Peter Salem* (Plate 29). This small panel was a detail study for the larger painting of *The Battle of Bunker's Hill,* the first of a series of American history subjects that Trumbull began in Benjamin West's studio in 1784–1785. The two figures in this sketch were obviously intended for the lower right-hand corner of the final composition: both lean to the right, providing a Baroque counteraction to the charge of red-coated soldiers moving diagonally up the hill to the left behind them. Their faces reflect a dramatic mixture of fear and concern for the lives of those who have fallen, in the center of the picture. Peter Salem may play a subordinate role in this image, but there is no hint of caricature in the treatment of his features. He seems as brave and as willing to fight as his master; in fact, from all accounts, it was he who actually shot Major John Pitcairn of the British Marines at the climactic moment of the third and finally successful assault by the British forces on the American fortifications at the top of Breed's Hill.

When this Trumbull sketch is compared with Benjamin West's finished painting of *Colonel Guy Johnson* (Plate 23), one is reminded of the important role that race relations played during the Revolutionary War. In West's portrait, painted in London just after the beginning of hostilities, the shadowy Indian presence can be taken to represent the loyalty of most Indian tribes along the frontier to the English Crown and to the English commanders in the field throughout the war. This loyalty led to a number of savage attacks on colonial settlements, including the Wyoming Valley massacre in Pennsylvania and the Mohawk raid on Cherry Valley, New York, led by Joseph Brant. Conversely, the presence of Peter Salem holding a musket in Trumbull's painting of 1785 testifies to the loyalty of those Black freemen and servants who were willing to risk their lives to further the colonial cause. Any list of these Black patriots would have to begin, of course, with the name of Crispus Attucks, killed in the Boston Massacre on March 5th, 1770.

To exactly what extent the partially eclipsed figure of Peter Salem in Trumbull's sketch was intended to be a serious comment on the Black contribution to the American side during the Revolution it is difficult to say. Seventy years later, however, Trumbull's composition (in a slightly altered form) *was* pressed into service as Abolitionist propaganda. In William C. Nell's book, *The Colored Patriots of the American Revolution,* published in Boston in 1855

29. John Trumbull (1756–1843), *Lieutenant Grosvenor and his Negro Servant,
Peter Salem,* 1785. Oil on panel, 15 x 11⅝ inches. Yale University Art Gallery,
New Haven, Connecticut, Mabel Brady Garvan Collection.

(with an Introduction by Harriet Beecher Stowe), the chapter on the Battle of Bunker Hill was illustrated by a crude wood engraving after Trumbull's finished painting of the event. In the lower right-hand corner of this illustration, though, one finds only the figure of Peter Salem. His master, Lieutenant Grosvenor, was simply eliminated from the scene altogether as a way of retelling the story with a Black bias, tipping the scales in the opposite direction as a counterbalance to the early written histories of the War of Independence that so often totally overlooked the courageous deeds of Black soldiers in the common defense of liberty.

In contrast to the oil sketches just discussed, images relating directly to the slave trade in America tended to take a very different form with very different results aesthetically. For the period before the Revolutionary War, the broadside reproduced here (Plate 30) will serve as a typical example. It was published in Charlestown, South Carolina, on July 24th, 1769. To represent the mixed cargo of ninety-four slaves who had survived the voyage from Sierra Leone, and to call attention to the coming sale on August 3rd, the anonymous printer

30. Anonymous (American printer), *Broadside* (A Cargo of Ninety-four Prime, Healthy NEGROES), 1769. Printed sheet, 10¾ x 6½ inches. Plimpton Slavery Collection, Columbia University Libraries, New York.

Store room

Girls Room

Store room

Men's room Boys' room Women's room

31. Anonymous (American engraver), *Plan of an African Ship's Lower Deck,* 1789. Engraving, 4⅜ x 13¼ inches. Published in *The American Museum; or, Repository of Ancient and Modern Fugitive Pieces, Prose and Poetical,* V, no. 5, May 1789.

of this sheet employed two woodcuts that he undoubtedly kept on hand for precisely this purpose. One image shows a male African dressed in a brief skirt and holding a spear (with a tiny imp at his feet), while the other represents a female figure, naked to the waist, wearing jewelry as well as a loin-cloth (with a girl-child at her side). In practice, the use of these wood blocks may remind one of John Foster's *Seal of the Massachusetts Bay Colony,* carved in 1675 (Plate 11), but in visual effect the extreme crudity of these later, unappealing images of African slaves is harder to forgive.

In the first decade after the American Revolution, two major antislavery images appeared in the former Colonies, although both were issued in England by the newly-formed Committee for Affecting the Abolition of the Slave Trade (founded in 1787). Consisting largely of Quakers, who had long been opposed to the institution of slavery as inconsistent with the precepts of Christianity and common justice between men, this antislavery society recognized the need for effective pictorial propaganda, in addition to an endless stream of pamphlets and essays, to publicize its cause. On the suggestion of the chapter at Plymouth, for example, the Committee issued its famous print of the plan and section of a slave ship (Plate 32 shows a later version), "designed to give the spectator an idea of the sufferings of the Africans in the Middle Passage."

By 1789, at least one edition of this "striking illustration of the barbarity of the slave trade" was available in the United States. Through the efforts of the new Pennsylvania Society for Promoting the Abolition of Slavery, the Relief of Free Negroes Unlawfully Held in Bondage, and for Improving the Condition of the African Race, the most horrifying part of the British print was re-engraved and issued anew in the Philadelphia monthly, called *The American Museum,* in May of 1789 (Plate 31) together with the following explanation:

The annexed plate represents the lower deck of an African ship of one hundred and ninety-seven tons burden, with the slaves stowed on it, in the proportion of not quite one to a Ton.

In the men's apartment, the space allowed to each is six feet in length, by fifteen inches in breadth. The boys are allowed five feet by fourteen inches. The women, five feet ten inches, by fifteen inches; and the girls, four feet by one foot each. The perpendicular height between decks is five feet eight inches.

The men are fastened together, two and two, by handcuffs on their wrists, and by irons rivetted on their legs. They are brought up on the main deck every day, about eight o'clock, and as each pair ascend, a strong chain, fastened by ring bolts to the deck, is passed through their shackles; a precaution absolutely necessary to prevent insurrections. In this state, if the weather is favourable, they are permitted to remain about one-third part of twenty-four hours, and during this interval they are fed, and their apartment below is cleaned; but when the weather is bad, even these indulgences cannot be granted them, and they are only permitted to come up in small companies, of about ten at a time, to be fed, where, after remaining a quarter of an hour, each mess is obliged to give place to the next in rotation.

It may perhaps be conceived, from the crowded state in which the slaves appear in the plate, that an unusual and exaggerated instance has been produced; this, however, is so far from being the case, that no ship, if her intended cargo can be procured, ever carries a less number than one to a ton, and the usual practice has been to carry nearly double that number. . . . The Brooks, of Liverpool, a capital ship, from which the above sketch was proportioned, did, in one voyage, actually carry six hundred and nine slaves, which is more than double the number that appear in the plate. The mode of stowing them was as follows: platforms, or wide shelves, were erected between the decks, extending so far from the sides towards the middle of the vessel, as to be capable of containing four additional rows of slaves, by

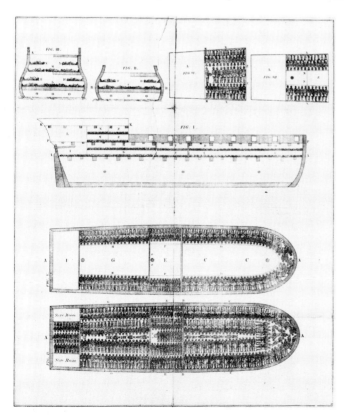

32. Thomas Clarkson (1760–1846), *Diagram of a Slave Ship*. Engraving by Hemsley, 19 x 16¾ inches. Published in Thomas Clarkson, *The History of the Rise, Progress, and Accomplishment of the Abolition of the African Slave Trade by the British Parliament*, London, 1808, volume II.

which means the perpendicular height between each tier, after allowing for the beams and platforms, was reduced to two feet six inches, so that they could not even sit in an erect posture; besides which, in the men's apartment, instead of four rows, five were stowed, by placing the heads of one between the legs of another. All the horrors of this situation are still multiplied in the smaller vessels.[4]

The second image of importance appeared on the seal of the English Abolition Committee. In this case there was a single emblematic figure, instead of hundreds of Black bodies, to plead more explicitly for the cause of the "injured Africans." (Plate 33). Through the generosity of Josiah Wedgewood, this design was turned into an elegant, even though mass-produced cameo, with the Negro figure "in his own native colour" set off against a delicate white ground. These small cameos were then distributed among the supporters of the abolition movement in England, starting a popular fad. According to Thomas Clarkson, some gentlemen had them laid in gold on the lids of their snuff-boxes, and some ladies wore them in bracelets, while others fitted them to pins in their hair. "At length," Clarkson continued, "the taste for wearing them became general; and thus fashion, which usually confines itself to worthless things, was seen for once in the honourable office of promoting the cause of justice, humanity, and freedom."[5]

Shipments of this slave medallion were also sent to Philadelphia where they were eagerly received. In a recent article Robert C. Smith has pointed out that Benjamin Franklin, President of the Pennsylvania Abolition Society, was particularly delighted with the emblem, saying, in an appreciative letter to Wedgewood, that this one image had a psychological effect "equal to that of the best written pamphlet in procuring favour to those oppressed people."[6] Not surprisingly, the "Am I not a Man and a Brother?" emblem and motto appeared on American posters, pamphlets, and other forms of printed propaganda against slavery well into the nineteenth century.

seal. An African was seen, (as in the figure *,) in chains in a supplicating posture, kneeling with one knee upon the ground, and with both his hands lifted up to Heaven, and round the seal was observed the following motto, as if he was uttering

33. Anonymous (English engraver), *Am I not a Man and a Brother?* (Seal of the English Committee for Affecting the Abolishment of the Slave Trade. First designed in October 1787). Woodcut, 1½ inches high. Published in Thomas Clarkson, *The History of the Rise, Progress, and Accomplishment of the Abolition of the African Slave Trade by the British Parliament,* London, 1808, volume I.

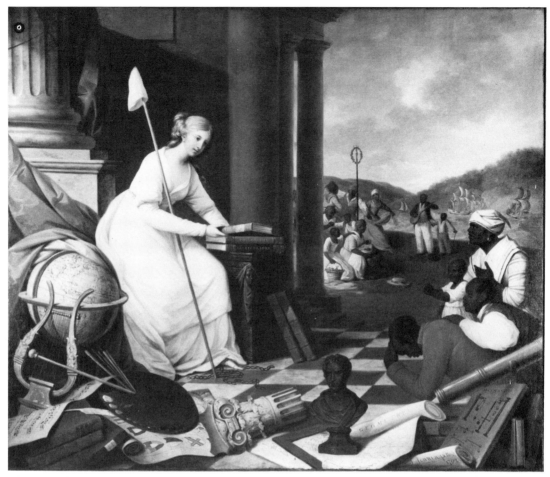

34. Samuel Jennings (c. 1755–after 1834), *Liberty Displaying the Arts and Sciences,*
1792. Oil on canvas, 60¼ x 73⅛ inches. From the Collections of The Library
Company of Philadelphia.

In this same international context belongs the first history painting by an
American artist to deal directly with the question of slavery—namely, the pic-
ture of *Liberty Displaying the Arts and Sciences* by Samuel Jennings (Plate
34). Jennings was actually working in London in 1790 when he wrote to the
directors of The Library Company in his native Philadelphia, offering to paint
a moral and instructive history picture for their new building "that would be
applicable to so noble, and useful an Institution."[7] In reply, a subcommittee of
the shareholders—most of them Quakers involved in other philanthropic
organizations, such as the Abolition Society—recommended that the painting
should show Liberty (not Clio, Calliope, or Minerva as Jennings had sug-
gested) seated among the striking symbols of the arts, while placing a pile of
scientific books on a pedestal. It was further suggested to the artist that a broken
chain should be placed at Liberty's feet, "and in the distant back Ground a
Groupe of Negroes sitting on the Earth, or in some attitude expressive of Ease
& Joy," signifying the happy end of slavery in America.

When the final version of this highly topical painting was ready in 1792,
Jennings sent it on to Philadelphia. But, hoping to turn a profit on the entire
project, he kept a smaller replica of the work in London from which he appar-

ently intended to have engravings made. Announcements for this engraving were published, but no copies of the print, which might have added to the stock of antislavery images circulating in America, are known.

Philadelphia was the first center for Abolitionist sentiments in America, only later to be surpassed by Boston. At the same time, as the capital of the new Republic from 1790–1800, it was also the destination of numerous Indian delegations seeking the ear of the president or the Congress. Following a pattern established by British colonial officers, the protocol for these state visits required the exchange of ceremonial gifts as tokens of mutual honor and respect. While Sir William Johnson was Superintendant of Indian Affairs in the northern Colonies, for example, he gave away silver gorgets, peace medallions, and parchment certificates to those warriors and sachems who had distinguished themselves by repeated proofs of their "Attachment to his Britannic Majesty's Interest, and Zeal for his Service upon Sundry occasions."

The image that appeared at the top of Johnson's Indian testimonial (Plate 35)—two hundred copies of which he ordered from a Philadelphia printing firm in 1770—reinforced the political meaning of the words that followed. Inside the delicate Rococo frame, engraved by Henry Dawkins, a conference is taking place. All of the figures are tiny and awkwardly drawn, but the symmetry of the composition as a whole implies a full recognition of the Indians as foreign ambassadors, to be treated with every diplomatic courtesy.

When the Colonies became a nation, this peace conference imagery was adopted wholesale with a few variations, as seen on the most famous example, *Red Jacket's Medal* (Plate 36). In March of 1792, a delegation of over forty Iroquois chiefs, representing the Seneca, Cayuga, Onondaga, Oneida, and Tuscarora tribes (most of whom had remained loyal to the British during the Revolution) visited Philadelphia to talk peace with President Washington. As

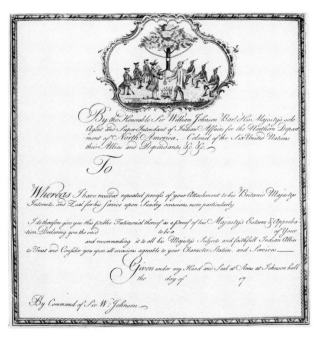

35. Henry Dawkins (Philadelphia engraver), *Sir William Johnson's Indian Testimonial,* 1770 (1946 restrike from original plate). Copper plate engraving, 9½ x 9¼ inches. Courtesy of the New-York Historical Society, New York. A White figure, representing Sir William Johnson, "His Majesty's Sole Agent," hands a peace medal to a stylized Indian. Three Colonial and three Indian representatives are seated symmetrically on either side of the Tree of Peace, from whose branches hangs a symbolic chain of friendship.

36. Anonymous (Philadelphia Silversmith), *Red Jacket's Peace Medal* (obverse), 1792. Silver oval, inscribed, 6¾ x 4 inches. Buffalo and Erie County Historical Society, New York.

a special gesture in return, a large silver medal was ordered from a Philadelphia silversmith, who engraved the Seal of the United States on one side and a pastoral landscape on the other in which George Washington graciously welcomes the arrival of an Indian chief who has dropped his tomahawk and carries only a peace pipe. This medal was presented to Sagoyewatha, or Red Jacket (c. 1758–1830), the famous Seneca orator, who must have been the chief spokesman for the Iroquois on that occasion. For the rest of his life Red Jacket wore this trophy around his neck with fierce pride (see Plate 37)—the same pride born of a powerful intellect, according to Thomas L. McKenney, that he often used in defending ancient Indian customs and beliefs against the relentless intrusion of the White man's ways, especially Christianity.

A visual comparison between *Red Jacket's Peace Medal* of 1792 and the image of *The Washington Family,* painted and engraved by Edward Savage (Plate 38), offers further insight into conventional racial attitudes held by the Federal aristocracy at the end of the eighteenth century. In a matter as easily overlooked as the relative positions of the figures, there seems to be a world of difference between these two works. At state ceremonies, George Washington would have stood up to speak with Indian representatives, as William Penn and Sir William Johnson had done before him, and just as logically he would have remained seated to be waited on by one of his own Negro slaves. The distinction seems to rest on respect for what is unknown and *foreign* versus rather unquestioning acceptance of what is well-known and *domestic*.

At the bottom of his print, Edward Savage identified his subjects as "George Washington, his Lady, and her two Grandchildren by the name of Custis." But no name was given for the Black servant, dressed in fine livery, who is standing in the background, even though this figure, said to be "Billy"

37. Charles Bird King (1785–1862), *Red Jacket, Seneca War Chief.* Colored lithograph, 12 x 8 inches. Published in Thomas L. McKenney and James Hall, *History of the Indian Tribes of North America,* Volume I, Philadelphia, 1836.

38. Edward Savage (1761–1817), *The Washington Family,* 1798. Stipple engraving, 18⅛ x 24½ inches. Prints Division, New York Public Library, Astor, Lenox and Tilden Foundations.

39. Henry Sargent (1770–1845), *The Dinner Party,* c. 1820–1823. Oil on canvas, 59½ x 48 inches. Courtesy Museum of Fine Arts, Boston, Gift of Mrs. Horatio A. Lamb, in memory of Mr. and Mrs. Winthrop Sargent.

Lee, was probably painted from life on the original canvas of 1796. Obviously, master and slave could never be shown on the same level, facing each other as equals. Inverting the general relationship of the Black boy kneeling at the feet of Charles Calvert (Plate 22), the presence of the *standing* Billy Lee in this portrait of *The Washington Family* serves to enhance the dignity of the *seated* figures. And the same can be said of similar attendants, waiting on their White masters, in any number of genre and portrait paintings of the early nineteenth century—such as Henry Sargent's ambitious picture of *The Dinner Party* (Plate 39), painted in Boston in the early 1820s, but intended to represent a social event of 1798. Sargent's fashionable dinner guests seem well used to the luxury of being waited upon.

After 1800 American artists began to produce a rapidly increasing number of landscape paintings in which Indian figures were an indispensible element. Whether these Romantic painters were working at home or abroad, the one *outdoor* theme, the one *sublime* natural object in the explored part of North America that provided them with endless inspiration was, of course, Niagara Falls. And seemingly, from the time of Benjamin West's portrait of *Colonel Guy Johnson* (Plate 23), a few Indians, conspicuously placed in the foreground, were obligatory if an artist wanted to create a truly affective view of this natural wonder.

The first American to paint this subject was John Vanderlyn, who made the long overland journey from New York City to Niagara in September of

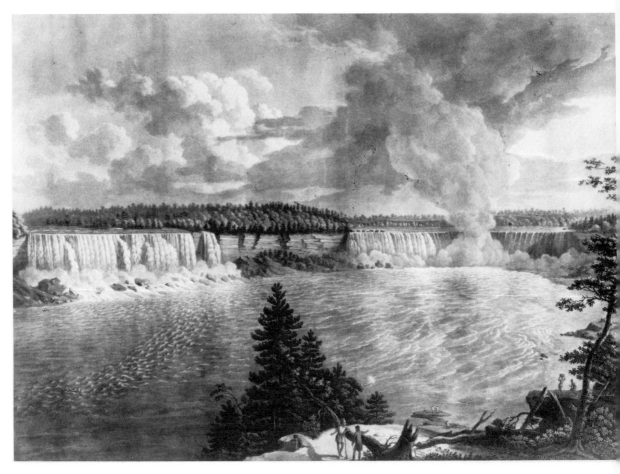

40. John Vanderlyn (1775–1852), *A Distant View of the falls of Niagara,* 1804. Steel engraving by J. Merigot, 20¾ x 29½ inches. Senate House Museum, New York State Office of Parks and Recreation, Division for Historic Preservation.

41. John Trumbull (1756–1843), *Panorama of Niagara Falls, from Under Table Rock,* 1808. Oil on canvas, 29 x 168½ inches. Courtesy of The New-York Historical Society, New York.

1801. From the sketches he executed there Vanderlyn worked up two oil paintings that he took to London in 1803, hoping to have them engraved and sold for a profit. The engraving by Merigot, shown here (Plate 40), includes the staffage Indian figures that Vanderlyn thought necessary as well as a full inscription: "A distant view of the falls of Niagara including both branches of The Island and Adjacent Shores, taken from the vicinity of Indian Ladder. To the Society of Fine Arts of New York this print is respectfully inscribed by their most obedient humble servant, John Vanderlyn."[8]

While this inscription suggests a degree of national pride, it also seems to promise topographical accuracy. The "Indian Ladder" was actually a well known location on the Canadian side below the falls—easily found on contemporary maps of the site (see Plate 42). To provide a means of communication between the river's edge and the top of the steep cliff, large masses of earth and rock had been moved and "ladders" constructed by Indian workmen in two locations. Nearer to the Horseshoe Falls was the steeper and more dangerous "Indian Ladder," consisting "simply of long pine trees, with notches cut in their sides, for the passenger to rest his feet on."[9] These trees, placed one below the other, were so long and slender that they vibrated alarmingly under foot, "though many persons are still in the habit of descending by their means"—like the man just disappearing over the edge of the precipice in the foreground of Vanderlyn's print. Further downriver was "Mrs. Simcoe's Ladder," named for the wife of the British governor of Canada, who had insisted on a safer and easier climb by means of real ladders.

John Trumbull visited Niagara Falls in 1807. From his drawings and sketches of the site he prepared two panoramic views—each measuring two and a half feet high by fourteen feet long (Plate 41)—which he took to London in 1808. Trumbull's plan was not to have engravings made, but to create a full scale, 360° panorama which could be exhibited in one of the two rotunda-theaters built for that purpose in London. Since he had served on a diplomatic mission to London from 1794 to 1804, the same period in which the panorama grew from a curiosity into a successful enterprise, Trumbull was undoubtedly aware of both the visual principles involved and the financial rewards to be gained in this special branch of topographical landscape painting. The wording of a letter he sent to his banker in London, before

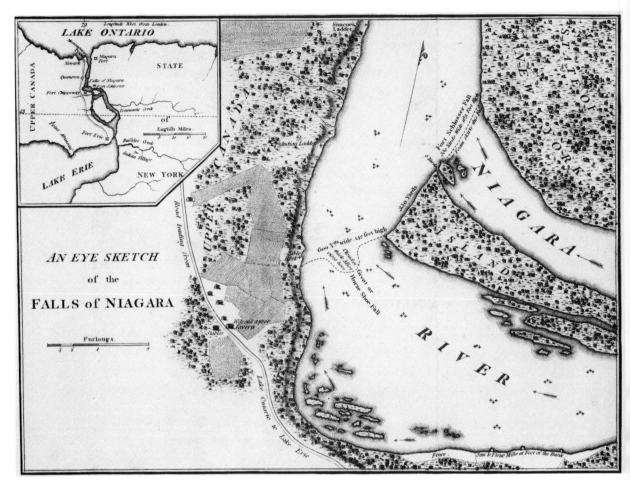

42. Isaac Weld, Jr. (1774–1856), *An Eye Sketch of the Falls of Niagara,* Engraving, 6⅜ x 8⅞ inches. Published in Weld, *Travels through the States of North America,* London, 1799.

leaving New York in 1808, stressed precisely those qualities required for popular success—a fresh subject of considerable general interest that was treated with painstaking truth to the original: "I shall also bring with me two panoramic views of the falls of Niagara, and surrounding objects—The scene is magnificent and novel, —I have copied it with all the fidelity in my power, and am not without a hope that it will at once excite and in some measure gratify the public curiosity."[10]

Among the "surrounding objects" in his view of the Falls from under Table Rock (Plate 31), Trumbull decided to include an Indian family gathered in front of a bark hut to greet the young boy who is returning with a catch of fish. However, in spite of all his efforts to excite and gratify public curiosity, the project failed. In an era of mounting tension and hostility between England and her former colonies, leading to the War of 1812, Trumbull was unable to convince the proprietors of the panorama in London that America's most famous scenic wonder would draw large enough crowds to meet expenses—even with these Indian figures in the foreground to lend their added interest.

By the later 1820s, western New York was no longer a wilderness. The opening of the Erie Canal in 1825 had brought increasing commerce and a flood of tourists to the area of Niagara Falls. As the frontier moved rapidly westward, the displacement or disappearance of the Indians from the land became a major nineteenth-century theme, contrasting the once free and happy state of the noble savage with the sad idea of his imminent extinction. This contemporary Romantic theme, so manifest in the novels of James Fenimore Cooper, also appeared in William Dunlap's play about travelers in the American landscape, called *A Trip to Niagara,* first performed at the Bowery Theater, New York, in November of 1828.

Dunlap admitted that his play was written as a kind of "running accompaniment to the more important product of the Scene painter," which consisted of a series of conventional stationary backdrops as well as a *moving* panorama. During one long interlude in this play, the stage became the deck of a river vessel and the painted scenery began to move from right to left (from one large roller to another) across the back of the stage, giving the impression of the steamboat's departure from New York and gradual progress upriver amid dramatically changing weather conditions.

At a key point in the second act, Dunlap introduced the figure of Leather-Stocking, dressed, according to the stage directions, in a coonskin cap and a leather shirt, "as describing in J. F. Cooper's Pioneers." At first sight, the English travelers (Wentworth and his sister, Amelia) took him to be an Indian—"A wild and noble figure"—although they realized immediately that he did not resemble the wax Indian effigy they had recently seen in a museum in New York City. Leather-Stocking replied that his skin was white, but that he preferred Indian ways to those of the White men who were so foolishly altering the landscape in the name of civilization: "All changed! The beasts of the forest all gone! What is worth living for here, now! All spoilt! All spoilt! . . . I am going far west, with the deer and the Indians."[11]

The final scene of this play opened with Leather-Stocking sitting on a rock, with a view of "The Falls of Niagara, as seen from below, on the American side" behind him. After rising, he came downstage to voice one final complaint against the destruction of the wilderness, speaking not just for himself, but for all of his red-skinned friends and enemies as well: "This looks as it used to do, they can't spoil this—yet a while—Hawk-eye has taken his last look at the places he loved and now away to the prairie, the woods, and the grave."[12]

Thomas Cole visited Niagara Falls in the spring of 1829, just before leaving for Europe. By this time, tourist facilities had undoubtedly taken the place of any Indian encampments near the Falls. Nevertheless, when Cole, as a Romantic interpretor of the American landscape, used his sketches to produce several views of Niagara Falls in London, he suppressed any evidence of commercial development that might have marred the effect. Instead, following the long-accepted precedent, he inserted two Indians on a foreground ledge in his *Distant View of Niagara Falls* (Plate 43) to add that

43. Thomas Cole (1801–1848), *A Distant View of Niagara Falls,* 1829. Oil on panel, 18⅞ x 23⅞ inches. Courtesy of The Art Institute of Chicago, The Friends of American Art.

extra bit of drama (and perhaps a touch of nostalgia) to his deliberately turbulent and windswept picture.

The use of tiny Indian figures as staffage details was essentially benign, even after this practice was transferred from eastern to western landscapes in the later 1850s and 1860s (see Plate 80). To find Indians portrayed as bloodthirsty savages, intent on murder, one must turn from Romantic landscapes to history paintings of the early nineteenth century. In this category, one of the most popular themes was an actual event that became a political *cause célèbre* during the Revolutionary War—the Death of Jane McCrea.

Politically the story was explosive because of the moral issues involved. The young Jane McCrea came from a Tory family in New Jersey; in July of 1777 she was on her way to General Burgoyne's camp north of Fort Edward, New York, to join her fiancé who was a young British officer. For some unknown reason, possibly an internal squabble, her Indian guides suddenly turned and murdered her, taking her scalp as well for the bounty it would bring. News of this atrocity along with reports of other massacres stirred violent debate over the immoral use of Indians as soldiers by the British Army. Like so

many other Romantic subjects, the Death of Jane McCrea was first expressed in words—in editorials, histories of the period, and poems—long before it ever took visual form.

In tracing the history of this theme in American Art, Samuel Y. Edgerton, Jr. has pointed out that the story offered an undiluted confrontation of "good and innocence versus evil and cruelty."[13] This is readily apparent in John Vanderlyn's version of the scene (Plate 44). This canvas, painted in Paris in 1804, was intended to illustrate a passage from Joel Barlow's attempted American epic, *The Columbiad; A Poem.* In Vanderlyn's hands this subject, which must be considered an American variation on the much older tradition of the Massacre of the Innocents, is given a French neoclassical flavor with the large sculptural forms inhabiting a narrow foreground stage.

Vanderlyn was supposed to have supplied a series of illustrations for Barlow's poem, but when he lost interest in the project, the commission was given to an Englishman, Robert Smirke. This choice was fairly logical, not because of the quality of Smirke's designs, but because of the fact that he had recently completed a painting that showed White figures, male and female, in the company of Polynesian savages. With the advantage of wider circulation, Smirke's illustration of *The Death of Lucinda* (Plate 45), as Barlow renamed the foul murder of this helpless female, became the standard image to be copied and varied endlessly by other artists to the end of the nineteenth century, with the death scene often descending into Victorian sentimentality (see Plate 49).

During the War of 1812, the British forces again resorted to the use of Indian soldiers along the northern and western frontiers—to the consternation of the American public. As a pictorial indictment of this inhuman practice,

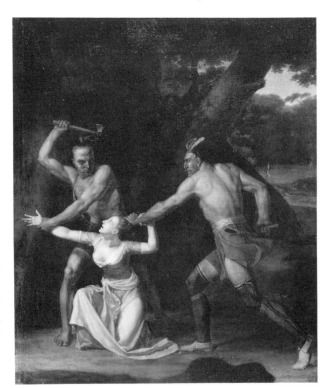

44. John Vanderlyn (1775–1852), *The Death of Jane McCrea,* 1804. Oil on canvas, 32½ x 26½ inches. Courtesy Wadsworth Atheneum, Hartford, Connecticut.

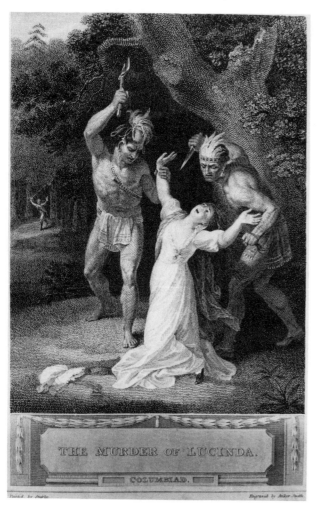

THE MURDER OF LUCINDA.

COLUMBIAD.

45. Robert Smirke (1752–1845), *The Murder of Lucinda*. Engraving by Anker Smith. Published in Joel Barlow, *The Columbiad, A Poem*, Philadelphia, 1807.

46. William Charles (1776–1820), *A Scene on the Frontiers as Practiced by the Humane British and their Worthy Allies*, c. 1813–1815. Hand-colored engraving, 9¼ x 13⅜ inches. Library of Congress, Washington, D.C. The corpulent British officer on the left is portrayed as saying, "Bring me the Scalps and the King our master will reward you"; the bounty being a new rifle for every sixteen American scalps, no matter how they were collected.

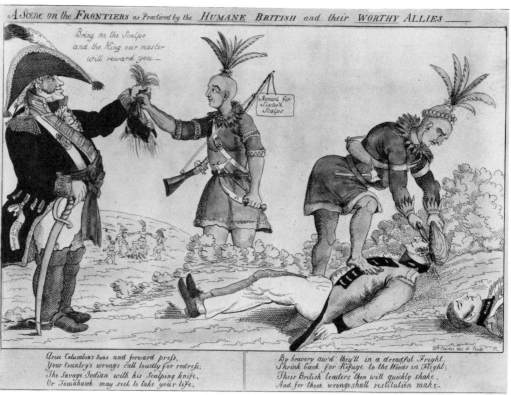

A Scene on the FRONTIERS as Practiced by the HUMANE BRITISH and their WORTHY ALLIES

Bring me the Scalps and the King our master will reward you—

Reward for Sixteen Scalps

Arise Columbia's Sons and forward press,
Your country's wrongs call loudly for redress;
The Savage Indian with his Scalping knife,
Or Tomahawk may seek to take your life.

By bravery aw'd they'll in a dreadful Fright,
Shrink back for Refuge to the Woods in Flight;
Their British leaders then will quickly shake,
And for those wrongs shall restitution make.

William Charles issued a hand-colored political cartoon (Plate 46), showing Indians being generously rewarded for their barbarity. This cartoon may have been drawn and engraved in the conventional English style of the period, derived from the work of Gilray and Rowlandson, but the message was unmistakably American. The eight lines at the bottom of the print were a call to arms:

> Arise Columbia's Sons and forward press,
> Your Country's wrongs call loudly for redress;
> The Savage Indian with his Scalping knife,
> Or Tomahawk may seek to take your life,
> By bravery aw'd they'll in a dreadful Fright,
> Shrink back for refuge to the Woods in Flight;
> Their British leaders then will quickly shake,
> And for those wrongs shall restitution make.

A prose variation on the Murder of Jane McCrea—this time applied to a still earlier moment in American history, the French and Indian War—served as the dramatic climax of James Fenimore Cooper's *The Last of the Mohicans; A Narrative of 1757,* which was published in 1826. As early as the following spring, the young landscape painter, Thomas Cole, exhibited his version of the climactic scene in Cooper's extremely popular novel at the new National Academy of Design (Plate 47); and the following passage was printed immediately below the title of the picture in the catalogue:

> "Woman," he said, "choose! the wigwam or the knife of Le Subtil!" Cora regarded him not; but dropping on her knees, with a rich glow suffusing itself over her features, she raised her eyes and stretched her arms toward heaven, saying [to God] in a meek and yet confiding voice—"I am thine! do with me as thou seest best!"—But Cora neither heard nor heeded his demand. The form of the Huron trembled in every fibre, and he raised his arm on high, but dropped it again, with a wild and bewildered air, like one who doubted. Once more he struggled with himself and lifted his keen weapon again—but a piercing cry was heard from above them, and Uncas appeared, leaping frantically from a fearful height, upon the ledge.
> —*Last of the Mohicans.*[14]

It has been demonstrated that Cooper derived his very imperfect knowledge of American Indians from a few earlier writers, and not from extensive research on his own. On the matter of his title, *The Last of the Mohicans,* for example, it is clear that he confused the *Mahican* tribe of the upper Hudson Valley with its offshoot, the *Mohegans,* of Connecticut and Rhode Island; the seventeenth-century chief, named Uncas, was a Mohegan. Furthermore, by following the biased accounts of the Delaware Nation published by John Heckewelder, a Moravian missionary, in 1819, Cooper was led to accept as fact the dramatic, but highly artificial contrast between *good* Indians (the loyal and noble Delawares and Mohicans—and *bad* ones (the brutal, fiendlike Hurons,

47. Thomas Cole (1801–1848), *Landscape, Scene from "The Last of the Mohicans,"* 1827. Oil on canvas, 36 x 48 inches. Van Pelt Library, University of Pennsylvania, Philadelphia.

the Maguas or Mingoes, and the rest of the Iroquois Confederacy). On the other hand, what may have been poor ethnology, based on hearsay evidence and misconceptions, made for most effective storytelling.

For his part, Thomas Cole attempted (somewhat unsuccessfully) to integrate the dramatic action of the narrative at the moment of Cora Munro's death with an exciting landscape composition. The end result was far from pleasing, however, because the towering cliffs, the dead trees, the burning Huron village in the middleground, the distant view of the untamed wilderness, and the gathering storm overhead all tend to overwhelm the foreground stage, dwarfing the main actors on their precarious ledge. As a key source for the life and death struggle taking place between good (Cora and Uncas) and evil (the Hurons, particularly Magua, alias Renard Le Subtil), Cole undoubtedly turned to Vanderlyn's painting of the *Death of Jane McCrea,* then owned and exhibited by the American Academy of the Fine Arts in New York City. Without Vanderlyn's training and ability as a figure painter, though, Cole had some difficulty in making the murder of the White girl as deeply horrifying as the story demanded. By comparison, the incident seems lost in the immensity of the landscape.

As Cole tried to arrange his figures according to an established formula, so did Alfred Johannot in his illustration of *La Mort de Cora* (Plate 48). This engraved vignette appeared on the title page of Volume III of *Le Dernier des*

Mohicans, part of a complete French edition of Cooper's works, issued in Paris in 1828. Working without access to Vanderlyn's, Smirke's, or Cole's designs, Johannot produced a surprisingly similar version of the murder scene for obvious reasons. He had only to combine the American details described in the text with the longer and always effective pictorial tradition of the Massacre of the Innocents or, perhaps, the Rape of the Sabine Women to achieve the same result—an evil savage about to plunge his knife into the body of a beautiful and helpless woman.

At the beginning of the nineteenth century, American artists began to travel abroad to study art in ever increasing numbers; many went to London (because of language and cultural ties) and others to Paris (for current political and ideological reasons). At the same time, foreigners, like Chateaubriand, were coming to the United States to see with their own eyes this new democracy, so recently planted in the wilderness. Among these European visitors were one or two amateur artists who brought with them new ways of seeing, new ways of recording portraits of people or landscapes they encountered without the usual interference of stylistic conventions. This could be done then by means of new optical devices, reminding one once again that the Romantic age was also a period of intense scientific experimentation, coupled with the eager exploration of the natural world on every continent.

When Charles Balthazzar Julien Févret de Saint-Mémin arrived in New York in 1794, he was certainly not expecting to stay in the United States for twenty years. Aristocrats exiled by the French Revolution, he and his father were on their way to Santo Domingo to reclaim family property, but the slave revolution there prevented them from going any farther. Forced to rely on other resources, Saint Mémin made good use of his abilities as an amateur

48. Alfred Johannot (1800–1837), *La Mort de Cora.* Engraving, 2½ inches high. Titlepage vignette for the third volume of *Le Dernier des Mohicans,* actually Volume XV of the *Oeuvres Completes de J. Fenimore Cooper,* Paris, 1828.

49. Anonymous (American wood engraver), *Memorable Women of America—Jane McCrea,* 1876. Wood engraving, 8 x 6 inches. Published in *Frank Leslie's Lady's Magazine,* XXXVIII. no. 2, February 1876.

scientist with a penchant for the fine arts by reinventing two basic drawing devices of the day—the *camera obscura,* with which he made accurate topographical views of New York City (and possibly one of Niagara Falls), and the *physionotrace,* with which he became a successful portraitist among the Federal "aristocracy" in America.

Saint-Mémin was working in Washington, D.C., during the early eighteen hundreds when, as a consequence of the Lewis and Clark expedition, a series of Plains Indian delegations began to arrive in the nation's capital to see President Jefferson. In addition to the rounds of diplomatic meetings taking place in 1804–1807, many of the chiefs and warriors, who were generically called *Osages,* also sat for physionotrace portraits by Saint-Mémin. The enormous advantage of this French invention, compared to other techniques, was that it made it easier and less expensive to create an extremely faithful likeness: witness the portrait of *Payouska,* "Chef des Grands Osages" according to the inscription on Saint-Mémin's drawing (Plate 50)—although this same chieftain has been identified elsewhere as "Aw Paousa" and "Pahuska," a leader of the Sauk tribe. In the artist's studio Payouska was posed in profile between a source of light (a candle or a window) and the physionotrace machine at his left shoulder. As he sat motionless, the shadow of his features fell directly on the translucent screen at the top of the drawing machine. It was then an easy matter for Saint-Mémin, on the other side of the device, to trace the outline of the Indian's face as carefully as possible with a pointer. And since they were connected vertically by a pantograph, every movement of the pointer against the

screen above resulted in a crayon line on a sheet of colored paper below. Finally, once the sitter's profile had been traced (note the heavy outline of Payouska's face in Plate 50), the drawing paper could be removed from the lower part of the machine and the subtle modeling of the head filled in by hand.

It is hard to judge Saint-Mémin's motives for making these Indian drawings. He obviously lavished meticulous attention on the sculptural effect of the visible half of each face, creating the impressive effect of a neoclassical bas-relief, suitable for national medals or coins, but he took far less trouble with details such as Payouska's military costume and his jewelry from the ear ornaments to the Jeffersonian peace medal around his neck. On the other hand, eight of Saint-Mémin's drawings (the set now in the collection of the New-York Historical Society) were purchased in 1807 by Meriwether Lewis—no doubt because of their unquestionable accuracy—to be used as illustrations when Lewis published an account of his expedition. In this respect Saint-Mémin's profile images must be considered in the same tradition of direct and honest portraiture as the earlier paintings of Tishcohan and Lapowinsa (Plate 18) by Gustavus Hesselius and the later Indian Gallery of oil portraits, created for the War Department by Charles Bird King in the 1820s and 30s (see Plate 37).

When the *profile concept* was applied to the Black man in America during the nineteenth century, the artistic and social results were obviously very different. Instead of the customary attempt to determine basic character traits from the mere outline of a person's features, crude profile drawings of escaped

50. Charles Balthazar Julien Fevret de Saint-Mémin (1770–1852), *"Payouska, Chef des Grands Osages,"* c. 1806. Crayon drawing on pink paper, 22 x 16 inches. Courtesy of The New-York Historical Society, New York.

slaves were frequently used like "mug-shots" on public posters, describing each runaway and announcing a reward for his or her recapture and return to the rightful slave owner. Even after the Civil War, furthermore, authors of anti-abolitionist pamphlets as well as writers of respectable books on physical anthropology continued to employ profiles of Negroes in a way that perpetuated the grossest racial stereotypes within a pseudoscientific framework. Assuming that cranial shapes were an accurate index of mental capacities, these theorists published carefully measured diagrams of typical human skulls; and in every series the White man's head came at the top of the list as the epitome of beauty and intelligence, while the Black man's was invariably placed at the bottom, next to the higher apes on the evolutionary charts.

The second drawing aid worth considering, in connection with foreign visitors and optical devices, was the *camera lucida*. Invented in England in 1806, this instrument was easy to carry and simple to use. It consisted mainly of a triangular glass prism mounted on an adjustable metal stalk above a drawing board. Looking downward through the eyepiece, the artist could see both the object to be drawn (its image reflected off one of the sides within the prism) and the drawing paper below—the one superimposed on the other. It was then a simple task to trace the outlines of the human figure or the landscape view selected with impressive accuracy.

Such a device was brought to the United States by Basil Hall, a British naval officer (retired), world traveler, and amateur artist, who was collecting material for a book on his *Travels in North America, in the Years 1827 and 1828* (3 volumes: Edinburgh, 1829). During his sojourn in the New World, Captain Hall claimed to have had many "opportunities of making sketches with the Camera Lucida." And, as if to promote this artist's-aid personally, he published an appendix in his book with instructions on the use of the camera lucida for his fellow "amateur artists, and travelers, who, without much knowledge of drawing, are anxious to preserve some traces of what they see, with strict fidelity."[15]

To show what he had seen and recorded with "strict fidelity" in North America, Basil Hall selected those camera lucida sketches which seemed to be most characteristic and had them published as a separate volume of forty etchings—each plate accompanied by a long caption that stressed the factual, journalistic nature of the images. If the daguerreotype process had been available in the 1820s, Hall surely would have used it to achieve even greater accuracy, since he obviously felt the same impulse that inspired Fox Talbot, Niepce, and Daguerre to experiment with photochemical ways of fixing the image of nature without the hand of the artist.

Hall's book of *Forty Etchings, From Sketches made with the Camera Lucida, in North America, in 1827 and 1828* consisted primarily of landscape and city views with only a few figure groups thrown in—derelict Mississagua Indians of Upper Canada, two aged chiefs of the Creek Nation, displaced from their former lands in Florida, and two Black slave drivers, etched in the same frame with a backwoodsman (Plate 51), creating the visual effect of assorted

51. Basil Hall (1788–1844), *Two Slave Drivers and a Backwoodsman with his Rifle.*
Etching, 4⅝ x 8½ inches. Plate XX from Basil Hall, *Forty Etchings, From
Sketches made with the Camera Lucida, in North America, in 1827 and 1828,*
Edinburgh, 1829.

snapshots pasted down on the same page. In spite of their admittedly slender
pretensions as art, these images of real persons may remind one that Basil Hall,
like other foreign visitors (including Alexis de Tocqueville, Mrs. Trollope, and
Charles Dickens), was interested in every aspect of American life—and the
moral question of human slavery fascinated him the most.

In the course of his *Travels in North America,* Basil Hall made many ob-
servations about the American Negro. He visited a school for free Black and
Mulatto children in New York City. He looked on in disgust as a young Negro,
named George, was sold for $143 in Washington, D.C. At a slave auction in
Charlestown, South Carolina, he watched as an entire family fetched the "fine
price" of $1450; and he was told afterwards that Negroes "have a singular
species of pride" in bringing a high price, "holding it amongst themselves as
disgraceful to be sold for a small sum of money." He also visited plantations
throughout the South, speaking to the White proprietors as well as the Black
foremen or slave drivers whose likenesses he also drew with the camera lucida.
The following caption appeared in his book of etchings:

> The figure on the left in this sketch [Plate 51], was a Black man in
> charge of a plantation in South Carolina, which we visited in the absence
> of the proprietor. He was a man of information, and really very well bred
> —though he could neither read nor write. I did not suppose it possible that
> a negro in the situation of a slave-driver, could be so much like a gentle-
> man—but so it was. The other driver on the right, is a native African, born
> near Timbuctoo. When twelve years old, he and his family were captured,
> and sent into slavery. On their way to the coast a lion, it seems, attacked

the party, and overthrew this lad amongst others. On his breast the marks of what he said were the lion's claws are distinctly to be seen, and he told me that he remembers all the incidents which occurred on the occasion. He belongs now to a plantation in the state of Georgia.[16]

Since slavery had been legally abolished in England for more than twenty years, Captain Hall's official position was one of deep moral disapproval—deeper and more vehement than American public opinion in the 1820s—and yet he found Southern slave owners to be a better class of human beings than he had expected from reading antislavery tracts at home. Nevertheless, he did notice the strange psychological interaction through which "no man can degrade another, without in some degree degrading himself."[17] And recognizing a measure of English complicity in the demand for cheap cotton, Hall concluded that the best to be hoped for was a calm and gradual improvement in the evil system of slavery—a system that often depended on the whip in the hands of a slave driver.

During the Colonial period, as E. McClung Fleming has pointed out, the standard personification of America as a political entity remained an Indian princess. After the Revolutionary War, however, this official figure was quickly transformed into something more in tune with European taste—namely, a neoclassical goddess with a Phrygian or Liberty Cap (instead of a bow and arrow) as her principal attribute (see Plate 34). If Indians abruptly disappeared from the context of national symbolic imagery (except for peace medals), their numbers increased, if anything, on every other level of American art and especially on the sidewalk in the form of advertising images, trade signs, and cigar-store figures.

The origin of the American cigar-store Indian that flourished in the nineteenth century can be traced back to an English source. According to several writers, a popular misconception arose towards the end of the sixteenth century in England, confusing the idea of the American Indian who grew and used tobacco long before the arrival of the White man, the Virginia planter who raised tobacco as a highly profitable export, and the African slaves who actually tended the tobacco plantations. As a result, the wooden figure of a *Black Boy* or *Virginian,* wearing a headdress and kilt of tobacco leaves, instead of feathers, carrying a roll or rope of tobacco under one arm, and holding up a long-stem pipe with the opposite hand, became a standard store-front emblem for London tobacco shops. In the eighteenth century, similar part-Indian part-Negro figures, equally dark-skinned, but more adult than the earlier *Virginians,* appeared on countless tobacco labels as an integral part of the brand identification. The printed label for *The Best York River* (Plate 52), for example, advertised the tobacco grown along the York estuary in eastern Virignia that could be purchased in London at the sign of the Indian Prince. [It is amusing to compare the business transaction taking place on this label with the image on *Red Jacket's Peace Medal* (Plate 36)].

The Best York River

52. Anonymous (English printer), *The Best York River,* mid-18th century. Printed Tobacco Label, 2 x 2¾ inches. Arents Collection, New York Public Library, Astor, Lenox and Tilden Foundations.

American businessmen used much the same technique to attract potential customers, but on this side of the Atlantic there was no confusion over racial types. When the firm of Caldwell & Solomons purchased space in the Albany *Gazette & Daily Advertiser* in 1817, a woodcut of their shop figure (Plate 53) was included in the ad to identify their Tobacco and Snuff Store, located at No. 346 North Market Street, "at the sign of the Indian Chief and hand of Tobacco." Luckily, the original wooden figure (Plate 54), repainted by the Albany artist, Ezra Ames, in 1823, has survived, although through damage or decay, the original bow and the proffered "hand of tobacco" have disappeared, only to be replaced by imperfect restorations.

53. Anonymous, Newspaper advertisement for Caldwell & Solomons Tobacco and Snuff Store. From the Albany *Gazette & Daily Advertiser,* November 17, 1817. Courtesy of The New-York Historical Society, New York.

Tobacco and Snuff Store,
No. 346 NORTH MARKET STREET,
)pposite the Store of Dudley Walsh and Co. at ι
sign of the Indian Chief and hand of Tobacco,
CALDWELL & SOLOMONS,

INFORM the friends and t public, that th have at all tim on hand, for sa on the most re sonab e terms, l wholesale or r tail, of their ov manufacture, a which they wa rant of the ve first quality—

SWEET SCENTED
Fine Plug Tobacco, 6 and 8 hands to the lb.
Plugtail Tobacco, in 12 lb. rools and kegs,
do. of 1 1-2 lb and 1-4 lb. roo

54. Anonymous (American carver), *Cigar Store Indian,* early 19th century. Painted wood, 31½ inches high. Albany Institute of History and Art, New York, Francis S. Woods Collection.

55. Anonymous (American carver), *Cigar Store Negro,* mid-19th century. Wood, once painted. Courtesy of The New-York Historical Society, New York.

By the middle of the nineteenth century, wooden Indians in the streets of a city like New York must have been so numerous that proprietors of *new* tobacco stores were forced to commission other figures, preferably unusual ones, in order to have their shops noticed and patronized at all. For this reason, amid a host of other figure-types from Punch to Christopher Columbus, the image of the *Black Boy* returned (Plate 55), not as a *Virignian,* but as a contemporary northern street urchin, dressed in picturesque, shabby clothing and holding out a bunch of cigars. Furthermore, by the last quarter of the century, more flagrant southern stereotypes, named Sambo or Darkey, could be ordered in cast iron through the mail. These three-foot-high *Colored Boys* standing on bales of cotton and extending one hand with a ring, were being mass-produced as trade signs or hitching-posts (along with White jockeys and Chinamen) by the larger iron foundries in New York and Chicago.

Where the original concept of America as an Indian princess may have demanded a seminude figure, virtually all of her commercial descendants in the nineteenth century tended to be far more respectably dressed, befitting their public, everyday, street-level function. It was on the more exalted plane of art

56. Joseph Wright of Derby (1734–1797), *The Indian Widow,* 1783–1785. Oil on canvas, 40 x 50 inches. Derby Museum and Art Galley, Derby, England.

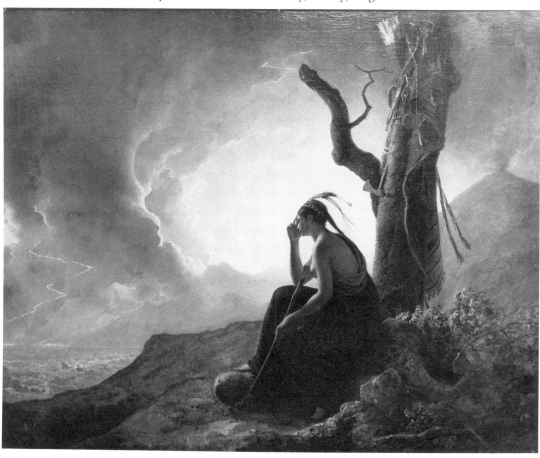

that the question of Indian nudity and sexuality survived as a significant theme for White painters and sculptors and their public.

In certain European paintings of the Romantic era, such as Joseph Wright of Derby's *The Indian Widow* (Plate 56) or Anne-Louis Girodet's *Entombment of Atala* of 1808 (based on a story of ill-fated Indian lovers by Chateaubriand), the powerful and compelling mood of noble sacrifice and profound sorrow, stoically endured, was partially subverted by the obvious voluptuousness of the female figures. This subcurrent of erotic interest in Indian women had strong echoes in America, where sexual contacts and occasional marriages between races had been taking place since the arrival of the first White settlers. The growing literature of Indian myths and love stories provided one outlet for this kind of interest, while nude or seminude figures in gleaming white Italian marble offered another.

Charles Bird King's romantic vision of *An Indian Maiden* (Plate 57) must be considered in the same context. Although created during the period in which King was painting factual portraits of Indian visitors in Washington, D.C., this image seems to belong to a different, dreamlike world of its own. The beautiful Indian girl, nude to the waist, sits in an imaginary landscape where the unblemished softness of her flesh is played off against the surface of the rocks and the bark of trees. As she fixes colorful red and blue feathers in the front of her beaded headband with the aid of a mirror, she seems totally unaware of any other presence. In the end, the seductive intimacy of this scene

57. Charles Bird King (1785–1862), *An Indian Maiden,* c. 1825–1835. Oil on canvas, 26½ x 21¾ inches. Photo: Courtesy of Sotheby Parke-Bernet Galleries, Inc.

seems to invite the viewer into the picture—to share this maiden's less complicated world as more than just an idle observer.

Dramatic gestures, like effective facial expressions, were a basic ingredient of Romantic history paintings wherever they were painted. The two story-telling pictures that follow—one showing a Negro and the other a Red man in a key position—employ somewhat similar gestures towards a sail on the horizon, but there the correspondence stops because dramatic identification with shipwrecked passengers off the coast of Africa or with the first American Indian to see a European sail called for very different emotional responses on the American viewer's part.

In 1862 a painting entitled *The Wreck of the Medusa,* attributed to the French Romantic artist, Théodore Géricault, was presented to the New-York Historical Society. This work, reproduced here for the first time (Plate 58), could not possibly be an original. Although it follows the general outlines of Géricault's huge history painting, first shown at the Paris Salon in 1819, it does so on a much smaller scale, the scale of a copy painted for a private collection. Distortions in the shape of the raft, the limbs of the foreground corpses, and

58. George Cooke (1793–1849), *The Wreck of the Medusa* (after Géricault), 1831. Oil on canvas, 50½ x 77 inches. Courtesy of The New-York Historical Society, New York.

the size of the rescue ship on the horizon are all tell-tale signs of a copyist's work —and none of these clues is more telling than the omission of a second main-stay on the right side of the mast. Géricault would never have overlooked such a logical and necessary nautical detail.

This oil copy after *The Raft of the Medusa* is undoubtedly the work of the American painter, George Cooke. A prolific portraitist who worked primarily in the southern states, Cooke had gathered enough money by 1826 to make an extended tour of Europe. In all, he spent five years abroad, painting commissioned copies of famous pictures (such as Raphael's *Transfiguration*) and views of famous places (including the *Interior of St. Peter's*). According to a recent biographical account, Cooke was in England in 1831 when he received a commission from James Robb of New Orleans for a copy of Géricault's work in the Louvre. From Paris, as soon as this copy was completed, Cooke returned directly to New York (August 1831), where he wasted little time in arranging to exhibit his most recent painting. The following review appeared in the *New-York Mirror* (November 19, 1831):

> The Wreck of the Medusa./This large painting, by G. Cooke, also in the American Academy in Barclay-street, forcibly illustrates one of those exquisitely awful scenes which are continually occurring, but the full horror of which is seldom conceived. It is a copy from one in the Louvre by Gere-coulf [*sic*], and adheres closely to the accounts of the actual event.
>
> The Medusa, a French frigate, was wrecked in 1816, on the coast of Africa, but not within sight of land, and one hundred and forty-seven persons confided themselves to a raft, which sank three feet with their weight. Amidst famine, bloodshed, madness, and despair, these unhappy creatures remained twelves days, except that their number rapidly diminshed, sixty-five having perished in one night. Imagination shrinks from relating by what means survivors preserved themselves from starvation until they were taken off by the French brig Argus. The painting represents the moment when the Argus is descried on the horizon, and the few still alive on the raft are making a last effort to attract its notice. The sea is lifting its waves around them, and the sail glides in the distance. A variety of affecting objects strike the eye of the spectator, and call to mind Byron's powerful description of a similar scene.[18]

What obviously appealed to Cooke (who in 1840, painted an even larger copy), to his patron, and to his American audience in general was the sublime horror of this historical event, involving mutiny, cannibalism, madness, and murder. Contemporary reviews stressed only the gory aspects of the scene without comment on the moral and political meanings of Géricault's original painting.

The right of Blacks to self-determination had been debated in France since the Revolution of 1789, and the controversy had been kept alive by the slave insurrections in Haiti and Santo Domingo. As an ardent liberal with full sympathy for the exploited or oppressed, Géricault joined a group of artists in Paris who were violently opposed to the restoration of the Bourbon monarchy after

the fall of Napoleon. The *Medusa* had been carrying a number of governmental officials to Senegal, West Africa, to continue French administration of that colony, when it foundered. The sinking of this government frigate and the death of so many passengers through the negligence or incompetence of the newly-appointed officers became a political scandal, offering Géricault a perfect opportunity to attack the new government through his art.

At the same time this was also a human drama. After twelve days on the raft only nineteen passengers survived, including three Blacks, to be rescued by the *Argus*. For the three Negro figures who appeared in his final painting —one near death, one standing near the mast, and the other waving vigorously —Géricault made many drawings and sketches of Black faces and torsos. Significantly, it is a Black man who represents the dramatic climax of the composition. Half standing on a barrel, half supported by others, he waves desperately at the ship on the horizon. Through his position and active gesture he becomes a symbol of hope and a heroic proof of the equality of men who endure a disaster together.

It is safe to say that George Cooke copied only the outlines of Géricault's painting and not the central ideas or spirit. Had the Abolition movement been further advanced in the United States, this copy of *The Raft of the Medusa* might have served as excellent propaganda. As it was, however, when this image was shown in New York in 1831, it inspired only thoughts of unspeakable horror, thoughts that were awful and yet exquisite, with no regard for the moral implications of racial equality. Not until the famous *Amistad* affair in 1839—involving the shipboard rebellion of a "cargo of native Africans," led by Joseph Cinqué—were American Abolitionists presented with a blood-chilling, closer-to-home, mutiny-at-sea story that begged to be exploited in words and pictures for the antislavery cause. However, where the words were plentiful in propaganda pamphlets and even a play for the New York stage, the only major artwork resulting from the *Amistad* incident appears to have been the idealized portrait of Cinqué by Nathaniel Jocelyn (New Haven Colony Historical Society). No one attempted to turn the violent seizure of the Spanish sloop *Amistad* or the subsequent trial of the Black mutineers in New Haven into a history picture.

In the spring of 1837 John Gadsby Chapman, a prominent painter and illustrator, sent to the annual exhibition of the National Academy of Design in New York a painting called *The First Ship* (unlocated). The following review from the *New-York Mirror* of May 30, 1837, will give some idea of what this picture's expressive strengths and artistic weaknesses may have been:

> No. 52. The First Ship. For sale. J. G. Chapman. A truly poetical idea. The painter has imagined an Indian girl, who, looking from an eminence, sees at a distance a European ship approaching. It is "the first ship" she had ever seen. The story is well told; but the artist did not paint the figure from nature.[19]

What Chapman wanted to create was not a convincing study of human anatomy or an image of a specific Indian (like the portrait of the Oto squaw, *Eagle of Delight,* by Charles Bird King in the same exhibition), but a highly charged emotional scene in which the viewer could project himself into the mind of the Indian and reexperience the mixture of amazement and wonder, fear and dismay at seeing the first European ship arrive on these shores.

Whether this Romantic painting was actually sold from the exhibition in 1837 is not known, but Chapman did make another study of the same subject which appeared in the 1842 edition of *The Token and Atlantic Souvenir* (Plate 59). In this version the tone of the image was made more serious by changing the gender of the main figure. Instead of a young and, one supposes, very attractive Indian girl (with appealing erotic overtones), the engraving shows an Indian brave reacting to the strange and portentous sight before his eyes. The readers of *The Token* were expected to feel a nostalgic sense of loss at the coming of civilization in the form of "the introduction of Europe to America." In prose form, the essay that followed this illustration brought out the fundamental Romantic issues of the scene:

> The single figure in the picture recalls the period when "wild in the woods the noble savage ran," when he followed the chase with a form as stately as the pine and graceful as its foliage, before the white man's "firewater" had maddened his brain and unstrung his sinews, before the white man's vices had stripped him of his self respect and dignity of character,

59. John Gadsby Chapman (1808–1889), *The First Ship.* Engraving, 4¾ x 3¾ inches. Published in *The Token and Atlantic Souvenir,* Boston, 1842.

and the white man's wrongs had called forth all that was fierce, revengeful, and remorseless in his nature. . . .

To us, who look back through two hundred years, the scene, which the artist has here delineated, is full of deep interest. We need not the "foreign aid" of fancy to invest it with a character not its own. There is no fiction so melancholy as the sober truth. We see the end of which this is the beginning. . . . Here we see the "seminal principle" of a series of struggles, unparalleled for the fierceness of the passions involved in them; exterminating wars, midnight conflagrations, wrongs and insults fearfully avenged, the gradual decay and extinction of a most marked race, the slow retreat of the wigwam and the tomahawk, and the onward progress of the axe and the log cabin. There is no more saddening chapter in the world's history than that which records the fate of the Indian race.[20]

While the very sight or mention of the once noble Red man brought a train of sad associations and a tinge of guilt into the Romantic mind of the 1830s in America, comic relief could be found in the image of the Negro. Scenes as serious as Copley's *Watson and the Shark* or George Cooke's copy of *The Raft of the Medusa*—in which Black men play important dramatic roles—were relatively rare compared to popular genre paintings in which amusing Negro characters were made the focus of low humor. In John Quidor's picture of *The Money Diggers* (1832), for instance, Sam the Negro, wide-eyed with fear bordering on abject terror, is clambering so frantically to escape from the pit he was digging by firelight that his face and body are reduced to a crude caricature. But this was an extreme case. More common were the grinning or sometimes apprehensive Black faces to be found in less unusual settings.

Chapter XVII of James Fenimore Cooper's extremely popular novel, *The Pioneers; or, The Sources of the Susquehanna; A Descriptive Tale* (New York, 1823), provided just such a setting, involving the antics of a free Black man, who, like other Negroes in Cooper's writings, was inserted into the story as "a curious and picturesque part of the American scene."[21] The chapter opened with an epigram borrowed from Sir Walter Scott, "I guess, by all this quaint array, / The burghers hold their sports to-day," followed by Cooper's own statement that "The ancient amusement of shooting the Christmas turkey is one of the few sports that the settlers of a new country seldom or never neglect to observe."[22] It was the rural charm of this American winter scene that inspired artists like Charles Deas (Plate 60) and T. H. Matteson (Plate 61) to try to illustrate the event.

In later life, influenced perhaps by the example of George Catlin, Deas went west to paint Indians and mountain men, sometimes in single portraits and sometimes in wild confrontations (Plate 99) that seem to reveal traces of the madness that finally took full possession of his mind. In his painting of *The Turkey Shoot* (Plate 60), however, executed at the beginning of his career, the scene is calm with only a few details, such as the bird already shot and the tension between rifleman and target, to suggest violence.

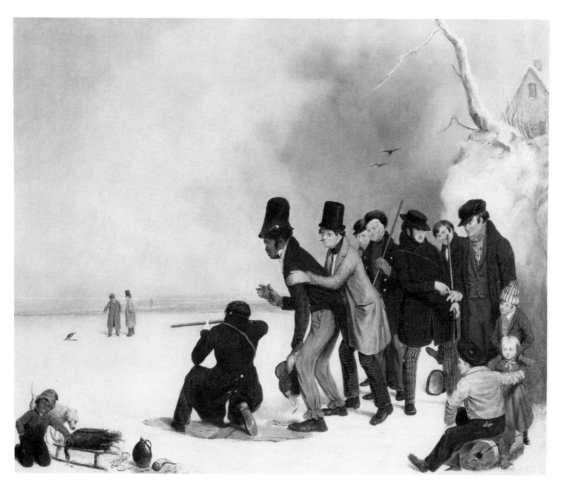

60. Charles Deas (1818–1867), *The Turkey Shoot,* c. 1836. Oil on canvas, 24¼ x 29½ inches. Collection of Mr. and Mrs. Paul Mellon.

When this work was first exhibited at the National Academy of Design in 1838, it was listed in the catalogue as "No. 313. Turkey Shooting. For sale." and it was favorably reviewed in the press as "A capital performance, giving promise of great things; [the artist] only wanting experience and unwearied perseverance, to rank among the best of American painters."[23] Later that same year, when this picture was exhibited again at the Stuyvesant Institute in New York City, it was identified more fully as "No. 110. Shooting on the Ice, from Fenimore Cooper's Pioneers. [Owned by] P. G. Stuyvesant. [and painted by] Deas. Much admired."[24] Actually, *The Turkey Shoot* by Deas was a rather free interpretation of the scene described in *The Pioneers.* Where later, less imaginative artists chose to follow the text meticulously, Deas was much more interested in the "quaint array." Considerable talent is obvious in his handling of the actors, their gestures and expressions, not to mention the convincing recession into space on the left. As a whole, with its low horizon and humorous details, this winter sporting scene has the flavor of a Dutch seventeenth-century genre painting.

Importantly, two characters who appear in Chapter XVII of Cooper's novel also appear in this work, making the relationship certain. One figure is Abra-

ham Freeborn or "Brom," a free Black man as his name implies, who ran the Christmas shooting contest for whatever profit he could make. Deas has pictured him, wide-eyed and apprehensive, in the very center of the canvas. He is shown holding the hat and gloves of Edward Effingham (identifiable by the initials "EE" on the brim of the hat), but he has grown so agitated with fear, lest the marksman should kill his last turkey with the first shot, thereby destroying his margin of profit, that he has to be restrained from behind.

The humor of the scene depends on Brom's expression. Already set apart by his ragged clothes, his unusual hat, and the gold earring in his left ear, his face, if not his entire form, is made to express a childlike fear. In this respect, the visual image that Deas presented is only mildly condescending compared to the stereotype of Negro behavior described in the novel. It is essential to turn to Cooper's text for a complete understanding of the shooting scene and a full description of Brom's antics.

For the occasion of the Turkey Shoot, according to Cooper, Abraham Freeborn had prepared a collection of live birds "admirably qualified to inflame the appetite of an epicure." The sport was played by fastening one bird at a time to a stake at "one hundred measured yards: a foot more or a foot less being thought an invasion of the right of one of the parties." The contestants then

61. Tompkins H. Matteson (1813–1884), *The Turkey Shoot* (Scene from Cooper's *The Pioneers*), 1857. Oil on canvas, 36⅛ x 48 inches. New York State Historical Association, Cooperstown.

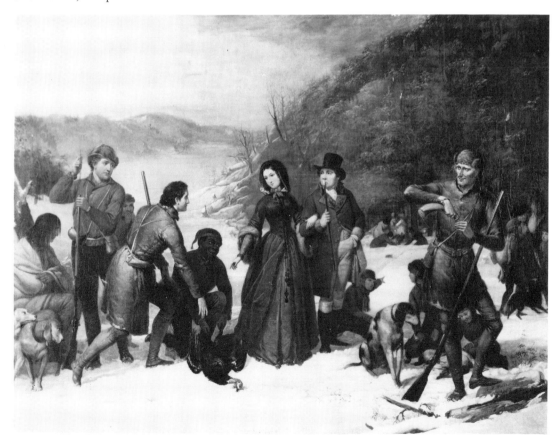

paid Brom a certain amount, depending on the quality of the game, for the right to take a shot. Whoever managed to hit a bird won the right to carry it home for Christmas dinner. As the chapter opened, some shooting had already taken place, "much to the pecuniary advantage of the sable owner of the game."

The first to pay a shilling and take aim at the prize turkey was the boastful Billy Kirby. Just as he raised his gun, according to Cooper's account, Brom tried to distract him with a stream of chatter: "Fair play, Billy Kirby—stand back —make 'em stand back, boys—gib a nigger fair play—poss up, gobbler; shake a head, fool; don't you see 'em taking aim?"[25] When Kirby missed, Oliver Edwards (who had not yet revealed his true identity as Edward Effingham) took aim—as he does in the painting by Deas—but a wound in his shoulder made him miss as well. Then Natty Bumppo or Leather-Stocking prepared to shoot. On pulling the trigger, however, his rifle only clicked; the flint failing to ignite the gunpowder. Brom claimed excitedly that a snap was as good as a fire, but Natty threatened to "hit a nigger" if Brom did not get out of the way and let him have another try. After considerable discussion it was resolved that Natty, the best marksman in the area, had lost his turn and would have to pay a second shilling for a second chance.

No one in the crowd made a sound, the story continued, as Billy Kirby prepared to try again, but when he missed a second time, Brom erupted in paroxysms of delight that Cooper described at length, as if to stress the world of difference between Brom's behavior and the unshakable self-confidence of Natty Bumppo and the stoic, self-contained nature of Chingachgook, Old Indian John (on the right and left respectively in Plate 61):

> Then, indeed, the shouts of the negro rung through the bushes, and sounded among the trees of the neighboring forest like the outcries of a tribe of Indians. He laughed, rolling his head, first on one side, then on the other, until nature seemed exhausted with mirth. He danced, until his legs wearied with motion, in the snow; and, in short, he exhibited all that violence of joy that characterizes the mirth of a thoughtless negro.[26]

Since Cooper based *The Pioneers* on his own boyhood experiences around Cooperstown in Otsego County, New York, it is possible that he might have known a freeborn Black on whom to model his fictional character. At the same time it is perfectly clear that Cooper was more than willing to exaggerate certain characteristics for narrative effect. As the chapter progressed, a seesaw battle was taking place in Brom's mind between the two basic motivations in the mind of "a thoughtless negro," as the author conceived them. On one hand, avarice showed itself in Brom's repeated attempts to distract the marksmen and in his subsequent delight over their many missed shots which meant more money in his pocket. On the other hand, this avarice was obviously mixed with the fear of being cheated at his own game, hence his constant plea of "gib a nigger fair play."

This is as far as Cooper went in his exploration of Black psychology. Brom was portrayed only from the outside, and so he remained a comic stereotype,

offering but a brief interlude in a story that concerned more serious things (the destruction of the wilderness west of the Hudson, a forest fire, and the death of Chingachgook). Given the nature of the literary source, it is not surprising that artists who chose to illustrate the turkey shooting scene from *The Pioneers* would treat Brom in the same picturesque but patronizing way. Within the popular context of American genre painting of the early nineteenth century, the fearful figure in Deas's painting and the grinning Brom, wearing a stocking cap and gold earring, in Matteson's later version of the end of the shooting match represent standard and often repeated types, thoroughly enjoyed by White audiences in New York and other cities.

4

The Growing Taste for Realism

AT THE HEIGHT of the Romantic Movement in America—that is, from the mid-1820s into the 1840s—a subtle, but persistent countercurrent was gradually evolving into something different. While it is relatively easy to recognize the results of this slow change, it is much more difficult to trace the exact origins of what might be called the growing taste or thirst for realism in the visual arts. No matter what descriptive terms are applied to it today, however, the fact remains that artists and image-makers in increasing numbers during this period were inspired to strive for greater accuracy, or objectivity, or truth to nature by allowing each subject to begin to speak for itself, instead of imposing artificial or extrinsic interpretations of their own.

Almost every American painting produced during the remainder of the nineteenth century could be labeled "Romantic-realist"—as if to signify with this one phrase the changing mixture in the artist's mind of *subjective,* emotional involvement on one hand versus a detached, *objective,* and occasionally scientific attitude towards a given theme on the other. The variable blend of these two ingredients is especially clear in pictures dealing with Negro or Indian topics, as described in this and the following chapters. For the American artists who chose to illustrate these themes, residual factors, such as limited stylistic training or the inescapable dominance of pictorial precedents, were now tempered by new relationships to the subject matter.

The career of George Catlin, the artist who wanted to paint representatives of every tribe in North America, offers an excellent example of the transition from purely Romantic to Romantic-realist thinking. No appreciable change in style was involved, since Catlin was largely self-taught and never acquired any great facility in depicting lifelike human figures, except in half-length portraits. It was a question, instead, of a new energy, a new dedication and perseverance in the task of gathering visual (as well as ethnographic) materials as encyclopedically as possible in order to create "a Gallery Unique, for the use and instruction of future ages."

The initial inspiration which led Catlin to become a major artist-explorer sprang from a typical, yet profoundly-felt Romantic sense of the inevitable doom facing the Red man. Having given up his attempt to become a lawyer, Catlin was working as a portraitist in Philadelphia when a delegation of ten to fifteen eminently dignified-looking chiefs arrived from the "Far West." The story is best told in the artist's own words:

[They] suddenly arrived in the city, arrayed and equipped in all their classic beauty; with 'shield and helmet,' with 'tunic and manteau,' tinted and tasselled off exactly for the painter's palette. In the silent and stoic dignity these Lords of the Forest strutted about the city for a few days, wrapped in their pictured robes; their brows plumed with the quills of the war-eagle, attracting the gaze and admiration of all who beheld them....

MAN, in the simplicity and loftiness of his nature, unrestrained and unfettered by the disguises of art, is surely the most beautiful model for the painter; and the country from which he hails is unquestionably the best school of the Arts in the world, and such I am sure, from the models I have seen, is the Wilderness of America. The history and customs of such a people, preserved by pictorial illustrations are themes worthy the lifetime of one man, and nothing short of the loss of my life shall prevent me from visiting their country and becoming their historian.[1]

Consequently, rather than staying in civilized Philadelphia where he might comfortably have painted imaginary scenes entitled "Lo, the poor Indian" or "The Last of his Race," Catlin spent several years of his life in the 1830s living and painting among the tribes west of the Mississippi. In a well-known letter, written upon his arrival at the mouth of the Yellowstone River on the Upper Missouri in 1832, Catlin explained his fundamental attitudes and motivations even more clearly:

I have, for some years past, contemplated the noble races of red men who are now spread over these trackless forests and boundless prairies, melting away at the approach of civilization. Their rights invaded, their morals corrupted, their lands wrested from them, their customs changed, and therefore lost to the world; and they at last sunk into the earth, and the ploughshare turning the sod over their graves, and I have flown to their rescue—not of their lives or of their race (for they are "doomed" and must perish), but to the rescue of their looks and their modes, at which the acquisitive world may hurl their poison and every besom of destruction, and trample them down and crush them to death; yet, phoenixlike, they may rise from the 'stain on a painter's palette,' and live again upon canvas, and stand forth for centuries yet to come, the living monuments of a noble race.[2]

In addition to three hundred and twenty oil portraits painted from life, Catlin also produced more than two hundred landscapes and views, showing Indian villages and dwellings, dances and games, buffalo hunts and other

amusements. In all, the artist claimed, there were more than three thousand figures in his "Indian Gallery," along with numerous costumes and a complete collection of native manufactures of all kinds, "including their implements of war and the chase." This gallery Catlin exhibited successfully in the East before taking the entire collection to London in 1839 and eventually to Paris in the 1840s.

It was in London that Catlin began to publish his extensive anthropological notes on the *Manners, Customs, and Condition of the North American Indians;* two volumes were issued in 1841, embellished with about three hundred line engravings. To capitalize further on the popularity of his Indian Gallery exhibition, which often included live performances by real Indians (even when it toured from city to city), the first book project was followed in 1844 by *Catlin's North American Indian Portfolio,* a collection of twenty-five hand-colored lithographs with a printed explanation for each one, written by the artist. In overall effect, since it contained mostly lacrosse and hunting scenes, this *Portfolio* was really a Western sequel to the illustrated books on American rural sports that had long been popular with the well-to-do in the East.

On the other hand, when one of Catlin's lithographs of a *Buffalo Hunt* on the boundless prairie, printed in 1844 (Plate 63), is compared with an eastern artist's idea of the same scene (Plate 62), a greater degree of realism is immediately apparent. While Catlin was living among the Indians in the Far West, participating in these hunts himself and making notes on exactly how they took place, Alvan Fisher was at home in Boston, preparing his version for *The Token* of 1835. The dried bones in the left foreground and the towering clouds of smoke rising from a prairie fire in the distance in Fisher's illustration, seem like artificial intrusions beside Catlin's equally composed, but sunlit and fairly factual presentation, made still more believable by his firsthand account in the notes to this plate:

> In the midst of precisely such a scene [buffalo breaking from a ravine in all directions at once] I was thrown, in a desperate chase by a party of Sioux Indians, near the mouth of the Teton River, on the Upper Missouri. . . .

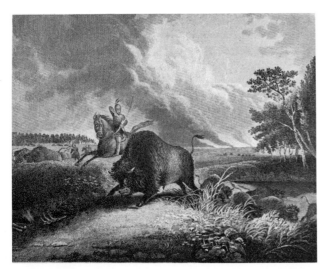

62. Alvan Fisher (1792–1863), *The Buffalo Hunt.* Engraving by W. E. Tucker, 3⅛ x 3⅞ inches. Published in *The Token and Atlantic Souvenir,* Boston, 1835.

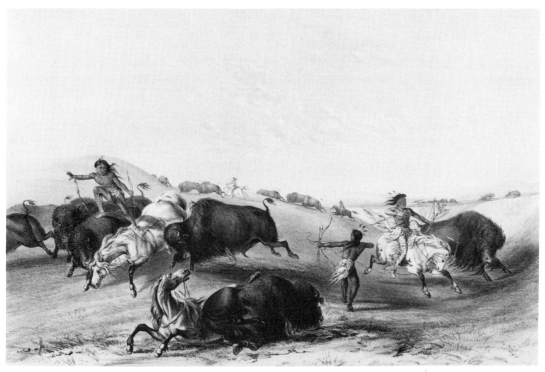

63. George Catlin (1796–1872), *Buffalo Hunt.* Colored lithograph, 11½ x 17½ inches. Plate 7 from *Catlin's North American Indian Portfolio,* London, 1844.

I have been familiar with these hunting scenes of the Indians for several years and have sometimes, for months together, almost daily joined in them myself. . . .

The buffalo is a harmless and timid animal until severely wounded, or closely pursued, when it often turns upon a horse and rider with great rage and shocking disaster, unless a sudden escape can be made from its relentless fury.

In this group is seen the position and expression of the Indian and the buffalo, at the moment the arrow has been thrown and buried to the feather in the animal's side. In the front of the picture, the wounded bull is seen dying, whilst wreaking his vengenance upon the horse; and on the left, another bull goring the horse of his assailant, who is forced from his seat and obliged to pass over the backs of several animals, which is often the case when they are running in numerous and confused masses.[3]

For later artists who were inspired by Catlin's international reputation or by his success as a publicist, lecturer, and entrepreneur, and even for those painters who never traveled through the West to collect firsthand observations on their own, images of Indians hunting buffalo remained a major American theme until the very end of the century. To be sure, this popular subject admitted endless variations—from the *Tables Turned* by Henry H. Cross (Plate 101) to *The Last of the Buffalo,* 1889, by Albert Bierstadt (Corcoran Gallery) —but no matter how romantically or how realistically the scene was portrayed, the confrontation of man and animal always produced excitement.

Compared to the more adventurous artists of the West, William Sidney Mount never traveled far from his boyhood home at Setauket, Long Island. The settings for his mature pictures tended to be quiet pastoral landscapes, and his primary subjects were the day-to-day occupations and incidents of life in the country. Treated with consummate attention to realistic details, these rural scenes were intended to please, rather than enthrall his viewers, many of whom had moved only recently to the city and still longed for the rustic pleasures of the changing seasons.

Given the frequency of their appearance in his genre paintings, it seems that Mount, more than any of his contemporaries, was fascinated by the African and West-Indian Negroes he encountered. In his picture of *Farmers Nooning* (1836), for example, a Black fieldhand sleeping in the midday sun is being tickled with a straw by a White boy, and yet the humor is not forced. The teasing is an innocent noon-hour diversion, and the sleeping man is far from a caricature of laziness or sloth. Another Black man neglects his chores for a moment as he listens, transfixed by the sound of a fiddle, in *The Power of Music* (1847). Smiling and impressive portraits of Black musicians, playing fiddles or banjos (or in one case "bones"), were also a favorite theme for Mount, a theme that in other hands often descended into the stereotype of the grinning, dancing minstrel in Blackface.

None of the Negro figures in Mount's oeuvre was ever given greater dignity than the Black woman in his *Eel Spearing at Setauket* (Plate 64). This title for the painting is a modern addition and slightly misleading. In the artist's own notes he referred to the work as "Recollections of early days. Fishing along shore —with a view of the Hon. Selah B. Strong's residence in the distance during a drought at Setauket, Long Island." Besides being a topographical portrait of Judge Strong's estate, commissioned by his family presumably, this canvas was also meant to be a highly expressive landscape in itself, conveying an indelible sense of summer heat and still air in the morning sunlight. On top of this, Mount added a recollection of his own early days when he learned the technique of fishing with a spear from an old Negro named Hector. In this painting of 1845, however, the artist used a Black woman as model for the standing figure. Like some Olympian statue, magically caught between rest and motion, she is nobly poised in the front of the boat, ready to use her spear in the serious, down-to-earth task of catching edible eels and fish for dinner.

As a rural sporting scene, what Mount's *Eel Spearing at Setauket* may lack in dramatic excitement or comic diversion when compared to *The Buffalo Hunt* by Catlin or *The Turkey Shoot* by Deas, it more than makes up for through the intense concentration of the main characters. The White boy, silently guiding the skiff with his oar, can be taken as a stand-in for the artist himself as a youth. His face openly expresses the admiration of an eager apprentice for the superior skill and ability of his teacher. And through Mount's mastery of his own medium, this boy and his dog, along with the Black fisherwoman, are perfectly fixed in place on this canvas with a sureness and monumentality only matched in certain works by Winslow Homer and Thomas Eakins later in the century (see Plates 91 and 106).

64. William Sidney Mount (1807–1868), *Eel-Spearing at Setauket,* 1845. Oil on canvas, 29 x 36 inches. New York State Historical Association, Cooperstown.

In the mid-1840's while Mount was working on Long Island and George Caleb Bingham was just beginning to paint pictures of life on the Missouri and the Mississippi, another artist was preparing a very different kind of river scene that offered an even greater potential for realism. According to his own biographical account, John Banvard traveled "thousands of miles alone in an open skiff, crossing and recrossing the rapid stream, in many places over two miles in breadth, to select proper points of sight" from which to make sketches. Due to the exertion and exposure, he reported proudly, "his hands became hardened with constantly plying the oar, and his skin as tawny as an Indian's."[4] Finally, when he had enough drawings in hand, Banvard took a makeshift studio in Louisville where he began to paint "the largest Picture ever executed by Man," a *moving panorama* of the Mississippi River.

Instead of employing his riverscape sketches in the traditional way, working up individual views as separate easel paintings, Banvard was determined to create one continuous view of country, 1200 miles in length, extending from the mouth of the Missouri River to the City of New Orleans: and this was done, he claimed, on three miles of canvas. This moving panorama had special advantages over the original type of panorama theater that account for its enormous popularity. First of all, the landscape was linear, rather than circular. Instead of enveloping the viewer in space with a 360° view, taken from

a particular spot, it had the more dramatic effect of moving and developing through time, like the unfolding plot of a story. As the canvas unrolled in a two-dimensional plane across the back of a stage (where the mechanical parts of the display could be hidden), each segment of the riverbank passing before the audience was seen in one direction only—head-on. There was no single vantage point for the whole, but a constantly advancing viewpoint that represented the present moment of experience—with more to come until the end of the reel.

There were disadvantages involved too, of course. Banvard had to invent adequate machinery to unroll and take up the canvas smoothly and evenly, while preventing it from sagging in the middle. Secondly, although the entire panorama was probably less than 2000 feet long (rather than three miles in length as advertised), it was still impractical to rewind the painting between performances which lasted about two hours. So, after one voyage downriver, Banvard advised his next audience to follow along in their descriptive pamphlets by starting in the back as he lectured on the major points of interest on the trip upriver from New Orleans to the Missouri.

The role of the artist, speaking in front of his own work, made this moving panorama into a form of illustrated lecture, a fascinating travelogue before the general use of lantern slides and long before the invention of motion-picture photography. As a public entertainment, it proved to be extremely successful first in Louisville in the fall of 1846, then in Boston (1846-1847), New York (1847-1848), and finally in Europe. Banvard succeeded in this field, where later imitators failed, for two reasons: the moving panorama was still a novelty when he began, and the American subject he chose was familiar in name yet remote enough in detail to inspire universal interest.

When he took his panorama to England in 1849—just ten years after George Catlin's arrival there with his Indian Gallery—Banvard added several parts to it, including views along the Ohio River and an opening section that contained fifteen notable scenes along the Missouri River from the mouth of the Yellowstone to its confluence with the Mississippi. It was this further extended painting, showing over 3000 miles of country, that Banvard exhibited daily to large crowds at the Egyptian Hall, Piccadilly, in London. And like Catlin before him, he also gave a command performance for Queen Victoria, Prince Albert, and the royal children at Windsor Castle.

What must have impressed Banvard's American and English audiences was the completeness of his work (not the quality of his style). This moving panorama represented a comprehensive cross-section view of the heart of the North American continent. Like other travelers of the same period, Banvard was intrigued by the geography and geology of the West, but it was the human elements in the running foreground that obviously held special interest for him as a painter and a lecturer. Although the original canvas is now lost, engravings after parts of it (Plate 65), printed descriptions, and reviews reveal that White settlements were certainly an integral part of the work, but even greater attention was paid to the more picturesque details, from Indian encampments on the northern plains to Black slaves and their quarters on

"CITY OF THE DEAD." WORDUM INDIAN ENCAMPMENT.

ASSINABOIN INDIANS. "THE DOMES."

65. John Banvard (1815–1891), *Views on the Missouri from Banvard's Great
Panorama.* Wood engravings, each section 2¾ x 6¾ inches. Published in *People's
and Howitt's Journal,* VII, London, May 19, 1849.

cotton plantations in the South. In this manner, these disparate, yet major
contemporary themes, so symbolic of America in general, were tied together
as essential parts of an endless continuum of life from the upper reaches of
the Missouri to the Gulf of Mexico.

It is regrettable that Banvard's personal commentary on the panorama,
said to have been replete "with Jonathanisms and jokes, poetry and patter,"[5]
was never written down. It would be interesting to know exactly what he said
about certain scenes as he lectured, but then again his audiences were undoubt-
edly mixed—some tolerant of slavery, others violently opposed to it; some in
favor of the extermination of the Indians, and others hopeful of more humane
treatment for these wards of the federal government. Since his livelihood
depended on the public, Banvard probably concentrated on entertaining his
paying customers without involving himself too deeply in antislavery politics
or Indian affairs.

Neutrality was undoubtedly the best policy. In the relentless unrolling of
this panorama, there was no opportunity for the artist to monumentalize single
figures, Red or Black, even if he had wanted to; and there was no time to

linger over a particularly touching scene without destroying the illusion of a continuous journey by stopping the canvas altogether. Banvard's success depended on his ability to manipulate popular taste by orchestrating the sequence of visual events. One or two realistic views, to satisfy the public thirst for facts about the West, were almost always followed by a more Romantic scene, often calling for a shiver of horror.

The London periodical, *People's and Howitt's Journal,* published four "Views on the Missouri, from Banvard's Great Panorama," along with a full description of the painting in 1849. To begin with, the magazine suggested, "the spectator must fancy himself seated on the deck of a steamer; and as the picture slowly passes before him, in its beautiful and endless variety, it will not be difficult to complete the illusion." Traveling from right to left down the Missouri, the viewer first passed by the clay bluffs called "The Domes," before coming to an Assiniboin Indian village (Plate 65). Unfortunately, the magazine continued, the Assiniboin are "now little known, for since the time Banvard made the drawings, this and other tribes have linked with the whites and are now nearly extinct." As a matter of fact, it was generally regretted that "the Red Men of the West are fast receding before the march of Saxon civilization."[6]

Farther downriver, at the Grand Detour on the Missouri, the panorama actually left the riverbank in favor of an overland portage that permitted several important views of characteristic Indian activities. At the first encampment, Sioux warriors could be seen performing a war dance. Next, on the grassy plains stretching away to the horizon, a buffalo hunt was in progress for the gathering of hides to be sold to White traders. A little farther on, one suddenly came upon a "City of the Dead, where the bodies of deceased Indians are laid upon plaforms or in the arm of a tree, instead of burying them in the earth. . . . The graves of the chiefs are distinguished by bare poles ereceted beside them. The bodies remain in this state till the sun and rain destroy, and the winds scatter them on the earth to mingle with the dust from whence they sprang."[7] According to formula, the next scene was a happy one, a view of the prairie covered with myriads of wild flowers, followed immediately by a fearful scene of the prairie on fire. Then Banvard showed an Indian village by moonlight and this gave way to a view of Indian ruins, a "deserted village of the Mandans, an extinct tribe."

Black figures began to appear along the Mississippi once the panorama had gotten past Memphis and the northern plains were replaced by southern agriculture. At President's Island, according to Banvard's descriptive pamphlet, "the voyager will begin to see fine cotton plantations, with slaves working in the cotton fields" in addition to the "beautiful mansions of the planters, rows of *slave quarters,* and lofty cypress trees."[8] In the midst of this continuing pageant of life on the lower Mississippi, Banvard again introduced sudden, melancholy reminders of death—as if to balance out the deserted villages and cities of the dead seen along the Missouri. Near Baton Rouge he pointed to Prophet's Island as the place where Wotongo, an Indian prophet and the last

of his tribe, had lived and died. And just above Bayou Sara he called special attention to a stark reminder of local vigilante justice:

> A short distance above this town stands an old dead tree scathed by fire, where three negroes were burned alive. Each of them had committed murder: one of them murdered his mistress and her two daughters.[9]

By the very nature of the process involved in painting a likeness, portraiture was inherently more realistic than depictions of the human figure in any other guise—and this was particularly true for images of Indians and Black men. In eighteenth- and nineteenth-century America, a portrait was usually judged by how faithfully the painted face followed the original model—a *strong* resemblance to the sitter being the first and often the only criterion for aesthetic approval. Optical aids from the physionotrace to the camera lucida offered a measure of accuracy greater than most artists could achieve with the unaided eye, but these drawing devices were quickly supplanted by the most realistic image-making process imaginable, the *daguerreotype*. Given the growing taste for authenticity, it is not surprising that the daguerreotype enjoyed such an enormous vogue in the United States, a vogue that lasted for nearly twenty years after the initial announcement of Daguerre's invention in Paris in 1839.

As a fairly easy means of creating a cheap, but remarkably faithful image, the silver-coated and then sensitized metal plate inside a daguerreotype camera was ideal. Unlike the human eye, it was totally unemotional. It could neither choose a landscape or portrait subject for itself, nor could it refocus the visual information, entering through the lens, into preset compositional patterns or popular stereotypes. In truth, all it *could* do was passively record the relative strength or absence of light being reflected from the subject set before the camera. Nevertheless, from the moment of exposure, that instant of light was captured forever with magical precision and detail.

It goes without saying that this new method of producing images was used exclusively by White daguerreotypists, sometimes for their own amusement, but more often for the handsome profit they could make from portrait studios in the major cities and towns. At the same time, when an occasional operator focused his camera on an Indian or Negro subject, the results were astonishing —witness the daguerreotypes of *Keokuk* and *Caesar* included here (Plates 66 and 67).

Earlier in his life, *"Keokuk, or The Watchful Fox"* (c. 1780/3-1848), a famous chief of the Sauk tribe, had been painted by several artists, including Charles Bird King and George Catlin. In 1847, however, the year before his death, he also allowed his picture to be taken with a camera, operated by Thomas M. Easterly in St. Louis, Missouri. Luckily, because it was rephotographed in 1868, this daguerreotype has survived as part of the National Anthropological Archives. In spite of its small size and the lack of glowing color, this image, the first known photographic likeness of an American Indian, far

66. Thomas M. Easterly (American daguerreotypist), *Keokuk, or The Watchful Fox,* 1847. Daguerreotype, copied in Washington, D.C., in 1868 by A. Zeno Shindler. National Anthropological Archives, Smithsonian Institution, Washington, D.C.

67. Anonymous (American daguerreotypist), *Caesar,* 1851. Daguerreotype (in case), 7 x 8 inches. Courtesy of The New-York Historical Society, New York.

surpasses any painted portrait of Keokuk in fidelity and psychological intensity.

Equally fascinating *and* hypnotic is the anonymous daguerreotype of *Caesar,* an aged "colored retainer in the family of Rensselaer Nicoll." Caesar was a household servant, born of slave parents on the Nicoll family estate ("Bethlehem"), just south of Albany, New York; the year of his birth was 1737—almost the same date as the *Marten van Bergen Overmantel* (Plate 17), showing Black slaves as well as Indians on another wealthy Dutch estate a few miles farther south along the Hudson. A vigorous and handsome man, described as "a magnificent specimen of physical manhood," Caesar lived to see six generations of his master's family and five generations of his own.

Although the State of New York passed two gradual Abolition acts, one in 1799 and the other in 1817, Caesar was too old each time to be covered by the provisions of this legislation, and so he may have been the last Black man to die a slave in the Northern states. But there were compensations. According to a descendant of the Nicoll-Sill family, Caesar was "a slave cherished, trusted, and beloved by all the members of the several generations of his first master's family who knew him while alive." Still alert and physically active even at the age of 80, he retired to a room on the ground floor of the kitchen extension of the old house at "Bethlehem." There he spent the last thirty-five years of his life, "playing his fiddle and throwing chunks of wood at his great-grandchildren," because, as Duncan H. Sill wrote in 1925, "he had a somewhat testy temper and did not like being 'bothered with young niggers.' "[10]

In 1851, the year before his death at 115, Caesar was persuaded to sit for a daguerreotype portrait, probably made in a photographer's studio in Albany. In this plate there is no trace of a "testy temper." On the contrary, here for the first time we are confronted with an image of a Black man that is equal in every way to the corresponding image of an Indian. The White daguerreotypists involved can be credited for the quality of these two plates, but not for their content. The two images are equal, despite the superficial differences in costume, not because of any conscious design on the part of the camera operators, but simply because in each case the subject summoned up all the dignity of his old age and presented himself to the camera as a commanding human presence. The fact that the Black slave felt this as strongly as the Sauk and Fox chief comes through inevitably in the final plate.

That both Keokuk and Caesar posed for their portraits holding ornamented canes only adds to the impression of venerable age and authority—reminding one perhaps of Rembrandt's magnificent *Self-Portrait* of 1658 (Frick Collection, New York) in which he too confronts the viewer as an older man, seated in a chair and holding a cane. Compared to the probing ability of a painter's eyes, however, the lenses on most mid-nineteenth-century cameras had but a shallow depth of field, telling us less than we might like to know. For example, while Keokuk's face is sharply defined, other details in the daguerreotype, such as the presidential face on his Peace Medal and the shiny metal strips at the top of his cane, are out of focus. In the other portrait image it is especially regrettable that Caesar's cane, which appears to have bands of incised decora-

68. Henry Gudgell (1826–1895), *Afro-Missourian Cane with Figural Relief*, c. 1863. Carved wood, 36¼ inches high. Yale University Art Gallery, New Haven, Connecticut, Director's Fund.

tion, is also indistinct. The possibility of African influence on this cane naturally arises, but in the 1850s, while Indian artifacts were eagerly collected and preserved by farsighted artists or explorers, art-objects created by Black men in their spare time tended to survive only by accident. Strong African influence is well documented in the case of the wooden walking stick carved by Henry Gudgell, a former slave, during or just after the Civil War (Plate 68), but the lack of better definition in the portrait image of Caesar makes further speculation about his cane useless at this point.

In the end, even with their minor shortcomings, one must be thankful for these two undeniably realistic images, showing two old patriarchs as they saw themselves and as they wanted to be seen by the impartial camera.

5

The Slavery Issue and The Indian Question

I N THE RISING STORMTIDE of antislavery literature and propaganda of the 1850s, no single work made a deeper impression on the American public than Harriet Beecher Stowe's *Uncle Tom's Cabin; or, Life Among the Lowly*. The story was serialized at first in *National Era,* an Abolitionist newspaper (1851-1852), and then it was issued as a book that sold more than 300,000 copies in a single year, besides being translated into several foreign languages. The first edition (Boston, 1852) had only six full-page illustrations, but the publisher (John P. Jewett & Co.) quickly responded to the demand for something more lavish, more in the manner of the novels of Charles Dickens enlivened by George Cruikshank's popular vignettes. Before the end of 1852 an "illustrated edition" appeared with 116 wood engravings by Baker & Smith, made from designs by Hammatt Billings, a Boston illustrator working in the Cruikshank tradition.

It was the avowed purpose of Mrs. Stowe's narrative "to awaken sympathy and feeling for the African race as they exist among us; to show their wrongs and sorrows, under a system so necessarily cruel and unjust as to defeat and do away the good effects of all that can be attempted for them."[1] To this end, one of the most touching episodes in her novel, an obvious favorite with sympathetic readers and illustrators alike, comes at the opening of chapter 22. To escape the heat of New Orleans, the St. Clare family had moved with all their colored servants to a summer home on the shores of Lake Pontchartrain It is the moment of sunset on a Sunday evening, as the chapter opens, and the angelic, golden-haired Little Eva is reading the Bible to her "humble-friend," Uncle Tom, as they sit "on a little mossy seat, in an arbor, at the foot of the garden" Plate 70).

The suggested landscape was appealing in itself, but the scene was also tinged with Christian love and touches of melancholy. Uncle Tom, described as a "remarkably inoffensive and quiet character" of a man, had actually rescued little Evangeline St. Clare in Chapter XVI when she fell from a riverboat and almost drowned in the Mississippi. Thereafter, according to the

69. Anonymous (Afro-American carver), *Boy holding a Bucket,* mid-19th century. Carved wood, 8 inches high. Courtesy of the Abby Aldrich Rockefeller Folk Art Collection, Williamsburg, Virginia.

authoress, "the friendship between Tom and Eva had grown with the child's growth. It would be hard to say what place she held in the soft, impressible heart of her faithful attendant. He loved her as something frail and earthly, yet almost worshipped her as something heavenly and divine. He gazed on her as the Italian sailor gazes on his image of the child Jesus,—with a mixture of reverence and tenderness."[2] Unable to read on his own except haltingly, Uncle Tom was willing to sit for hours and have Little Eva read the stirring passages of the Bible to him; but on this occasion, a line from Revelations led to his premonition of Eva's imminent and woefully premature death.

In the eyes of modern readers it may be embarrassing to see a grown Black man being read to by a little White girl with blond hair and a pretty dress, but Little Eva was clearly meant to represent the highest moral virtues of the Christian heart and soul, totally devoted to works of love and kindness. In the context of this antislavery novel, her natural goodness often took the form of innocent questions not so easily put off as childish ignorance of established conventions:

70. Hammatt Billings (1818–1874), *Little Eva and Uncle Tom in the Arbor.* Wood engraving by Baker & Smith, 3½ x 5½ inches. Used as a titlepage vignette for *Little Eva; Uncle Tom's Guardian Angel* by John Greenleaf Whittier, Boston, 1852.

LITTLE EVA;

UNCLE TOM'S GUARDIAN ANGEL.

LITTLE EVA AND UNCLE TOM IN THE ARBOR.

COMPOSED AND MOST RESPECTFULLY DEDICATED TO

MRS. HARRIET BEECHER STOWE,

AUTHOR OF "UNCLE TOM'S CABIN."

POETRY BY

JOHN G. WHITTIER.

MUSIC BY

MANUEL EMILIO.

Price, 25 cents net.

BOSTON:

Published by John P. Jewett & Company.

CLEVELAND, OHIO:

Jewett, Proctor & Worthington.

1852.

"Mamma, why don't we teach our servants to read?"

"What a question, child! People never do."

"Why don't they?" said Eva.

"Because it is no use for them to read. It don't help them to work any better, and they are not made for anything else."

"But they ought to read the Bible, mama, to learn God's will."[3]

By the end of the same chapter, this remarkable child had made a firm resolution on the issue of education for Negroes. If her mother's expensive diamonds were hers to dispose of, she decided, they ought to be sold in order to buy a place in one of the *free states* where all of the family slaves could be taken, liberated, and then taught to read and write. With no power to effect such a sweeping change alone, however, Little Eva simply went about the task of teaching the household servants, one at a time, the basic fundamentals of reading and writing. Far too good for this earth, unfortunately, she died only a few pages later, leaving the great promise of her moral example deeply imprinted on the conscience of every reader.

John Greenleaf Whittier, a major New England warrior-poet in the literary crusade against slavery, was inspired by this same section of *Uncle Tom's Cabin*. His poem, entitled "Little Eva; Uncle Tom's Guardian Angel," was "composed and most respectfully dedicated to Mrs. Harriet Beecher Stowe." When this composition was set to music and published as a popular song in 1852, the printer found the most appropriate possible image for the coversheet. He simply borrowed the wood engraving of "Little Eva and Uncle Tom in the Arbor" that had already appeared in the illustrated edition of the novel and reused it as a central vignette on the title page, surrounded by type (Plate 70).

Considered by itself, this wood engraving offers a striking parallel to the *Peaceable Kingdom* imagery employed by Edward Hicks (Plate 27). The lion's place has been taken by the fully dressed figure of Uncle Tom, but it is still the smaller, white-skinned child, holding his hand, who embodies the power of Christian love to conquer, tame, and then reeducate the animal nature of less-civilized creatures. Hammatt Billings, the obviously White artist who created this representation of Uncle Tom had no intention of flattering his subject. The relationship between the angelic Little Eva and her "humble friend" was meant to be true to the original passage in the novel—and so the patronizing tone was inescapable.

In this light two further comparisons are worth considering. Even though he is wearing almost exactly the same clothes as Caesar in the daguerreotype taken only the year before (Plate 67), the Black man in this wood engraving of 1852 is far from realistic. He looks more like an overgrown boy, rather than a mature and prideful man, confident, even as a slave, of himself and his position in the world. And when this same illustration is juxtaposed with an Afro-American carving from Fayetteville, New York (Plate 69), showing a *Boy Holding a Bucket*, it is easy to see that, while Hammatt Billings was willing to bend the Negro figure to suit his own purposes, the free Black man

who created this statue was transmitting a cultural image of much greater dignity through the sober, erect, and self-contained posture of his subject—without the slightest trace of caricature or social distance between maker and subject, as Robert F. Thompson has pointed out.[4]

Among the American oil paintings that dealt with the theme of slavery before the Civil War, one of the most impressive was Eastman Johnson's canvas, now called *Old Kentucky Home* (Plate 71), but first exhibited in 1859 as *Negro Life in the South*. The backyard of the artist's father's house on F Street, between 13th and 14th Streets, in Washington, D.C. provided the actual setting, whereas the substitute title was borrowed sometime later from Stephen Foster's popular ballad (in Negro dialect), "My Old Kentucky Home," of 1853.

The picture actually consists of a series of anecdotes, held together by the central motif—music. This composition was an instant success because every good-natured detail was treated with such painstaking care. And yet, from a moral point of view, the treatment was essentially noncommittal; it remained

71. Eastman Johnson (1824–1906), *Old Kentucky Home (Negro Life in the South)*, 1859. Oil on canvas, 36 x 45 inches. Courtesy of The New-York Historical Society, New York.

descriptive and aloof, rather than passionately involved with the virtues or vices of the subject matter. To Southerners, therefore, this image seemed to show that the institution of slavery was not the endlessly dreary and tormented existence for Negroes so often described in Abolitionist tracts, such as *Uncle Tom's Cabin.* For Northern critics, however, the "dilapidated and decaying negro quarters" were a mute but significant prophecy that the end of slavery was near at hand.

Eastman Johnson painted other Negro subjects during the Civil War period, often from more sympathetic and impassioned points of view, but this first essay in the genre remained his best known work. The following lines by the critic Henry T. Tuckerman, published in 1867, give a good idea of the reasons for Johnson's popularity:

> In his delineation of the negro, Eastman Johnson has achieved a peculiar fame. One may find in his best pictures of this class a better insight into the normal character of that unfortunate race than ethnological discussion often yields. The affection, the humor, the patience and sincerity which redeem from brutality and ferocity the civilized though subjugated African, are made to appear in the creations of this artist with singular authenticity. . . . "The Old Kentucky Home" is not only a masterly work of art, full of nature, truth, local significance, and character, but it illustrates a phase in American life which the rebellion and its consequences will either uproot or essentially modify; and therefore, this picture is as valuable as a memorial as it is interesting as an art-study.[5]

Belonging to the same tradition of quaint and often humorous images of "life among the lowly" at mid-century were the bronze or plaster sculpture groups by John Rogers, designed as conversation pieces for Victorian parlors. The very first group that Rogers mass-produced and offered for sale on a mail-order basis was *The Slave Auction* of 1859. From that moment on, Negroes of various types were a conspicuous part of his repertoire, sometimes interacting with White characters and sometimes having the entire pedestal to themselves—as in *Uncle Ned's School,* one of Rogers' most popular pieces which appeared just after the Civil War (Plate 72).

As a commentary on the important theme of education, so long denied by law to Black slaves in the Southern states, this particular group was applauded for the combination of human truth and homely pathos "that renders it exquisitely funny and sad at the same time." According to one contemporary critic, the sculptor's claim to greatness rested on a "perfect freedom from class prejudice."[6] In the present instance, the pathos and humor depended on the contrast between idleness and industry in the first efforts of former slaves towards self-improvement. The full meaning of the piece is best explained, perhaps, in newspaper reviews of the period. The following clipping from the New York *Evening Post* (February 10, 1866) was preserved in Rogers' own scrapbook:

72. John Rogers (1829–1904), *Uncle Ned's School,* 1866. Bronze master model,
20 inches high. Courtesy of The New-York Historical Society, New York.

Rogers is engaged on a new statuette, entitled "Uncle Ned's School." It represents a venerable colored gentleman, whose legitimate profession is that of a boot-black, engaged in teaching a bright-looking black girl the alphabet. The exceedingly wise expression in the old darkey's face, the learned wrinkles across his forehead, and the self-complacency which he shows, are wonderfully suggestive and characteristic. He has paused a moment in the act of polishing the boot into which his left arm is thrust, while he holds a brush in his right hand, to explain a difficult letter to the slim, hoopless girl, who stands with downcast eyes and opened book, resting upon the cupboard within which the old man keeps the tools of his trade, beside him. The old fellow himself, with patched trousers and shoeless feet, is seated on top of the cupboard, with one foot just touching the ground, and the other raised a short distance above it. Leaning against the cupboard, and half-lying on the earth, is a little black boy, with a dog-eared book, resting beside him, engaged in the laudable occupation of tickling, with his fingers, the bottom of "Uncle Ned's" lifted foot. The old darkey is too much engaged at the moment with his studious scholar to pay attention to what the idle one is doing; but we feel a certain conviction that when he is through with "Miss Nancy" the shoe-brush which he holds will form an acquaintance with "Timothy's" skull. The humor displayed in this group is excellent, and the story forcibly told.[7]

As a consequence of the Abolition movement in the North and the Secession of the Southern states, finally leading to open warfare, Indian images were displaced for the first time from the center of national attention they had always enjoyed. They did not disappear completely, as we shall soon see, but they played only a very secondary role during this period. In the early 1860s even the most hostile contacts between Whites and Indian war parties along the Western frontier were minor incidents compared to the struggle to preserve the Union and to free the slaves. In this context, east of the Mississippi, the role and occasionally the image of the Black man was changing rapidly.

After the outbreak of the Civil War, and especially after he announced that his Emancipation Proclamation would go into effect on New Year's Day, 1863, President Lincoln was frequently ridiculed in hostile political cartoons as a satanic fiend and a "nigger lover"—among other things. The Blacks depicted with him in these crude drawings tended to be standard caricatures—from fawning domestic servants to "field niggers" and from large "mammies" to little "pickaninnies" with corkscrew curls and tattered clothes. Only in the hands of more competent cartoonists were Black figures treated with even a modicum of respect, and then only at a great distance. That underlying touch of dignity that one senses in the Negro subjects of Eastman Johnson or John Rogers, in spite of the comedy situations superimposed on picturesque poverty, was almost impossible to find in American cartoons and jokes aimed at a mass audience.

When the Northern naval blockade of Southern ports began to threaten

the English industries dependent on cheap cotton, President Lincoln became a natural subject for attack by English editors and cartoonists, as well. For Sir John Tenniel, remembered best for his later illustrations to *Alice in Wonderland* and *Through the Looking Glass,* the American president was a particularly inviting target to be portrayed as "a repulsive compound of malice, vulgarity, and cunning,"[8] dressed in a' Brother Jonathan (Uncle Sam) outfit with striped pants. Tenniel's cartoon of *One Good Turn Deserves Another* (Plate 73), caustically mocking Honest Abe's ulterior motives and suggesting how he might try to inveigle Blacks to serve in the Union Army, appeared in the issue of *Punch, or The London Charivari* for August 9, 1862, almost a full year before the first Negro regiments were actually formed in the North. The caption gives Lincoln's words in a British idea of American dialect: Old Abe. "Why I du declare it's my dear old friend Sambo! Course you'll fight for us, Sambo. Lend us a hand, old hoss, du!"

What a stunning sequel this cartoon offers to the peaceful political message engraved on *Red Jacket's Medal* seventy years earlier (Plate 36). Here again a president of the United States is standing face to face with the single representative of another race inhabiting the North American continent, but the reasons for this symbolic confrontation have changed drastically, like the identities of the participants. The key issue in the national arena was now slavery, not peace terms with the Indians of New York State. Compared to the apparent equality of Washington and Red Jacket, the Black man in Tenniel's drawing, because of where and why he was created, appears to be a far more noble figure than the unctuous Lincoln. Unmoved by sweet talk, he steadfastly refuses to accept the tools of war being proffered to him.

The detachment implicit in this English point of view could never be matched by an American. However, since copies of the London *Punch,* then the leading humor magazine in the English language, were also distributed on this side of the Atlantic, Tenniel's views of American race relations *did* have a wide circulation in this country as well—wider than the distribution of silver peace medals, to be sure. In the end, though, his cartoons, like their American counterparts, were hardly a very fair or accurate record of the true situation for Blacks in the United States.

In retrospect, it is easy to see that the photographs of the Civil War period provided the most comprehensive survey of the Negro contribution to the Northern cause. Taken with the new wet-plate process that had completely replaced the daguerreotype by the end of the 1850s, these photographs took several different forms with different purposes. In most instances, however, the wet-plate camera was trained on groups of Black figures, not on individuals. So the single, prideful, even princely Black man in Tenniel's cartoon remained something of an anomaly.

From that early moment in the war (1861) when Major General Benjamin F. Butler at Fortress Monroe, Virginia, refused to return three escaped slaves, considering them to be confiscated property or contraband of war, Black "contrabands" were a notable feature of every Union camp. And the photographers who recorded endless scenes of life in camp between battles

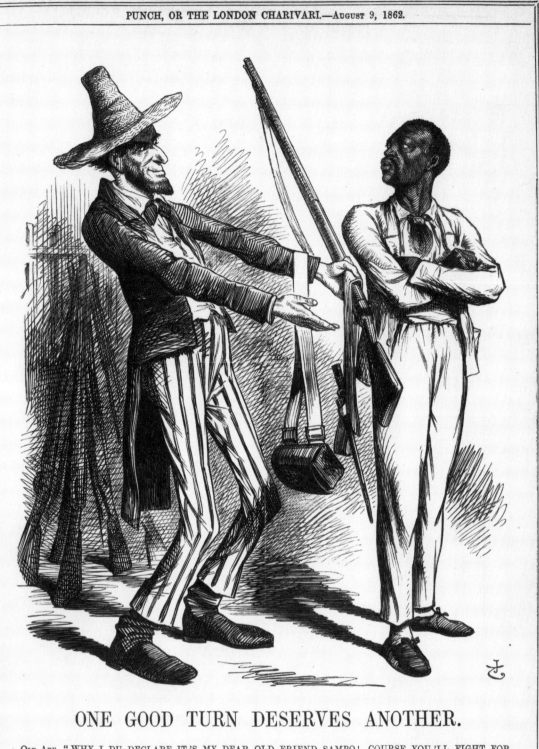

ONE GOOD TURN DESERVES ANOTHER.

Old Abe. "WHY I DU DECLARE IT'S MY DEAR OLD FRIEND SAMBO! COURSE YOU'LL FIGHT FOR US, SAMBO. LEND US A HAND, OLD HOSS, DU!"

73. Sir John Tenniel (1820–1904), *One Good Turn Deserves Another*. Etching, 9¾ x 7 inches. Published in *Punch, or The London Charivari*, XLIII, August 9, 1862.

often focused in on groups of contrabands who served as menials (cooks or personal servants) or else as laborers, long before other former slaves or freemen were allowed to volunteer for military service. As various companies began to publish sets of stereo views, thereby providing a highly educational armchair experience of the war, groups of contrabands became an even more familiar feature. The stereograph illustrated here (Plate 74) shows a group of Black teamsters posed in a receding row next to the type of heavy wagon they usually drove. The condition of their clothing testifies to the kind of work they were expected to perform, while the caption on the back of the photograph described the rude wooden shack in the background as their home.

Outside of military scenes that ranged from contrabands at leisure to rows of fresh Black troops, photographs of civilian Negro groups were rarely taken during the 1860s. One important exception to this was the image of a small group of *Emancipated Slaves* who posed among the standard Victorian props of the portrait photography trade in the studio of M. H. Kimball at 477 Broadway, New York, in 1863 (Plate 75). Like the bands of American Indians once taken to Europe to arouse public concern, these eight former slaves (3 adults and 5 children) were brought to New York from Union-occupied New Orleans to advertise the new schools that had recently been established in Louisiana for the education of Negroes. The photographs of these freed slaves were mass-produced, not to make a profit for a private publisher, but to raise money for a worthy cause, as indicated on the back: "The net proceeds from the sale of these photographs will be devoted exclu-

74. War Photograph and Exhibition Company, *A Group of Contrabands,* c. 1861–1865. Stereograph, mounted on cardboard. George Eastman House Collection, Rochester, New York.

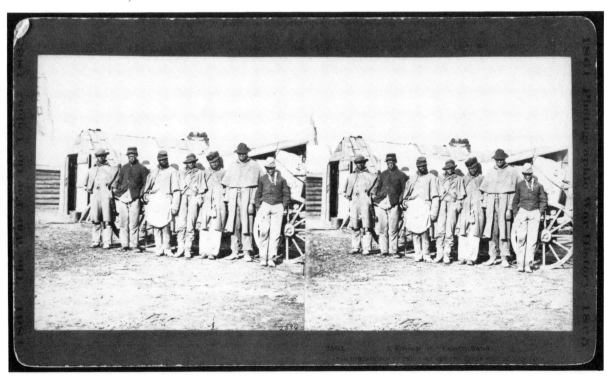

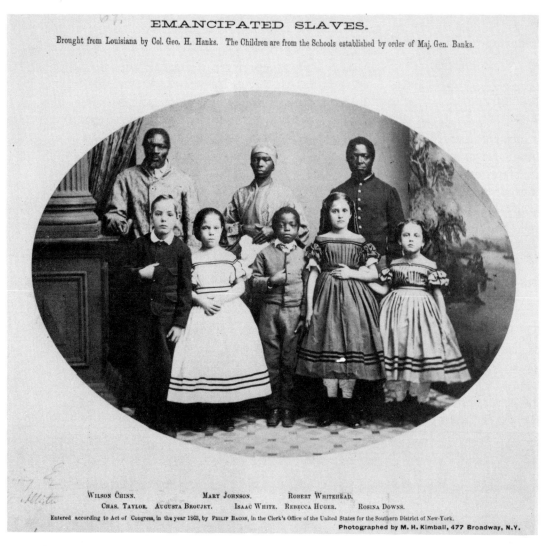

75. M. H. Kimball (American photographer), *Emancipated Slaves,* 1863. Photograph with printed captions. Courtesy of The New-York Historical Society, New York.

sively to the education of colored people in the Department of the Gulf, now under the command of Maj. Gen. Banks."

Thanks to the fact that one photo of this same group was reproduced as a wood engraving to illustrate an article on them in *Harper's Weekly* (January 30, 1864), we know more about these eight people than just their names. In fact, the mixture of their ages, their skin-coloring, and their personal histories must have been carefully selected to unlock Christian hearts and pocketbooks in the North. The written account in *Harper's* stressed the pathos involved in the social system that flourished in New Orleans before the Civil War, especially the market for quadroon and octoroon "Fancy Girls" and the fact that mulatto concubines, slave and free, were a White man's natural privilege. Furthermore, the offspring of these interracial liaisons were the sole responsibility of the mother, despite the fact that if she were still a slave, the child legally belonged to the father to be disposed of as he wished.

The fair complexions of four of the five children in the photograph reflect the racial mixture of much of the Negro population of New Orleans. The children are identified as follows from left to right: Charles Taylor, sold "down the river" into slavery by his Virginian father; Augusta Broujey, whose mother was owned by her own half-brother; little Isaac White, with the darkest skin, "who, though black, is none the less intelligent than his whiter companions" and who now has the opportunity to improve his lot through education provided by the Union; Rebecca Huger, formerly a slave in her father's house; and Rosina Downs, the daughter of an enlistee in the rebel army.

The three older figures represent the growing numbers of Black adults enrolled in night and Sunday schools that had just been established in the occupied parishes of Louisiana under a special Board of Education for Freedmen. As if to bring to life again the Gothic horror of certain episodes in *Uncle Tom's Cabin* and other Abolitionist attacks on slavery, the stories of these three adults were also recited at length in print. On the left behind the children stands Wilson Chin, sixty years old. Branded like a steer, he wears forever on his forehead the initials (VBM) of his second master, Volsey B. Marmillion, a sugar plantation owner of New Orleans. Mary Johnson, *now employed* as a cook for Colonel George H. Banks, we are told, still bears the scars of a lash across her back. And lastly on the right is Robert Whitehead, a regularly ordained minister and a skilled house painter, who at last could harvest for himself the fruits of his own intelligence and labor.

Ultimately, as an expression of new hopes and opportunities for former slaves in the South, based upon the promise of education, this photograph of 1863 offered a preview of one of the principal themes of the Reconstruction period—a period which had already begun in occupied New Orleans.

During the Civil War years, the image of *death* in a variety of ugly forms never strayed far from the public consciousness. Violent battle scenes were commonplace, showing White soldiers heroically or demoniacally killing other soldiers on either side. In visual terms the most frenzied and dramatic actions could only be sketched, and then rather imperfectly, by artist-reporters working for the major periodicals. Between the actual event and the reproduction, moreover, it usually took at least a week before the hurried drawings could reach New York to be translated into wood engravings. On the other hand, where photography produced more accurate images under controlled conditions, the wet-plate process was still too slow to capture rapid movements. For this reason, it was only after the fighting had stopped that photographers ventured to the center of the battlefields to take pictures of the motionless, rotting remains, scattered over the ground (see Plate 83).

In comparison to the wholesale casualties of battle, executions were normally a much quieter form of death, permitting spectators to gather beforehand in ghoulish expectation. Public hangings or lynchings, like the three events illustrated here (Plates 76-78), often took on the quality of public

entertainments, providing a moral lesson or at least a few hours' diversion for those with nothing better to do.

The first of these hanging scenes, a wood engraving published as a broadside after the event (Plate 76), shows the mass-execution of thirty-eight renegade Sioux at Mankato, Minnesota, in 1862. Captured and found guilty of attacking a White settlement and murdering its inhabitants, these Indians were led to the scaffold on the day after Christmas, drawing a considerable crowd in addition to a sizable guard detail of Union troops. The caption at the bottom of the sheet gave an account, based on eyewitness reports, of the unusual way in which these special prisoners accepted their fate:

> The scene represented in the above picture is the dance improvised just after the ropes had been adjusted, and before the fatal trap fell. When the white caps were drawn down over the eyes of the prisoners, shutting out the light of day, all joined in a mournful wail, and occasionally a piercing scream would be heard. We are told by those familiar with the Dakota language that there was nothing defiant in their exclamations, each one saying, "I'me here! I'me here!" [sic] indicating a readiness to meet death in partial atonement, at least, of their hellish outrages.
>
> Though pretending to die brave, a nervous clutching by some at their necks, when the ropes were being adjusted, was distinctly observed by those nearest the gallows. Several pushed the white caps up from their

76. Anonymous (American wood engraver), *Execution of the Thirty-eight Sioux Indians,* 1862. Wood engravings, 8⅞ x 14 inches. Arts of the Book Collection, Yale University Library, New Haven, Connecticut.

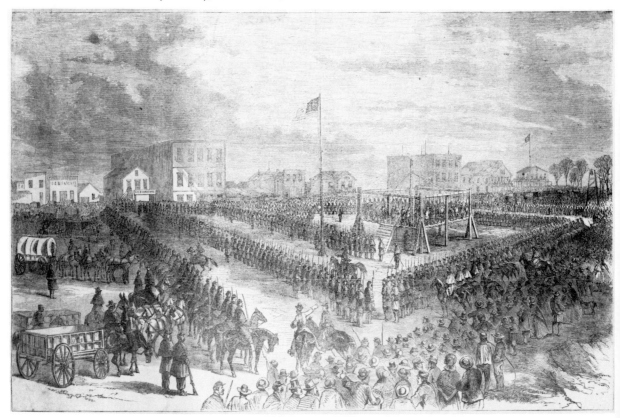

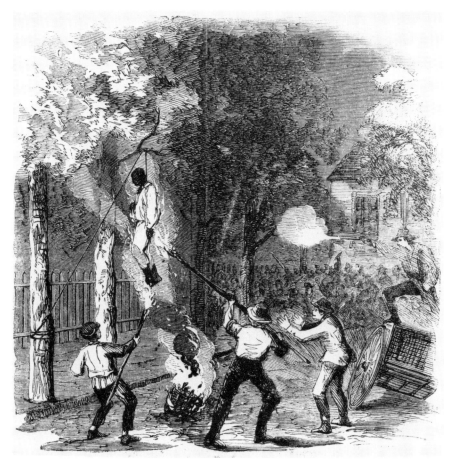

77. Anonymous (American wood engraver), *Hanging a Negro in Clarkson Street.*
Wood engraving, 4½ x 4½ inches. Published in *Harper's Weekly,* VII, no. 344,
August 1, 1863.

78. Taylor and Huntington (Publishers), *Execution of a Colored Soldier,* 1864.
Stereograph, mounted on cardboard. Courtesy of The New-York Historical Society,
New York.

eyes two or three times, and one changed the noose from its proper position, which, when the drop fell, failed to produce instant death. Being close together, several, as if by prearrangement, clasped hands tightly, and remained in that situation until cut down. One reached out his hands on each side, trying to grasp that of another, but failed, and died with one hand tightly clutched to the blanket of his nearest neighbor. When all was arranged, the signal was given by twice tapping on a large drum. At the second tap, almost drowned by the voices of the Indians, the stays were knocked away, the rope cut by the executioner, and with a crash, down came the drop. The rope of one—Rattling Runner—broke in the fall, but his neck was dislocated, producing instant death. His body fell heavily on the platform, but a new rope was procured and adjusted, and he was soon hanging with the others.

There was little struggling by the majority, and in some instances none at all was perceptible. A few, however, died hard, which was particularly the case with the one who had removed the noose from its proper place. It is unnecessary to speak of the awful sight of 38 human beings suspended in the air. Imagination will readily supply what we refrain from describing.

It was (and still is) a familiar habit of the Northern mind to think of midnight murders, burnings, and lynchings of Black men as a strictly Southern phenomenon. The fire-blackened execution-tree near Bayou Sara, Louisiana, that Banvard depicted in his moving panorama of the Mississippi and that he undoubtedly described aloud before his Boston and New York audiences in 1846-1848 is an early example in this vein. Racial violence was not so easily localized, however.

Usually ascribed to the "low Irish element" in the city, the New York Draft Riots took place in mid-July, 1863, just after the Battle of Gettysburg. As a protest against the unfairness of the Draft Law, which allowed the rich to find substitutes or to avoid military service entirely by paying a $300 fee, these riots began with assaults on civil authorities—the draft officials, the police, the army—but they quickly degenerated into savage attacks on helpless Negroes.

The Negro Orphan Asylum at the corner of Fifth Avenue and 43rd Street was sacked and burned on Monday night, July 13th, leaving scores of children homeless. Shops and stores, owned or patronized by Negroes, were also looted and set on fire, along with boarding houses and private homes. If any Black man was unlucky enough to be seen on the street, his only hope was to run for his life. Some escaped the pursuing mob by leaping off the end of the nearest pier into the East River or the Hudson; others reached the safe haven of a police station; but many, especially the old and the very young, were overtaken and cruelly beaten or even killed. "At one time," according to the journalist, Joel Tyler Headley, "there lay at the corner of Twenty-seventh Street and Seventh Avenue the dead body of a negro, stripped nearly naked, and around it a collection of Irishmen, absolutely dancing or shouting like wild Indians."[9]

A similar, but even more gruesome incident occurred in Clarkson Street, off lower Seventh Avenue. The *New York Illustrated News* described it as the "Brutal murder of a negro man in Clarkson Street by the rioters, who stripped off his clothes and hung him to a tree, afterwards burning the body, on Monday, July 13."[10] Several of the illustrated newspapers and magazines published versions of the scene (Plate 77) within a week or two after the event, but these wood engravings vary so markedly in their details that it seems doubtful that any of them were made from on-the-spot sketches. Probably, it was a staff artist for each paper or periodical who took the few available facts and fabricated a lynching scene that would give at least some idea of the horror of the event—while leaving the victim clothed as a concession to Victorian morality. And all this, Headley lamented, "was in the nineteenth century, and in the metropolis of the freest and most enlightened nation on earth."[11]

The third image in this series of Civil War hanging scenes can be dated June 1864. It is a stereograph, one of the countless photographic records of the Civil War that was meant to be looked at through a stereopticon viewer. (Plate 78). Although the original negatives of this scene were made with a double-lens camera in Virginia in 1864, this particular print, mounted on a card, was published in the 1890s by the firm of Taylor & Huntington of Hartford, Connecticut. It bears number 783, indicating its place in a long series of educational views of "The War for the Union, 1861–1865," that affluent parents might buy for their children. The value of these stereographs as an instructional device was enhanced by the paragraph or two on the back of each card, describing the scene.

In the case of No. 783, "The Execution of a Colored Soldier," the printed explanation of the image was intended to convey a strong sense of inevitable justice for any wrongdoer. But the wording of the paragraph suggests an insidious form of collusion between the White officers in rival camps to turn this particular execution into a racist entertainment. And the final stereo image, showing the Black soldier hanging in the noonday sun from a makeshift scaffold in the middleground, while his fellow Union soldiers are resting in the shade on the right, leaves a very disturbing impression of its own. The full text on the back of this *educational* photo speaks for itself:

> In the month of June 1864, a colored soldier in the Union Army in front of Petersburg, attempted to commit a rape on a white woman whose house chanced to be within our lines; the woman's husband was absent from home, serving in the Rebel army. This colored soldier, named Johnson, was caught, tried by Court-Martial, found guilty, and sentenced to be hanged. A request was made of the Rebels, under a flag of truce, that we might be permitted to hang Johnson in plain sight of both armies, between the lines. The request was granted, and this is a photograph of him hanging where both armies can plainly see him.[14]

On a far less tragic level, Indians as well as Black men provided other

kinds of public entertainment during the Civil War period—in the process helping to boost morale in camp on one hand (Plate 79), and to raise money for wounded soldiers on the other (Plate 81).

As a special free-lance artist for *Harper's Weekly,* Winslow Homer went to Virginia to live with the Army of the Potomac for a time in October of 1861. His drawings and mental impressions of daily routines and the occasional off-duty pleasures of training camp were translated, once he returned to New York City, into vivid graphic images for publication. One of the earliest of these was a striking double-page spread, showing "A Bivouac Fire on the Potomac" (Plate 79), which appeared right before Christmas in 1861.

Just beyond the fire in this calm yet crowded composition, one grinning "darkey" is fiddling furiously on an old violin, while another (with stereotypical corkscrew curls and shabby clothes) dances in the air at the center of the circle. If this image as a whole seems consciously composed because of its general symmetry and the obvious interest in difficult lighting effects, the impromptu minstrel show still has the ring of truth; it seems like something the artist might have witnessed for himself, a bit of innocent fun to pass the time and maintain morale on a long autumn night.

In the case of the Western landscape painter, Albert Bierstadt, one is hard

79. Winslow Homer (1836–1910), *A Bivouac Fire on the Potomac.* Wood engraving, 11¾ x 20 inches. Published in *Harper's Weekly,* V, no. 260, December 21, 1861.

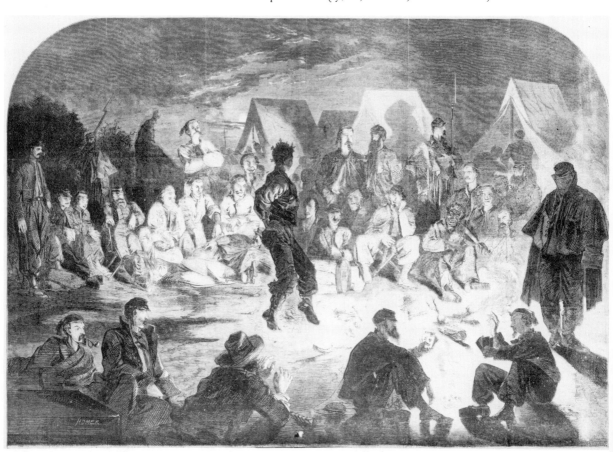

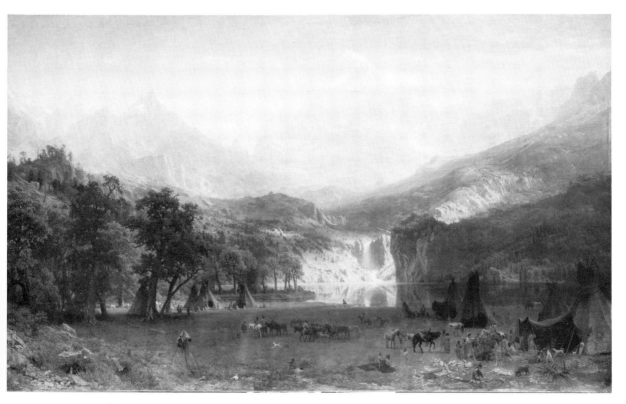

80. Albert Bierstadt (1830–1902), *The Rocky Mountains,* 1863. Oil on canvas, 73¼ x 120¾ inches. The Metropolitan Museum of Art, New York, Rogers Fund, 1907.

pressed to find a single work in which a Black man appears. Where Winslow Homer confined himself mainly to Eastern subjects, it is clear that Indians from the Plains to California held a special interest for Bierstadt to such an extent that he became an ethnographer-artist-entrepreneur in the tradition of George Catlin.

Beginning with his first Western trip in 1859, when he accompanied the Lander Wagon Road Expedition from Missouri to the Wind River Mountains in the Wyoming Territory, Bierstadt collected Indian artifacts—as well as photographs and stereo views—in addition to more conventional artistic notes in the form of oil studies and sketches. From this rich variety of study materials he worked up a series of Western landscapes during the Civil War period, culminating in his large canvas (ten feet long) of The Rocky Mountains (Plate 80). Finished in 1863, this painting was loaned in the Spring of 1864 to special money-raising exhibitions in New York and Philadelphia that were sponsored by the Sanitary Commission, a Red Cross-type of organization devoted to medical and spiritual aid for thousands of Union soldiers wounded in the War. Everywhere that it was shown, Bierstadt's majestic and compelling, yet strangely soothing, peaceful, and almost Arcadian landscape vision drew large and admiring crowds—as described in the following notice from a Philadelphia paper:

Perhaps the most attractive picture in the gallery is Bierstadt's *Rocky Mountains,* and about it an admiring group of visitors is always gathered.

The artist has given us a glorious picture of green sward, water fall, mountains and sky, with the eternal hills piled up in the background, and melting away in dreamy distance, while in the foreground savage life is illustrated with wonderful fidelity to detail. To the earnest gazer the picture is almost stereoscopic in its clearness and boldness, and the management of lights and shades afford unmingled satisfaction to the lover of art.[12]

At the Sanitary Commission's "Metropolitan Fair" in New York City, Bierstadt was more than just an immensely successful contributor to the art gallery. As one with firsthand experience of the West and its inhabitants, he was also asked to serve as an organizer for the Indian Department. In effect, what Bierstadt staged at the Fair was a *tableau vivant* reproduction of the foreground of his own picture, *The Rocky Mountains*. On a greensward (in baize) in front of a painted backdrop, he placed authentic teepees and *live* Indians engaged in the many native tasks and activities shown in the oil painting, especially the essential tasks of preparing foods and hides. At certain times these hired Indians also performed dances and rituals which were, needless to say, extremely successful as a tourist attraction, making Bierstadt's name even more famous. The popularity of his stage show was recorded in contemporary journals like *Harper's Weekly* (Plate 81) which ran a cartoon-view of one of the performances along with the following commentary (which ends in a premature use of the past tense):

> In the Fourteenth Street Building Bierstadt's Indian Wigwam has been constantly crowded by visitors desiring to study the habits and peculiarities of the aborigines. Several entertainments have been given daily by the Indians. Our Sketch represents a *War Dance,* as given on several occasions to the intense gratification of all spectators. Historically, no feature of the Fair has greater interest than this in which the life of those who, only a little while ago, held undisputed possession of our continent, is reproduced by a handful of the once absolute tribes for the pleasure of the pale-faced race, whose ancestors pushed them into obscurity and historical oblivion.[13]

81. Anonymous (American artist), *War Dance—Indian Department.* Wood engraving, 6¾ x 9⅛ inches. Published in *Harper's Weekly,* VIII, no. 382, April 23, 1864.

When the end of the Civil War finally came in April 1865, photographers were on hand, of course, to make their on-the-spot records of modern history just after it happened. In retrospect, most of the photos that were taken in Virginia that April seem unusually empty, frozen, and motionless—like the calm after a violent storm. And none of these pictures were more eloquent reminders of Southern suffering and defeat than the nearly abstract images of ruined, burned-out buildings (like the Gallego Flour Mill and the Confederate Arsenal) in Richmond.

It is certainly not surprising that no White Virginia citizens rushed out to pose amid the wreckage of their capital. Instead, photographers in the train of the Union Army had to look elsewhere for human interest, and it did not take long for the round, inquisitive eye of at least one Northern camera to find a group of Negro men, boys, and children willing to pose alongside a canal, near Crenshaw's Mill (Plate 82), with the ruins of Richmond, rather than studio props, serving as an interesting backdrop (compare with Plate 75).

Because of the strong sunlight, the faces of these former slaves are more

82. Attributed to Mathew B. Brady (c. 1823–1896), but probably by Alexander Gardner (1821–1882), *Freedmen in Richmond, after surrender,* April 1865. Photograph. Courtesy of The New-York Historical Society, New York.

hidden than revealed by this photograph, but individual identities were not the issue. What seems to come through in this round-cornered, somewhat asymmetrical image is a sense of group identity, a collective wish to be recorded calmly and with measured dignity. (Notice, for example, the central male figure who is smoking a pipe and trying unsuccessfully to keep his children still during the exposure). For a time, at least, these survivors of the slavery system and the war have inherited by default the depopulated cityscape around them; and on this day, the beginning of a new era, they have arranged themselves before the camera like rightful owners, proud of themselves and their extensive holdings as far as the eye can see.

April 1865 is also the date of John Reekie's photograph of *A Burial Party, Cold Harbor, Virginia* (Plate 83), which provides one of the grimmest imaginable comments on the fruits of war, harvested almost a year after the actual battle. Reekie was one of several photographers working for Alexander Gardner at the time, and when he visited the Cold Harbor battlefield that spring, he probably made several wet-plate negatives with his camera trained on the grisly human debris, piled upon a litter in the foreground.

Understandably, for his two-volume *Photographic Sketch Book of the War,* issued in 1866, Gardner chose to publish a positive print from Reekie's most

83. John Reekie (American photographer), *A Burial Party, Cold Harbor, Virginia, April 1865.* Positive print from Reekie's negative by Alexander Gardner. Published in *Gardner's Photographic Sketch Book of the War,* Washington, 1866, Volume II, No. 94.

effective negative (Plate 83). In this composition there are four Union soldiers, all Black men, in the background—three with shovels and the fourth bending over to pick up another skull. In the foreground, another Negro, apparently a contraband by the look of his nonregulation uniform, has acceded to what may have been the photographer's direct request; he sits on the ground at one end of the litter where the color of his skin plays off against the bleached white surfaces of the last skull, which has been turned to confront the camera.

For Reekie, as the original photographer, this stark juxtaposition of life versus death probably seemed like a perfect statement on the horrors of war-time experience; it was inescapably real in every photographic detail, down to the lifeless boot still attached to a rotting, half-empty pants leg. For Alexander Gardner, in his printed commentary of 1866, this sad scene, showing soldiers in the act of collecting the remains of their comrades, provided an excuse for chastising Virginians and Pennsylvanians alike for their failure to bury the dead after the armies had moved on. For modern viewers, Reekie's *Burial Party* still has enormous power as a *memento mori,* but is also reminds us at the same time that the most strenuous, backbreaking manual labor and the least pleasant, janitorial tasks were always left to Negro troops or contrabands without a second thought.

In the post-Civil War period the violent passions and politics of Reconstruction, centered around the Negro question, were a natural theme for the young, crusading cartoonist, Thomas Nast. Best known for his satirical drawings and lampoons in *Harper's Weekly*—the medium through which he later attacked Tammany Hall and Boss Tweed (1871)—Nast at times also took up brushes and paints for a favorite cause. In 1867, for example, he painted what he called a "Grand Caricaturama"—its purpose being a further indictment of President Andrew Johnson's policies towards the unreconstructed South.

In basic format Nast's caricaturama was a lineal descendant of Banvard's moving panorama of the Mississippi, save for the fact that it was not a continuous landscape, but "A Series of Thirty-Three Grand Historical Paintings" (of which five have survived). Like its predecessors in this field of public entertainment, the exhibition of Nast's work involved more than just the unrolling of the canvas. When the caricaturama was shown to appreciative audiences in New York City and then in Boston in 1867–1868, there was a catalogue available at the door, and each performance was accompanied by a seriocomic lecture, read by an actor or a hired speaker (not the artist himself), and by appropriate music, played by a woman pianist.

Illustrated here is Nast's scene number 24, "The Massacre at New Orleans" (Plate 84), which was introduced by the air, "Oh, fatal hour." The evil gnome on the right, wearing a crown and listening smugly to the sounds of a race riot, is President Johnson. He is portrayed in royal garments as a reference to the Radical Republican fear that he wanted to declare himself king. On the wall beside the open door Nast inscribed, with deliberate irony, some of the former

84. Thomas Nast (1840–1902), *The Massacre at New Orleans,* 1867, Section of Nast's *Caricaturama,* 94¾ x 138½ inches. The Swann Collection of Caricature and Cartoon, New York.

vice-president's more memorable sayings on the issue of civil rights for Negroes and Federal authority versus states' rights.

In the background on this eight-foot-high cartoon is Nast's rendering of the "New Orleans Massacre" of July 1866; when police stormed into an "illegal" Radical Republican convention, forty people were killed—thirty-seven Black delegates and three White sympathizers who had no chance to escape. For a dedicated liberal like Nast, this riot and a similar occurrence in Memphis, Tennessee, were easily blamed on the president, who did nothing to prevent bloodshed beforehand and nothing afterwards to apprehend and prosecute those responsible for outright murder. Abraham Lincoln may appear to be a devious, despicable man in Tenniel's cartoon of 1862 (Plate 73), but the tinge of evil there is superficial compared to Nast's vicious caricature of a satanic president, self-satisfied with the result of racial hatreds he had unleashed mainly through inaction and incompetence, if not through overt malevolence.

As for the Indian troubles in the West, one has only to study the three images that appeared on a single page of the issue of *Harper's Weekly* for

January 16, 1869, to catch a revealing glimpse of Eastern attitudes towards the necessity of ending these disturbances. The page as a whole was meant to celebrate Custer's surprise attack and victory over Black Kettle at Washita River (November 27, 1868), the latest success for the U.S. Army in "The Indian War." Under General Sheridan, the winter campaign of 1868–1869 was designed to catch the intransigent Indians at their weakest moment and to destroy as many as possible along with their horses and supplies, thereby forcing total submission. After all, as General Sherman was quoted as saying, "The more we kill this year the less will have to be killed the next year. For the more I see of these Indians the more convinced I am that they will all have to be killed or maintained as a species of paupers."[14]

Before turning to the pictures in *Harper's Weekly,* it is valuable to examine an earlier account of the Washita River "massacre" in a nonillustrated paper. On Friday, December 4, 1868, the *New York Times* published a verbal report on the progress of Sheridan's winter campaign—the first two paragraphs of which are quoted below. With regard to the latest news of Custer's raid on the undefended Cheyenne camp, the author of the report had to admit that "probably, when the truth comes to be known, it will turn out to have been a pretty murderous affair" (since no quarter was given), but the general tone of this piece was laudatory and supportive of our courageous troops in the field. From an eastern vantage point, it seemed that this bold and unexpected stroke by Custer in the midst of winter might finally "give us peace on the Plains"—from now on the West would be open to the Idea of Progress.

> Fighting Indians in the dead of Winter, in their own villages, and tracking them in snow twelve inches deep, is new business for our soldiery. But they have done both very well, and the first fruits of their campaign is a surprise and a victory after the hardest-fought and bloodiest Indian battle which has taken place on the continent during many a year.
>
> It was a "salty dose," as Sheridan would say, that Custer administered to the Cheyennes, Arapahoes and Kiowas. Our loss was severe—nineteen men and two valuable officers, the gallant Major Elliot and Capt. Hamilton being killed, and eleven men and three officers wounded. But Black Kettle's loss was far more severe—he and 102 of his warriors were left dead on the field, and his whole camp with great quantities of ponies, buffalo skins, powder, lead, arrows, tobacco, rifles, pistols, bows, lariats, dried meats and other provisions, were captured. In brief, the whole village, with all its lodges, its Winter's stores of arms, ammunition, food and forage, and the wives and children of the dead warriors, fell into our hands at one stroke.[15]

It was not until January 16th, 1869, that the editors of *Harper's Weekly* were ready with an *illustrated* account of these events in the Oklahoma Territory. The six week delay between the Washita River battle and the printed report—which might have been fatal to a conventional newspaper—was more than made up for by the addition of pictures. At the top and bottom of the key page in question (Plate 85) are wood engravings after drawings by Theo-

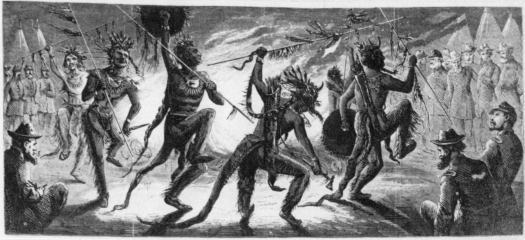

CUSTER'S INDIAN SCOUTS CELEBRATING THE VICTORY OVER BLACK KETTLE.—[SKETCHED BY THEO. R. DAVIS.]

THE INDIAN WAR.

THE Indian Peace Com-
mission of 1867 accomplished
greater harm than benefit.
Treaties were entered into
with the Cheyennes, Arrapa-
hoes, Kiowas, Comanches,
and at the recommendation
of the Commission the Pow-
der River country was aban-
doned. This latter action
was construed as the result
of timidity on the part of the
Government, and immediate-
ly the Sioux extended their
depredations to the Pacific
Railroad, on the Platte, while
the Indians south of the Ar-
kansas attempted to drive
the whites out of the Smoky
Hill country.

Last August the Cheyennes
took the war-path, and the
valleys of the Saline and Solo-
mon rivers became the thea-
tre of a relentless savage war.
It was at first supposed that
the Cheyennes were about to
attack a hostile tribe, but soon
the mask was laid aside, and
in less than a month one hun-
dred whites fell victims to
the tomahawk and scalping-
knife. The chiefs of the
Arrapahoes had promised to

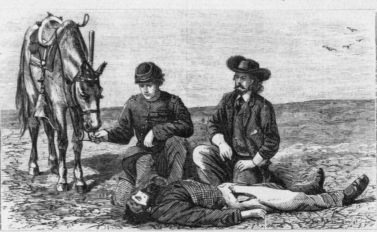

THE SCALPED HUNTER.—[PHOTOGRAPHED BY WM. S. SOULE.]

proceed to Fort Cobb and get
their annuities, and thence
withdraw to their reservation.
Instead of fulfilling their
promises, they began a series
of depredations on the line
between Fort Wallace and
Denver, in Colorado Terri-
tory. The Kiowas and Co-
manches about the same time
entered into an agreement at
Fort Zarah to remain at
peace, and left with that im-
pression fixed on the minds
of those who represented the
Government. The next in-
formation was that the Kio-
was and Comanches had
joined the Cheyennes and
Arrapahoes. General SHERI-
DAN, taking the practical view
of the condition of affairs
within the limits of his de-
partment, at once transferred
his head-quarters to the field,
and commenced preparations
for a determined war. Gen-
eral SULLY's fight near this
point, FORSYTH's gallant
fight on the Arrikaree fork
of the Republican, CARPEN-
TER's and GRAHAM's fight on
the Beaver branch of the
Republican, General CARR's
decisive fight in the same
vicinity, and General CUS-

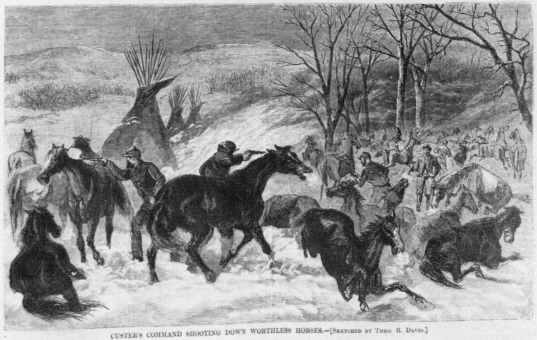

CUSTER'S COMMAND SHOOTING DOWN WORTHLESS HORSES.—[SKETCHED BY THEO. R. DAVIS.]

dore R. Davis, one of the best known illustrator-reporters on the staff at *Harper's*.

Davis had been out West as a correspondent in 1867, spending six months with Custer, it was reported; but he had returned to the East more than a year before Sheridan's "Winter Campaign" in order to cover the Impeachment of Andrew Johnson. When the news of Custer's victory reached New York at the beginning of December 1868, Davis was undoubtedly the most logical one to be assigned the task of inventing appropriate images that would have the flavor of eyewitness sketches. And the printed text that followed did little to dispel the impression of authenticity.

To Davis's credit, he did not try (with the limited means available) to depict the surprise attack itself. Instead, he was content to portray two animated side events—perhaps because they were unusual, but probably because they were also easier to draw. Even though these two secondary scenes involved a degree of barbarity, each was rendered in such a way that it is hard to tell exactly where the artist's sympathies lay. If Davis felt some measure of humanitarian indignation it is difficult to detect. The wood engraving at the bottom of the page shows two or three soldiers in "Custer's Command Shooting Down Worthless Horses," while some of the Cheyenne teepees are burning in the background. This is hardly a heroic moment, and the image gives only a feeble idea of the grim efficiency with which Custer's command eliminated eight hundred and seventy-five Indian ponies that were far from "worthless" to the Cheyenne.

The firelight picture of "Custer's Indian Scouts Celebrating The Victory Over Black Kettle" at the top of the page belongs to the same tradition (in *Harper's Weekly*) as Winslow Homer's version of "A Bivouac Fire on the Potomac" (Plate 79). But compared to the innocent, playful mood that Homer created—and especially compared to the nonthreatening, instructive theatrical performances staged by Bierstadt's Indians in 1864 (Plate 81)—the savage dancers sketched by Davis seem frenzied, even diabolical in the center of such a passive ring of White faces. The published description of this plate is considerably less spirited, although the benevolent background role of the army remains the same:

> The scouts are Osages and Kaws [Kansas]. The celebration took place at night around a large wood-fire, encircled by officers and men who formed a ring comprising hundreds in number—the front rows sitting down or kneeling. The ceremonies were enlived by music from the military bands. Inside the circle, by the Indian drummers, sat Generals Sherman, Custer, Forsyth, and staff-officers. The Indians were highly painted, and adorned with shields, spears, war-bonnets, bows, whistles, and other "toggery."[16]

85. Theodore R. Davis (1840–1894) and William S. Soule (1836–1908), *Scenes from the Indian War*. Wood engravings published in *Harper's Weekly*, XIII, no. 629, January 16, 1869.

Sandwiched in the middle of the same page from *Harper's Weekly* was an image of a completely different order. Although obviously smaller than its neighbors, this still picture has a greater impact, a greater sense of stark visual reality than either of the other two for a very good reason; it was made from a photograph taken by Will Soule. In spite of the process of transformation into a wood engraving, some of the bold and compelling qualities of the original survive, particularly in the strong contrast between the dark, sharply outlined figures in the foreground and the vacant, monotonous landscape behind them. Where the original print had a blank white sky, typical of most photographs of the period, the engraver for *Harper's* supplied a softer gray tonality and a small flock of birds for compositional balance.

The correspondent at Fort Dodge who supplied a copy of Soule's photograph also sent a long description of the image which *Harper's* gladly printed as part of their report on "The Indian War":

> [This] is probably the only picture ever taken on the Plains of the body of a scalped man, photographed from the corpse itself, and within an hour after the deed was done.
>
> The 7th of December Mr. Ralph Morrison, a hunter, was murdered and scalped by the Cheyenne Indians within less than a mile of this post. Mr. William S. Soule, chief clerk in Mr. John E. Tappan's trading establishment, an amateur artist [meaning photographer], availed himself of the opportunity to benefit science and gratify the curiosity of your readers, by taking a counterfeit presentment of the body literally on the spot.
>
> The pose of the remains is delineated exactly as left by the savages, the horrible contortion of the ghastly features, the apertures left by the deadly bullet, the reeking scalp, the wounds, the despoiled pockets of the victim, all are true to life, anomalous as the presentment of death may seem.
>
> It is a satisfaction to know that the Indians suffered severely for their bloody act, two being killed by a percussion-shell from a Parrott gun belonging to the ordnance of Fort Dodge.[17]

From this evidence it is easy to see why the editors decided to run this image of "The Scalped Hunter" despite the fact that it represented a different time and place. Fixed between the savage celebration of a crushing victory, bordering on genocide ("no male prisoners over the age of eight were taken"), and the ruthless slaughter of captured ponies, it was at the focal point of the page, flanked by short columns of type and demanding the reader's attention. In this way, the image of the death of one White hunter became the tangible excuse, the justification, in fact, for the brutal deeds already committed in reprisal raids by the U.S. Army against the Cheyenne.

Fortunately, for those American painters and illustrators who wanted to picture dramatic Indian subjects suitable for family enjoyment and edification, there was a ready alternative to the bloody realities of Indian Wars in the West. For artists and audiences alike, it was invitingly easy to escape from

present actuality into the welcome otherworld of Indian folklore and mythology. In some ways, what *Uncle Tom's Cabin* (1852) had been to the cause of Abolition, Henry Wadsworth Longfellow's poem, *The Song of Hiawatha* (1855), did for the cause of Indian ethnology. The immense popularity of Longfellow's "Indian Edda" inspired national interest in native legends that had to be collected and recorded before the accumulated oral traditions of each tribe died in the snow with the last wise men. These folktales and legends, in turn, were a fertile source for a variety of artists from F. O. C. Darley and Thomas Moran (Plate 86) to Thomas Eakins (Plate 103).

When James Fenimore Cooper began his *Leatherstocking Tales* in the 1820s, he had before him the Reverend Heckewelder's biased missionary account of the *"History, Manners and Customs of the* [Delaware] *Indian Nations Who Once Inhabited Pennsylvania and the Neighboring States"* (1819). In the summer of 1854, however, when Longfellow began to compose *Hiawatha,* he had access not only to books by Heckewelder and George Catlin, but also to Henry Rowe Schoolcraft's *Algic Researches* (1839) among the Ojibwa or Chippewa Indians of northern Michigan. The poet never made a secret of the fact that Hiawatha's epic deeds are based directly on the Algonquian culture hero-myths, gathered by Schoolcraft in the vicinity of Sault

86. Thomas Moran (1837–1926), *The Spirit of the Indian,* 1869. Oil on canvas, 32 x 48½ inches. Philbrook Art Center, Tulsa, Oklahoma.

Ste. Marie and Lake Superior. His contribution—from the study in his house in Cambridge—involved giving the hero, Manabozho, a more mellifluous name and recasting each legendary action or encounter into flowing, but insistent rhythmical form.

The immediate success of *The Song of Hiawatha* in 1855 encouraged Schoolcraft to reissue his *Algic Researches* in 1856 as an expanded edition with a new and more saleable title, *The Myth of Hiawatha, and Other Oral Legends, Mythologic and Allegoric, of the North American Indians.* In dedicating this volume to Professor Longfellow, Schoolcraft expressed his gratitude and admiration for the other man's accomplishment. But underlying the following words is the fervent hope that the superficial Indian stereotypes in the popular mind—the fiendish savage, ever thirsty for the blood of White men, the noble Red man, stoically enduring cold, famine, and even death without a word, and the drunken half-breed, left to beg in city streets—would be compelled to change when confronted with a deeper knowledge of Indian character, customs, opinions, and theories. Schoolcraft's dedication to Longfellow reads as follows:

> Sir:
>
> Permit me to dedicate to you, this volume of Indian myths and legends, derived from the story-telling circle of the native wigwams. That they indicate the possession, by the Vesperic tribes, of mental resources of a very characteristic kind—furnishing, in fact, a new point from which to judge the race, and to excite intellectual sympathies, you have most felicitously shown in your poem of Hiawatha. Not only so, but you have demonstrated, by this pleasing series of pictures of Indian life, sentiment, and invention, that the theme of the native lore reveals one of the true sources of our literary independence. Greece and Rome, England and Italy, have so long furnished, if they have not exhausted, the field of poetic culture, that it is, at least, refreshing to find both in theme and metre, something new."

The newness, the "American-ness" of *The Song of Hiawatha* obviously appealed to the landscape painter, Thomas Moran, in Philadelphia. In the summer of 1860, he traveled with a friend all the way to Lake Superior to sketch the Pictured Rocks and other scenes made famous by the poem, but the following year he went to London to study the work of Claude Lorrain and J. M. W. Turner. Moran was especially impressed with Turner's Romantic landscape visions; he even took the trouble to make oil copies of the English artist's *Crossing the Brook* and *Ulysses Deriding Polyphemus,* which later hung in his own studio.

After the Civil War and after a second study-trip abroad, Moran turned to American Indian subjects again for inspiration. His painting of *The Last Arrow* in 1868 was loosely based on the story of a Mohawk chief betrayed by a Dutch trader. In 1869, he chose the most sublime and melodramatic moment in Hiawatha's adventures as the subject of a more successful picture, *The Spirit of the Indian* (Plate 86). The scene is from Canto IX, "Hiawatha and the

Pearl-Feather." Egged on by his grandmother, Nokomis, Hiawatha has set
forth in his magic canoe in search of Pearl-Feather, also known as Megis-
sogwon, the Magician, the great manito or evil spirit of wealth and wampum,
pestilence and death. To reach his well-guarded enemy Hiawatha had to
defeat the fiery serpents and survive the pitch black water. At the moment
selected by the painter, the tiny figure of Hiawatha has just landed dry-shod
on the shore in the middleground. He raises his bow of ash-tree and hurls a
challenge to the evil presence looming above the lower hills in the distance:
"Come forth from your lodge, Pearl-Feather! / Hiawatha waits your com-
ing!"[18] It goes without saying that a titanic struggle ensued ("All a Summer's
day it lasted") and that Hiawatha won by nightfall at the end of the canto,
but in Moran's painting the issue is still in doubt. The hero seems small and
friendless in a forbidding, snake-infested land.

There is an interesting parallel between Moran's work and Longfellow's
creation that should be examined. In praising *The Song of Hiawatha,*
Schoolcraft was wrong about the newness of both theme and meter. To the
contrary, it has long been known that Longfellow borrowed important folk-
epic effects—namely, the use of repeated phrases and the simple drumlike
rhythm (trochaic tetrameter)—from a German translation of the Finnish
Kalevala. The novelty of *Hiawatha,* with its "pleasing series of pictures of
Indian life, sentiment, and invention," lay in its purely American content, not
in its form of versification.

Much the same thing can be said of *The Spirit of the Indian.* The subject
is a thrilling episode from native mythology, but the form is no more than a
minor variation on the deeply colored Romanticism of Turner's *Ulysses De-
riding Polyphemus* in the National Gallery, London, a large oil which also
shows a giant, vaporous, malevolent spirit on a cliff in the background. Moran
was obviously putting new wine in an old bottle, but then again a more realistic
style, like the one Bierstadt employed for his Rocky Mountain scenes (Plate
80), could hardly have evoked the same pervasive mood of poetic fantasy, re-
creating a mythical time and place at the dawn of Indian civilization.

Only five years later, another Philadelphia artist, Thomas Eakins, tried his
hand at illustrating a scene from *The Song of Hiawatha* (Plate 103). The fact
that the younger man chose a much calmer subject—the quiet moment after
Hiawatha's victory in wrestling over Mondamin, the Corn-Spirit—points to a
marked change in artistic generations; this change will be a significant issue in
the following chapter.

6

From the Centennial to the Turn of the Century

To THE MINDS of many Americans in the 1870s, the one hundredth anniversary of national independence from England loomed as a major landmark, offering final proof of the country's coming of age. There were pessimistic voices and counterindications, of course, but the underlying and irrepressible American faith in future growth and greatness could never be more than partially eclipsed by setbacks in the Reconstruction of the South, the continuing Indian Wars beyond the Mississippi and the Missouri, or the political scandals of Tammany Hall and President Grant's two graft-ridden administrations.

For individual American artists and photographers as well as their professional organizations, the coming Centennial Exhibition in Philadelphia acted as a source of inspiration, calling for their best efforts "commensurate with the occasion." The patriotic call, issued by more than one art organization, was not for a new, revolutionary style—on the contrary, even the most ardent cultural isolationists of the time would have been forced to admit that the United States could never claim stylistic innovation as its major contribution to the international world of fine and applied arts in the nineteenth century. Instead, it was an intensified call for authentic American subjects, treated with national pride, dignity, and respect for the past. Each subject was to be executed in the artist's finest manner so that its visual message would be immediately comprehensible to all—a democratic ideal that also helped in selling works of art to an untutored public.

Moreover, since public comprehension remained a highly desirable quality in American art even after 1900, it is hardly surprising that enormously popular themes, showing Blacks and Indians, continued to be painted in a "Romantic-realist" manner through the last quarter of the nineteenth century. The poetic sunset in the sketch of *Hiawatha* by Thomas Eakins (Plate 103) and the turbulent, shark-infested waters of Winslow Homer's *Gulf Stream* (Plate 119) demonstrate that even the finest American "realists" of the period were not immune to Romantic impulses. In general terms, though, painted

images of Indians tended toward the Romantic extreme, while Black men, women, and children were being portrayed with growing sympathy and realism.

It should also be remembered that the French Impressionist painters held their first group exhibition in 1874, introducing their avant-garde style to an initially reluctant, even hostile Parisian audience. At much the same moment in the United States, the artists who were painting cotton fields (Plate 91) and buffalo hunts (Plate 101) did nothing to challenge public expectations about art. In none of the works discussed below is a key figure or telling detail ever sacrificed in favor of some transient optical effect of light or atmosphere. Content was obviously more important than treatment in American image-making.

Perhaps the clearest manifestation of American nationalism in the mid-1870s can be found in the beautifully engraved stock certificate that was issued to share-holders in the Centennial Corporation (Plate 87). The primary aspects of the iconography on this plate were probably worked out by a committee or subcommittee of the Centennial Board of Finance; but then the project was given over to two Philadelphia artists, Felix O. C. Darley, the famous illustrator, and Stephen J. Ferris. Their task was to put the basic ideas into a visual form that would be easily understood by the general public and especially by potential investors. In the process of exploring this souvenir certificate, one soon discovers that several types of Indians, an African woman, and a free Black man are part of the supporting cast, gathered here in the equivalent of a *tableau vivant* to honor the march of American Progress.

Along the left edge of the certificate there is a knot of stylized figures meant to typify the South, the Great Plains, the Rockies, and California. A Southern planter, holding up a boll of cotton, is talking to a successful wheat farmer, while in front of them a forty-niner, offering a chunk of gold, and a rugged mountain man, covered in furs, look intently towards the representation of White America. Meanwhile, closer to the viewer, there is an extra figure—an Indian brave who angrily turns in the opposite direction in retreat and disgust.

Equally alone and unheeded, but obviously higher on the American social scale of the 1870s is the Black freedman near the right-hand margin. Like his Indian counterpart, he too must have been considered indispensable for a full iconographic picture of American civilization. Placed just above the Yankee mechanic and the Continental and Union soldiers, who are self-explanatory, this former slave is earnestly reading a book to better himself. Wisely, he is well separated from the Simon Legree—Southern planter-type on the other side. His new status and his present occupation reflect the benefits of Reconstruction for his race.

At the same time, though, this Black figure educates himself in isolation, without the aid of anyone. In this connection it is interesting to compare this detail of the Centennial Certificate with Hammatt Billings's image of Little

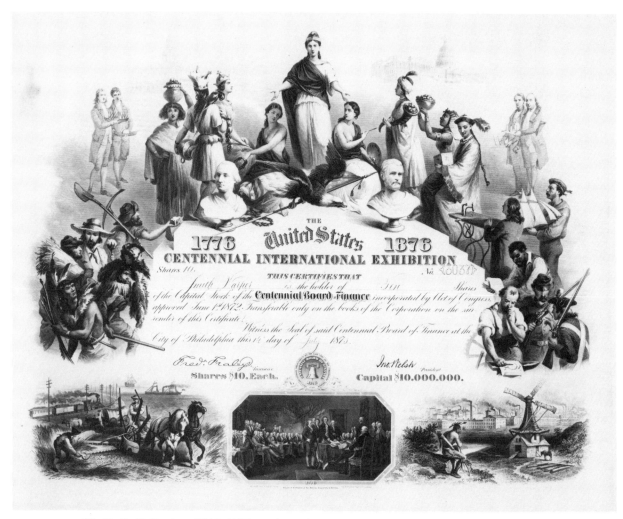

87. F. O. C. Darley (1811–1888) and Stephen J. Ferris (1835–1881), *Centennial Stock Certificate,* c. 1874–1875. Engraving, 18½ x 22½ inches. Private Collection, Pennsylvania.

Personifications of Fame (with a laurel wreath to bestow) and Art (with palette and brushes ready), portrait busts of Washington (1776) and Grant (1876), and a bald eagle carrying the flag of the United States in its talons are grouped at the feet of the white-skinned goddess of America, wearing a Liberty cap, at the apex of the central pyramid above the lettering.

On the steps to either side of *America* are personifications of foreign lands, bringing tribute for the occasion. To the left is Europe, followed by two Indian maidens representing Central and South America. On the opposite side the corresponding figures are India, a dark-skinned woman symbolizing Nubia or Ethiopia and hence all of Africa, and a Chinese girl with a box of tea as the Far East. Several American inventors also approach the central figure, offering their machines for the betterment of the entire nation.

Eva and Uncle Tom in the arbor (Plate 70). The differences between these two works obviously reflect the major change in social status for Blacks in America over the last quarter of a century; but underlying the image of 1875–1876, there is the feeling that Emancipation has also brought with it a new isolation or segregation of the races.

For a graphic demonstration of the Amercian popular belief in the absolute inevitability of industrial and territorial expansion across the continent, one has only to glance at the small imaginary landscapes in the lower corners of the Centennial Certificate. According to a contemporary description, "to the left of the base is represented *civilization,* combining the railroad, telegraph, steamship, and reaping-machine, in contrast with the Conestoga wagon, mail rider, sailing vessel, and laborer with a sickle."[1]

In the right-hand corner is a restatement of the same theme, which seems more emphatic and more poetic at the same time. The scene was described in 1876 as simply a "busy manufacturing city in contrast with the neglected windmill,"[2] but the artists intended to communicate more than this. Sitting on a felled tree-trunk in the foreground is a North American Indian who strikes a familar pose. With one hand raised to cover his face in a gesture of profound despair, this figure, although a distant cousin of Dürer's *Melancholia,* is more directly descended from Thomas Crawford's marble statue of *The Dying Indian Chief* (Plate 89).

Crawford's rather Romantic, pre-Civil War conception was readily available to illustrator-artists like Darley and Ferris. After all, his visualization of

88. Thomas Crawford (1813?–1857), *The Progress of Civilization,* 1854–1856. Marble, 8′ high by 60′ long. Pediment, East Front, Senate Wing, United States Capitol, Washington, D.C. Courtesy Architect of the Capitol.

this same noble savage, contemplating *The Progress of Civilization* (and the inexorable extinction of the Indian race), was installed as part of a series of symbolic figures and emblems in the east pediment of the Senate Wing of the U.S. Capitol Building in Washington, D.C. (Plate 88).*The Dying Indian Chief* is simply a replica of the one unclothed figure the sculptor liked so well that he produced a copy of it for separate exhibition. Looking closely at this statue, which is signed and dated "Rome 1856," anyone can see that Crawford's Indian chief is little more than a muscular, white-skinned artist's model—with Indian trappings to enhance his neoclassical nudity.

Like Crawford, the designers of the Centennial Certificate had no intention of depicting a specific warrior with specific tribal markings. What they wanted (and what they borrowed) for their generalized Indian hunter was the instant emotional effect of the despondent pose. To begin with, therefore, the viewer of the 1870s was being invited by Darley and Ferris to identify with the noble savage as he weeps for his former hunting grounds, the first seized by colonists who cleared the forest and built the windmill and now overrun by the more numerous and more industrialized Americans of the nineteenth century, who are covering the land with their homes and factories. In the actual context of investing money in the Centennial, however, such a Romantic identification could be but a momentary indulgence in an elegiac sense of loss. The certificate owner was also expected to accept the hard economic realities of the situation and in the end to look with pride on those distant chimneys belching black smoke and soot into the atmosphere, for they were a sure sign of expanding national prosperity.

89. Thomas Crawford (1813?–1857), *The Dying Indian Chief*, 1856. Marble, 55 inches high. Courtesy of The New-York Historical Society, New York.

The Dying Indian Chief (Plate 89) or any of his thematic descendants can be compared with one of the most popular pieces of sculpture exhibited in the Centennial Art Gallery, *The Freed Slave* (Plate 90). The differences between these figures provide another indication of the remarkable changes in racial attitudes between the time of General Washington and the era of General Grant. Several American-born sculptors, including Edmonia Lewis (who had an Indian mother and a Negro father), created single figures or figure groups to symbolize the end of slavery for the Negro race, but in Philadelphia in 1876 the most impressive crowds "gathered daily in admiration" of *The Freed Slave* by an otherwise unknown Austrian, named Pezzicar, who recognized the great dramatic potential of this borrowed American subject.

"The negro exultantly displays Abraham Lincoln's Proclamation of Emancipation, and his chains lie broken at his feet,"[3] wrote one art reviewer at the Centennial, describing this life-size bronze—and bronze was certainly the most appropriate material in terms of color for this figure, which was No. 163 in the Austrian section. Some critics tended to criticize the statue for being anatomically incorrect since "the upper portion of the chest protrudes too much," but others were willing to accept this abnormality:

> As the slave is in this instance, supposed to be the highest embodiment of the feelings of all other slaves, it was necessary to express this by intensifying the effect. Viewed in this light, the height of the chest, although not strictly in accordance with anatomical truth, is justified in an artistic sense.[4]

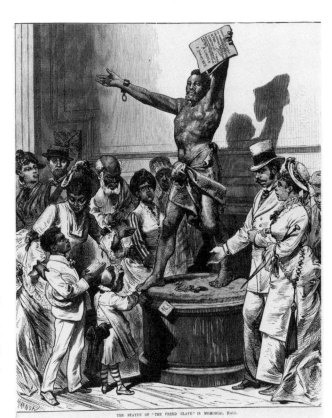

90. Pezzicar, F. (Austrian sculptor), *The Abolition of Slavery in the United States* (The Freed Slave). Wood engraving published in *Frank Leslie's Historical Register of the Centennial Exposition,* New York, 1876.

THE STATUE OF "THE FREED SLAVE" IN MEMORIAL HALL.

Where Red Jacket, the Seneca chief, advanced confidently to be greeted by Washington in 1792 (Plate 36), Crawford's image of an Indian chief sinks into a catatonic state of inactivity and despair over the eventual extinction of his people. Conversely, where the Black servant, Billy Lee, stood by silently, waiting for his master's orders in the Washington family portrait of 1798 (Plate 38), *The Freed Slave* bursts from his chains with a sense of righteous, swelling manhood that was meant to be inspirational.

For their part, when the editors of *Frank Leslie's Historical Register of the Centennial Exposition* decided to run a large wood engraving of "The Statue of 'The Freed Slave' in Memorial Hall," they made it into a past-and-present image with didactic overtones. Pezzicar's proud, but penniless former slave, holding up the Emancipation Proclamation of January 1, 1863, is pictured as a source of general fascination for the admiring crowd which is entirely Black. Except for the older man and woman with their heads solemnly bowed in the background, these urban art gallery visitors are comparatively well-to-do. In the thirteen years elapsed since 1863 their place in society has obviously risen to a middle-class respectability, and the institution of slavery belonged to a past distant enough that the beautiful young mother on the left in the wood engraving has to explain the historical meaning of the sculpture to her small son.

From the time of the Civil War, during which he began to paint in oils in addition to drawing illustrations, Winslow Homer was praised for being "very skillful in the delineation of Negro characteristics."[5] Contrabands, serving as cooks, teamsters, and assorted camp followers, mostly humorous in intent, peopled many of his graphic images and several of his initial paintings of the Union side of the war. In the early 1870s, however, after a trip to France, Homer stuck to rural or coastal New England scenes, far from any hint of controversial subject matter. Then, suddenly, just before the Centennial, he made a summer trip as far south as Petersburg, Virginia, where he sketched and painted watercolors in the Black section of town.

The American critic, George W. Sheldon, heartily approved of the canvases that resulted from this artistic journey in the midst of Reconstruction. In a review of 1878 he made special mention of the *Cotton Pickers* (Plate 91), one of Homer's latest productions, showing "two stalwart Negro women in a cotton-field."[6] This painting and other works in the same vein (see Plate 97) so appealed to Sheldon that he could not resist the use of a few superlatives to describe the artist's achievement:

> His Negro studies, recently brought from Virginia, are in several respects—in their total freedom from conventionalism and mannerism, in their strong look of life, and in their sensitive feeling for character—the most successful things of the kind that this country has yet produced.[7]

When viewed from a more international standpoint than Sheldon allowed himself, the picture of the *Cotton Pickers* does not appear to be so totally free

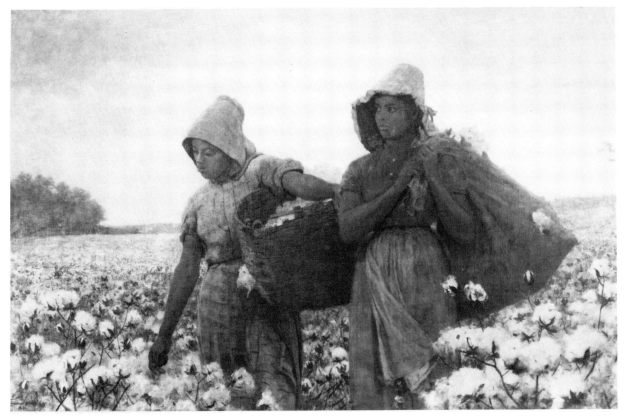

91. Winslow Homer (1836–1910), *Cotton Pickers*, 1876. Oil on canvas, 24 x 38 inches. Private Collection.

of "conventionalism." To the contrary, it should be thought of as an American adaptation of the French provincial peasant tradition that was such a dominant, influential theme in the second half of the nineteenth century. Homer's "stalwart Negro women"—because of their monumentality in relation to the edges of the canvas, because of their noble and attractive bearing under the burdens of rural existence, and because of the socially and pictorially interesting qualities of their costumes and their occupation, particular to the specific geographical area selected by the artist—belong in a picture-concept category established by Jean-François Millet's paintings of semi-idealized peasants in the fields near Barbizon and continued with the more academic treatment of folkways and religious customs in Brittany by artists as popular as Jules Breton.

But even if this general image-type was French in origin, Homer refitted it well to carry strictly American cargo. For example, just how strongly he captured the "look of life" as he encountered it in Virginia in 1875 one can judge by placing his oil next to a stereo view of a *Cotton Field* (Plate 92) by J. A. Palmer that may date from as early as 1875–1880. On the back of the cardboard mount for this view (the usual place for advertisements), Palmer took the liberty of informing the public that in his studio there was available "a large stock of Views of Negro Groups, Cabins, Teams, Cotton Fields and Plants, etc., kept constantly on hand. Also Florida, Georgia, and South Carolina Views."[8]

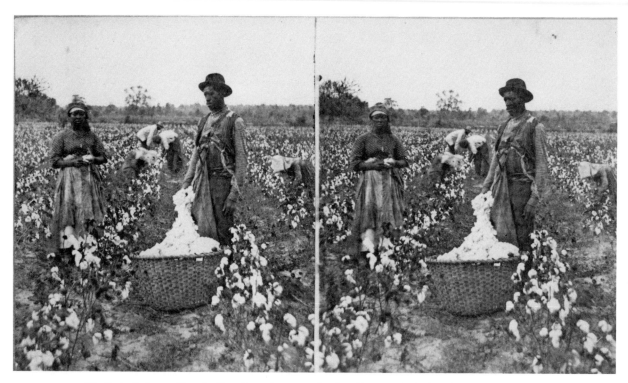

92. J. A. Palmer (South Carolina photographer), *Characteristic Southern Scenes: No. 171. Cotton Field,* c. 1870s. Stereograph. Courtesy of The New-York Historical Society, New York.

What these two images in different media seem to share is a common concern for "characteristics," for the basic visual elements that would define a Southern cotton field as a uniquely American landscape. These fundamentals obviously included the sea of cotton plants, somewhat out of focus in the very foreground, but flowing all the way back to the distant tree line which marks the far end of the field; the sacks and baskets used to collect the cotton; and the Black hired hands or sharecroppers who do the actual labor, clothed in tattered overalls or dresses and rough aprons with some kind of bonnet or hat as a picturesque, yet necessary protection against the midday sun.

For the photographer, exploring a Carolina plantation in search of additional "Views of Negro Groups" to increase or replenish his supply, the key to successful picture-making depended on two ingredients: first, selecting and composing a few workers in such a way as to illustrate a specific task as clearly as possible and, secondly, aiming his camera down the long rows of cotton (with figures at different distances from the lens) so that the three-dimensional separation, visible when the double-print was inserted in a stereopticon viewer, would be that much more effective. For Winslow Homer, on the other hand, working on the *Cotton Pickers* in his New York studio, no orthogonal plunge into depth could be allowed to divert attention from the two-dimensional design established by the foreground figures.

In making a serious picture, free of the "mannerism" that usually descended into racial caricature and cheap humor, Homer had an advantage over the photographer. By lowering the viewpoint and boldly cropping off along the lower edge of the canvas, he was able to draw the viewer closer to

the protagonists. As a result, these two young women, lost in private thought, loom above the endless cotton with a degree of added poetry and physical presence that J. A. Palmer's camera could not supply. The intrinsic nobility of these painted figures is all the more remarkable when compared to the stereotypes that Homer himself perpetuated during the Civil War (see Plate 79).

The ready public market for realistic images of Negro life in the South at the time of the Centennial and after, was paralleled by the national demand for the latest news in words or pictures from the West, especially after Custer's sudden defeat at the Little Bighorn (June 25, 1876), six weeks after the opening of the Centennial Exhibition in Philadelphia. Heightened interest in the progress of the war against the Sioux led *Frank Leslie's Popular Monthly* to publish a long lead-article, reviewing the entire situation, in its September issue for 1876. The title of this unsigned essay was a question, "What Shall We Do With Our Indians?" The use of this rhetorical device may seem prematurely paternalistic, since Sitting Bull and Crazy Horse had not surrendered or fled to Canada as yet, but their fate was certain. In charge of the army campaign was General George Crook who was reported to have "no other idea on the question of how to civilize the Indian than doing it at the point of a bayonet."[8]

To catch the reader's attention, an arresting image was placed just below the title-question on the cover of the magazine (Plate 93). It was a wood engraving of *A Group of Prominent Sioux Chiefs* that must have been executed from one of the dozens of formal portrait photographs that were taken of the numerous Indian delegations that visited Washington, D.C., in the later part of the century. Compared to the C. M. Bell portrait of the *Spotted Tail Delegation,* taken just four years later (Plate 94), the image used by *Frank Leslie's Popular Monthly* seems considerably less patronizing. There are no white flags of truce (or surrender), and there is no White Indian agent (and his half-breed assistant) standing in the background like the controlling intelligence or coach of the team.

The historical as well as anthropological value of this type of illustration is a fitting prelude to one side of the essay that follows. In his attitudes towards the Indians in general, the eastern author of this article seems to waiver between hatred and respect, disgust and despair on their behalf. His opening comments are tinged with a familiar Romantic melancholy ("some future romance will make a pathetic story of the last members of their tribes...."), but this quickly turns into a materialistic accounting of the terrible price the White man has had to pay:

> While we have multiplied and prospered, they have steadily diminished in numbers; but their savage instincts and habits have remained unchanged, and as we have grown mightily in power, adding constantly to our means of aggressive warfare, we have found ourselves confronted with a savage foe, whose ability to inflict injury upon us seems to have increased as he has diminished in numbers and been restricted in territory. To cope with the

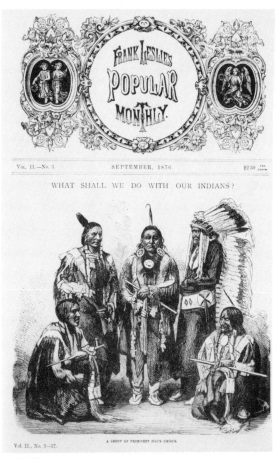

93. Anonymous (American wood engraver), *A Group of Prominent Sioux Chiefs*. Wood engraving, 10½ x 7½ inches. Published in *Frank Leslie's Popular Monthly*, II, no. 3, September 1876.

94. C. M. Bell (American photographer), *Spotted Tail Delegation*, 1880. Photograph. National Anthropological Archives, Smithsonian Institution, Washington, D.C.

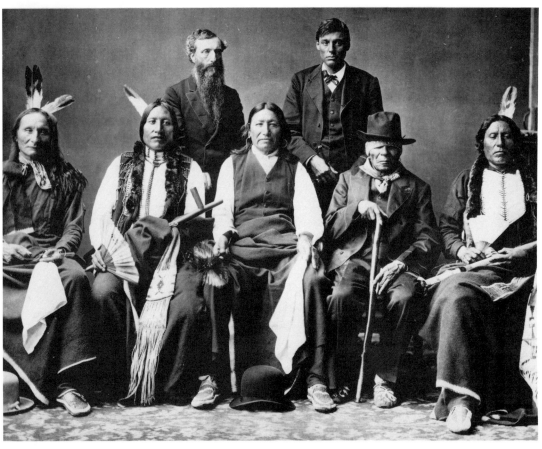

savages now appears to be more difficult than it was in the time of that sturdy fighter, King Philip, of Mount Hope, and our Indian Wars are now vastly more costly than they ever were before, and more disastrous in the sacrifice of our men. Certainly no such disaster ever before befell our army as the slaughter of the gallant Custer and his entire command by the Sioux.

We have been constantly engaged in reducing the Indians, in appropriating their hunting grounds, in compelling them to retire within the reservations assigned to them, and in making treaties with them. But, though so much nearer to extermination than ever before, they are not in the least degree less warlike or less troublesome.[9]

The article goes on to point out the folly of the treaty system, since most of the Indian treaties in living memory were negotiated by force and then quickly broken by the government itself, if not by "irresponsible adventurers" who were eager to possess the mineral wealth that would otherwise go to waste on Indian lands. The only solution, according to this writer, was the end of all reservations, since they stood in the way of progress, and the immediate abolishment of the Indian Agency, since it only served to foster the idle and barbarous ways of a dying culture. Supporting a separate nation of idle paupers ("war paint and feathers are altogether incompatible with industrious habits") was an expensive charity that the United States could not afford. Apparently many Americans agreed that the practice of giving out blankets had to be stopped in favor of providing more suitable and civilized working clothes (compare the costumes in Plates 93 and 94):

> The negro is imitative in his disposition, and is happy to dress like a white man, but the Indian is not at all imitative as to our social habits, and we have been guilty of the supreme folly of encouraging him in his savage ways, by giving him blankets to wear instead of supplying him with shirts, coats, and trousers.[10]

While counseling the rapid integration of the remaining "savages" into the mainstream of American life, the essayist for *Frank Leslie's Popular Monthly* had to end with a somber editorial note. Although he saw the enormous need for a careful study of the effects of cultural interaction, he also realized that it was already far too late in the case of the Indian:

> There has never been a finer opportunity offered any people for studying practically, on a large scale, the problem of race amelioration or improvement, than we have enjoyed in having under our entire control and subjugation the Indian races which we found here in their tribal organizations, and the African race, which we brought here and employed as slaves. But we have missed our opportunities; and, though the Indian is rapidly disappearing under our treatment, we have five or six millions of Africans left to experiment upon, and a hundred thousand or more of Chinamen.[11]

The next eight plates represent two significant pictorial themes that lasted from the beginning to the end of the nineteenth century; one is quiet, even contemplative—the calm just before or after the storm—while the other is as wild and thrilling as the artists could make it. Here again we are witnessing the process of steady transformation as Romantic themes, inherited from an earlier generation, are noticeably altered as they become more or less, but not entirely, realistic.

The first sequence of four pictures (Plates 95–98) involves the theme of confrontation. In the literature on Winslow Homer it is often shown that his painting of *The Visit from the Old Mistress* (Plate 97), another one of his Virginia subjects dated 1876, depends on his earlier work, *Prisoners from the Front,* of 1866 (Plate 96). What has all too often been overlooked, however, is the essential fact that Homer borrowed a well-established compositional formula for these confrontation pictures. And the formula itself carried a basic meaning, regardless of the local details superimposed upon it.

In its original context, this compositional schema was military in character. *The Capitulation of Madrid* by Baron Gros (Plate 95) offers a prototypical example; reading naturally from left to right, the viewer can comprehend the subject matter without any trouble. In the distant background on the left is the captured city of Madrid in the hands of Napoleon's troops; the center foreground is taken up by a defeated-looking contingent of Madrid's civil and religious leaders, kneeling and bowing before their conqueror; and on the right, just emerging from his tent under adequate guard, stands Napoleon. With an air of "noblesse oblige" to his stance and gesture, he calmly accepts the surrender of the Spanish city and the end of all resistance.

In *Prisoners from the Front* (Plate 96), having dispensed with the neo-Baroque trappings that clutter the stage in Baron Gros's painting, Homer nevertheless retained the meaningful core. Again positioned just to the left of center are the men who have surrendered. As the setting is American, these resisters are naturally Confederate soldiers, who refuse to bow and scrape before any man, let alone a Yankee. The young boy on the left may seem uncertain, while the older man in the center, holding his hat, looks worried about his fate, but the mature Rebel soldier in the prime of life on the right stares across the gulf between himself and the Union officer with an open, cocky, hand-on-hip defiance that made this canvas an instant success as an expression of the unbridgeable differences between North and South at the end of the Civil War.

The parallel structure in *The Visit from the Old Mistress* is unmistakable, even though the story-telling details have become civilian, indoor, and feminine. There is no soldier standing by to protect this White woman as she visits her former slaves in their own quarters, but the gulf that separates the central group and this single figure on the right is just as eloquent. If *Prisoners from the Front,* which Homer sent to the Paris Exposition in 1867, was a summation of one national experience, then *The Visit from the Old Mistress,* which he sent to Paris for the international exhibition of 1878, can be taken as a perfect sequel. In the standoff between the two main figures, in the contrast of skin-coloring and the quality of their clothes, Homer managed to suggest some of

95. Baron Antoine-Jean Gros (1771–1835), *The Capitulation of Madrid, December 4th, 1808,* Salon of 1810. Oil on canvas, 3.61 x 5 meters. Musée du Château de Versailles, France.

96. Winslow Homer (1836–1910), *Prisoners from the Front,* 1866. Oil on canvas, 24 x 38 inches. The Metropolitan Museum of Art, New York, Gift of Mrs. Frank B. Porter, 1922.

97. Winslow Homer (1836–1910), *The Visit from the Old Mistress*, 1876. Oil on canvas, 18½ x 24½ inches. National Collection of Fine Arts, Smithsonian Institution, Washington D.C., Evans Collection.

98. George de Forest Brush (1855–1941), *Before the Battle*, 1884. Reproduced as Plate 30 in M. G. Van Rensselaer, *Book of American Figure Painters*, Philadelphia, 1886. The Metropolitan Museum of Art, New York, Rogers Fund, 1907.

the major tensions and uncertainties of the Reconstruction era. Compared to the anecdotal approach that made Eastman Johnson's *Old Kentucky Home* (Plate 71) so perennially popular, even as late as 1876 when it was shown at the Centennial, the slave-quarter confrontation in Homer's painting seems to emphasize the somber fact of the separateness of America's Black population after the Civil War—thus repeating a theme that was also suggested in the Centennial Stock Certificate.

A painting by George de Forest Brush, called *Before The Battle* (Plate 98), relates this same compositional motif to the American Indian, but the visual result seems far removed from reality. In place of Homer's concern with the real-life issues of racial interaction in contemporary society, Brush created a highly stylized image where the elegantly-drawn figures are isolated against the desolate vastness of an imaginary landscape. The confrontation here is between generations; instead of racing off to battle their enemies, a band of young Indian warriors has gathered to listen patiently to the sage advice of an ancient medicine man who stands before them on the right.

The following four images (Plates 99–102), presenting another series of variations on a basic compositional idea, also reveal the significant extent to which *action* themes, involving lurking, skulking, or attacking Indians, were a consistently popular form of escapist entertainment during most of the nineteenth century. For this branch of American painting—in which Frederic Remington and Charles M. Russell would later excel—adherence to observed reality was never a necessary condition for success. Paintings of Blacks in urban or rural settings after the Civil War tended to be quieter, more realistic images, but the professional artists who chose to illustrate the most dramatic Indian subjects were always willing to sacrifice literal truth for emotional, story-telling effects.

The basic story in the next four plates is a literal cliffhanger, with the final outcome still in doubt. The heavy dramatic action in each case involves desperate flight and heated pursuit, ending at the edge of a precipice with a death-defying leap into the unknown or a cataclysmic fall into the abyss. Romantic precedents from lovers' leaps to the tale of Marcus Curtius were popular in European art at the beginning of the century, but in the United States this theme invariably involved Redskins in one or both of the leading roles.

Charles Deas painted *The Death Struggle* (Plate 99) in the mid-1840s when his headquarters were in St. Louis, rather than New York. Part of each year, dressed not as an eastern artist, but as a mountain man, he traveled to various army outposts along the frontier, recording "the history and scenery of a most interesting portion of the continent"[12] and sketching Sioux and Shawnee portraits from life. If his works in the field were generally realistic, like George Catlin's, Deas found it easy to switch into another mode when he returned to his studio. *The Death Struggle* is a prime example of the work of a fevered imagination, creating images in solitude, away from any external need or desire to be factual or realistic. There is no evidence that Deas ever ventured as

99. Charles Deas (1818–1867), *The Death Struggle,* 1847. Oil on canvas, 30 x 25 inches. Shelburne Museum Inc., Shelburne, Vermont.

100. Theodore R. Davis (1840–1894), *The Pursuit,* 1867. Crayon and chalk drawing, 14⅛ x 21 inches. Photo: Courtesy of Schweitzer Gallery, New York City.

101. Henry H. Cross (1837–1918), *Tables Turned,* 1879. Oil on canvas, 71 x 108 inches Photo: Courtesy of Danenberg Galleries, Inc., New York City

102. George DeForest Brush (1855–1941), *The Escape,* 1882. Oil on canvas, 15½ x 19½ inches. Philadelphia Museum of Art, Pennsylvania, The Alex Simpson, Jr Collection

far as the Rockies or that he ever witnessed such a violent confrontation, so we are left to conclude that he invented this scene for the pleasure of its terrifying impact. What eastern audience of the day would not be moved by the fate of this wild-eyed mountain man in the satanic clutches of his Indian attacker? The two men and their frightened horses are suspended over the chasm for our emotional enjoyment, forever caught in a tragic deadlock over trapping rights in Indian territory.

In a surprising signed and dated drawing of *The Pursuit* by T. R. Davis (Plate 100), any connection with reality in the western territories is even more remote. This drawing is doubly remarkable because Davis, as a staff illustrator for *Harper's Weekly,* had been out West as recently as the spring of 1867, but this carefully finished drawing was not based on any harrowing personal experience at the hands of the Plains Indians. Instead, it was actually a copy after a foreign lithograph, one of several American Indian subjects said to be drawn by the Swiss artist, Karl Bodmer, who had been to North America in the 1830s, but in fact the work of his young friend, Jean-François Millet, who lived in the village of Barbizon. In this light one may be able to see a strong touch of Millet's fanciful ideas of American savages in Davis's supposedly factual illustration of Custer's Osage scouts celebrating the victory over Black Kettle (compare Plates 85 and 100).

In *Tables Turned* by Henry H. Cross (Plate 101), the edge of a foreground precipice is again one of the major factors in a spirited composition, but this painting also conveys a sense of exploitation. The Indian theme is again being used by an eastern artist for his own purposes, and these purposes are far removed from the factual recording of reality. Where George Catlin tended to overload some of his buffalo-hunting scenes with too many details (see Plate 63), Cross has simplified this subject to the point of epic confrontation between man and animal; the wounded buffalo has turned on his assailant, knocking startled horse and rider over the brink of a cliff. It is true that Cross studied with Rosa Bonheur, the famous animal-painter in Paris, during the 1850s, but the hard-edged stiffness of the forms in this painting of 1879 tells us more about his job of the previous decade painting circus wagons for P. T. Barnum. The subject of *Tables Turned,* as a whole, rings with a circus-like theatricality—with no attempt to reach any deeper insights.

Later in his career, George de Forest Brush became known as a highly fashionable, highly Italianate "painter of motherhood and childhood,"[13] but at the outset of his career in the 1880s he concentrated on Indian subjects with evocative titles, such as *Silence Broken, Before the Battle, The Indian and the Lily, Mourning her Brave,* and *The Escape* (Plate 102). Neither the semiabstract Japanese quality of these images nor the poetic nature of their titles would come as a surprise in themselves, were it not for the fact that Brush had actually been out West before beginning to paint his own versions of these popular themes.

After returning from six years at the *École des Beaux-Arts* in Paris, Brush accompanied his brother Alfred to the Wyoming Territory early in 1881. At Fort Washakie he learned about Indian customs at first hand in the nearby

Shoshone and Arapaho camps under the Army's protection. He even attended a Spring Sun-Dance Festival which impressed him deeply. That the federal government should try to forbid this religious ceremony, because it tended to "over-excite" the young braves, making them prone to thoughts of war, struck him as an act of "ignorance and rudeness," but he did nothing on his own to change this policy. He spent the ensuing winter on the Crow reservation near Billings, Montana—an experience he later described as "wonderful."

All of Brush's Indian pictures, well known in their own time, were executed after 1882, that is, after his return to the East. As studio works they are far removed from the specific ethnographic facts that inspired serious artist-explorers from Catlin to Bierstadt. *The Escape,* for example, may seem refreshingly bold in its asymmetry and in the isolation of the main figure, but it belongs just the same to a long-standing tradition of pursuit and escape so thoroughly enjoyed by White audiences. In Brush's painting, the victor's call and gesture of defiance, raising aloft the trophy-scalp, has additional overtones of individual freedom and bravery for every eastern viewer daring enough to identify with this "savage" hero. Such an identification is made that much easier by the fact that the contest of courage is between tribes and not between races. What Brush was trying to express in these deliberately nonrealistic Indian subjects was summarized fairly well in a review of 1908:

> [He] took his youthful enthusiasms and fresh training out to the frontier and painted a series of small-sized, great Indian pictures, which remain an important record of the humanity of that type of vanishing being in whom men of our time have faced men of the stone age eye to eye. Here was a painter desirous to interpret the inner life and aspiration of that undeveloped brother, not his warfare, nor his picturesqueness, and painting well what he clearly saw. It was doubly an interesting thing to do for his country, while we were still in our century of dishonor toward the Indian.[14]

In the early work of Thomas Eakins, who had never been west of Pennsylvania in the 1870s, one can discover further evidence of a growing dichotomy between the rather Romantic treatment of Indian subjects and the increasingly realistic images of Black men. The two sides of Eakins' artistic personality are also revealed in a comparison of his oil study (for a lost watercolor) of *Hiawatha* (Plate 103) and a monochrome wash drawing of a Black man (Plate 104), lifted from a finished oil painting of 1874 (Plate 105). One image is a Romantic sunset, rooted in Indian mythology, while the other deals with noonday realities in the Philadelphia marshes.

Like many other American boys, Eakins had probably read *The Song of Hiawatha* (1855) for the first time when he was only 11 or 12. His reasons for returning to Longfellow's popular epic in 1874 can only be guessed at; possibly, it was the autumnal-harvest-sunset flavoring of the poem that appealed to him most, along with the sure-fire popularity of such a native theme just before the Centennial.

Even without seeing the finer details of the watercolor, it is evident from

the sketch that Eakins was illustrating Canto V of Longfellow's "Indian Edda." This segment of the poem, subtitled "Hiawatha's Fasting," mentions the mythical hero's "dreams and visions many" while fasting for seven whole days and nights. The totemic cloud formations marching across the sky represent Eakins's own idea of spiritual manifestations among the Indians, an idea that belongs in the tradition of Thomas Moran's *Spirit of the Indian* (Plate 86). But in contrast to Moran, the younger artist chose a comparatively quiet moment just after the mythical contest between Hiawatha and Mondamin, the benevolent Corn-Spirit. Hiawatha's victory in the wrestling match led to the new

103. Thomas Eakins (1844–1916), *Hiawatha* (Oil Study), c. 1874. Oil on canvas, 13¾ x 17⅜ inches. Joseph H. Hirshhorn Museum and Sculpture Garden, Smithsonian Institution, Washington, D.C.

104. Thomas Eakins (1844–1916), *The Poleman in the Ma'sh,* c. 1880–1881. Monochrome wash drawing, 11 x 5⅞ inches. Collection of Professor and Mrs. Julius S. Held, Old Bennington, Vermont.

On block 3½ × 4½

The Poleman
On the Ma'sh —

knowledge of how to plant and harvest corn, so necessary for the survival of his people. In the oil study, Eakins shows Hiawatha standing over his dark-green opponent in an appropriate pose of mingled triumph and exhaustion.

In 1880 Eakins was commissioned by *Scribner's Monthly Magazine* to supply two rail-shooting illustrations for an article on life in the tidal marshes along the Delaware, just south of the city of Philadelphia. Faced with an order for subjects that he had not been working on for several years, he naturally went back and selected from his own canvases those figures or groups that seemed most effective as artistic statements and as explanations of the sport. After his 1876 painting of *Will Schuster and Black Man Pushing for Rail* (Yale University Art Gallery), Eakins made a monochrome study that was reproduced in *Scribner's* with a simpler title, *Rail-Shooting* (Plate 106).

For his second illustration, Eakins did something a bit more daring. He returned to his painting of *Pushing for Rail* and extracted the carefully studied figure of the Black man with a pole, looking directly out at the viewer, on the far left side (Plate 105). Luckily, the wash drawing after this poleman has survived (Plate 104), and here we are confronted, not with the image of a particular sport, but by a unique human being, clearly seen in the bright autumn sunlight. Where Eakins treated the figure of Hiawatha as an idealized silhouette, this barefoot and slightly potbellied Black man was painted without any trace of idealization or condescension. He simply exists on paper as he was in real life.

Regrettably, when *The Poleman in the Ma'sh* drawing was translated into a wood engraving, some of the effect was lost because the image was cropped severely across the top, cutting off the end of the pole. Nevertheless, the fact that this image is the portrait of a real man whom Eakins knew in 1874 remained unchanged. In a letter to a friend, in which he described both *Pushing for Rail* and the *Hiawatha* subject, Eakins also mentioned an oil and water-

105. Thomas Eakins (1844–1916), *Pushing for Rail,* 1874. Oil on canvas, 13 x 30$\frac{1}{16}$ inches. The Metropolitan Museum of Art, New York, Arthur H. Hearn Fund, 1916.

106. Thomas Eakins (1844–1916), *Rail-Shooting*. Wood engraving, 3½ x 5 inches. Published in *Scribner's Monthly,* XXII, no. 3, July 1881.

107. Anonymous (American artist), *Pictures of Southern Life—Prawn Fishing.* Wood engraving published in *Frank Leslie's Popular Monthly,* I, 1876.

PICTURES OF SOUTHERN LIFE.—PRAWN FISHING.

color of *A Negro Whistling for Plover;* the model for these two works was "the selfsame negro, William Robinson of Backneck, but in a different position."[15] Unfortunately, as Eakins did not give the names for the men in *Pushing for Rail,* the Black poleman cannot be identified even though his appearance and his occupation are unmistakable. Like the inherent dignity of Winslow Homer's Virginia subjects, there is a seriousness and weight to Eakins's images involving Black men that set them apart from the vulgarizations of lesser artists (compare Plates 106 and 107). The unnamed Black "pusher" who steadies the skiff so that Will Schuster can fire in *Rail-Shooting* (Plate 106) plays an obviously subordinate role to the White man who has rented his services for the afternoon, but then again, on the picture surface, they are compositional equals. And what this poleman looks like in reality has been seized with the same directness of vision applied to the other figure. The image is innocent of the blatant prejudice and condescension that one cannot miss in *Pictures of Southern Life—Prawn Fishing* (Plate 107), a wood engraving that appeared in *Frank Leslie's Popular Monthly* at the time of the Centennial. The text describing this plate is self-indicting:

> There are many sights and scenes in our fair Southern land that seem strange and unfamiliar to the Northern eye, and perhaps nothing is more noticeable than the peculiar employments to which the freedmen have betaken themselves, since emancipation imposed upon them the necessity of providing ways and means for their bodily sustenance. . . .
>
> Our illustration shows the last-mentioned manner of capturing these little shell-fish [with a scoop-net], as practised by the negro fishermen on Warsaw Sound and the Savannah River. One darkey lazily sculls the boat slowly along, while the other handles the clumsy-looking net with a dexterity and quickness that generally results in "a good haul."
>
> The prawns are readily sold in Savannah markets, and the dusky fisherman, having invested the proceeds in a liberal allowance of tobacco for himself, and a little tea, with perhaps a calico frock or a gay bandanna handkerchief for the partner of his bosom, returns to his rude cabin "down de bayou," there to revel and idle until an exhausted larder compels him to resume his warfare upon the finny inhabitants of the sea.[16]

Although Thomas Eakins may have lived and worked near the heart of Philadelphia for most of his life, he obviously loved the city more for its outdoor pleasures near at hand (hunting, sailing, rowing on the Schuylkill, ice skating in the winter, etc.) than for its crowded streets or slums. To find significant and expressive images of Black men in an urban setting in the 1880s it is best to return to New York City.

Sidewalk scenes, showing newsboys or young street urchins at play, had been a persistent urban topic for American artists and magazine illustrators since the middle of the century, but the characters in these pictures were almost always White, or else all Black—never mixed. To the same street-corner tradition belongs Joseph Decker's painting (Plate 108), once called *The*

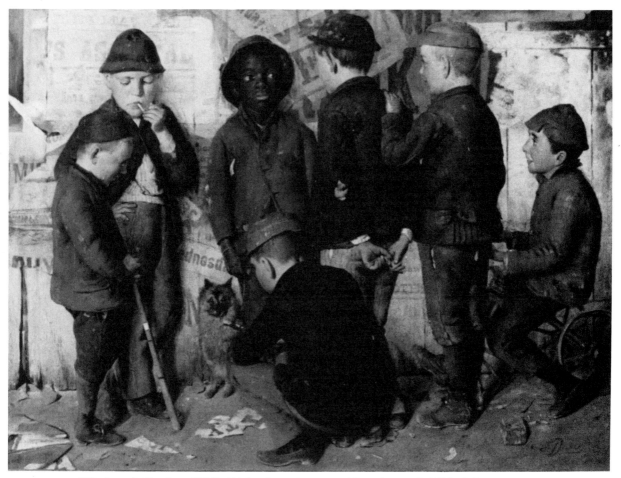

108. Joseph Decker (1853–1924), *Our Gang,* or *The Accused,* 1886. Oil on canvas, 24 x 30⅝ inches. Collection of Mr. and Mrs. H. John Heinz III.

Accused, but now given the more innocent title of *Our Gang.* Compared to its predecessors, the integrated cast in this image gives it a strangely disturbing power.

Joseph Decker, a rather mysterious artist who lived in Brooklyn, was primarily a still life painter, and some of the qualities of a still life are evident in *Our Gang.* The picture space is extremely shallow, sealed off by the fence which is covered with paste-up advertisements, most of which are torn. The seven figures, in turn, are very carefully placed on this narrow stage. Like the accessories to a meal, piled high on marble counter-tops in countless still life pictures, the composition of *Our Gang* also rises to an apex near the center and tapers off to either side. By their poses, the end figures act as parentheses, turning the viewer's attention back to the central confrontation. The small Black boy and his dog seem to be pinned against the wall, surrounded and outnumbered. Nothing has happened yet, but there is an element of fear and suspicion in the Black child's sideward glance. A threat of violence hangs in the air.

The great majority of urban images of Black men and women in the 1880s and 90s were single and group portrait photographs in which the individual sitters had a chance to compose themselves before the camera as they wanted to be seen by the rest of the world. As a result, these portrait photos tended to

project the self-confident image of middle-class prosperity and respectability. To find a few exceptional photographs of the potentially violent, sordid side of city life, one must turn to the work of Jacob A. Riis, the crusading newspaper reporter and self-taught photographer.

In the process of gathering information for his case against the ghetto slums and the hopeless plight of the poor, Riis took his camera and magnesium flash pan into the so-called black-and-tan dives in "Africa," the Black section of Lower Manhattan. One photograph that resulted from a visit to a Broome Street saloon about 1889 (Plate 109) was published by the new half-tone process the following year in Riis's compelling book, *How the Other Half Lives; Studies Among the Tenements of New York* (With Illustrations Chiefly from Photographs Taken by the Author). This largely uncomposed, accidental, snapshot image of a young Black tough, sitting on a whiskey barrel, was the only illustration to Chapter 13, the section of the book dealing with "The Color Line in New York."

The photograph lacks the finish of most paintings, no matter what their subject; and parts of it are extremely awkward—notice the Black hand coming around the shoulder of the woman on the right or the shawl-covered form inexplicably turned to the wall on the left. But, instead of detracting from the

109. Jacob A. Riis (1849–1914), *A Black-and-Tan Dive in "Africa,"* c. 1889. Photograph from The Jacob A. Riis Collection, Museum of the City of New York.

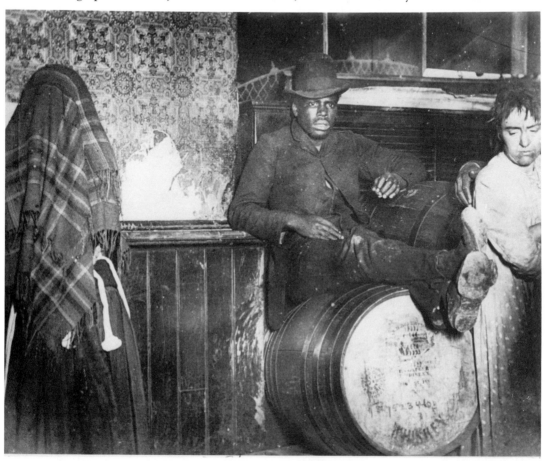

power of the image, these inelegant passages only add to the inescapable sense of total truth. Even in a weak halftone, this haunting photograph was a fitting partner to the following paragraph at the end of Riis's chapter:

> The border-land where the white and black races meet in common de-bauch, the aptly-named black-and-white saloon, has never been debatable ground from a moral stand-point. It has always been the worst of the des-perately bad. Than this commingling of the utterly depraved of both sexes, white and black, on such ground, there can be no greater abomination. Usually it is some foul cellar dive, perhaps run by the political "leader" of the district, who is "in with" the police. In any event it gathers to itself all the law-breakers and all the human wrecks within reach. When a fight breaks out during the dance a dozen razors are handy in as many boot-legs, and there is always a job for the surgeon and the ambulance. The black "tough" is as handy with the razor in a fight as his peaceably inclined brother is with it in pursuit of his honest trade. As the Chinaman hides his knife in his sleeve and the Italian his stiletto in the bosom, so the negro goes to the ball with a razor in his boot-leg, and on occasion does as much execution with it as both of the others together. More than three-fourths of the business the police have with the colored people in New York arises in the black-and-tan district, now no longer fairly representative of their color.[17]

At the same time that Jacob Riis was preparing his first book on the slums and taking his first photographs of street arabs, sweatshops, and saloons in New York, Frederic Remington was beginning to establish his reputation as an il-lustrator of Western Americana. Virtually every western excursion he went on in the 1880s resulted in at least a few illustrations for the popular press, if not in full-length articles. It is in reading Remington's own words, however, that one discovers how much he loathed and detested the Indians of the Southwest while making a living by creating pictures of them. Remington's drawing of *The Sign Language* (Plate 110) appeared in a story that he wrote and illus-trated himself for *Century Magazine* (April 1889). The story was called "A Scout with the Buffalo-Soldiers," and it recounted the artist's experiences on a difficult, cross-country patrol with an Army scouting party in midsummer (1888) in the Arizona Territory. The point of this patrol and hundreds of oth-ers like it was to make the Apache Indians realize that they might encounter a column of U.S. Cavalry almost anywhere in the vast solitude of the moun-tains and desert surrounding their reservation. This show of military presence, Remington explained, produced "a salutary effect on the savage mind."[18]

The lieutenant in charge of the scouting party was a friend of Rem-ington's, but what made the arduous journey particularly picturesque from the illustrator's viewpoint was the fact that the 10th United States Cavalry was composed of "colored men." The "tall sargeant, grown old in the service," and the four enlisted men who made up this detail were all Blacks, and Rem-ington clearly enjoyed making drawings of them along the trail and in camp.

110. Frederic Remington (1861–1909), *The Sign Language*. Wood engraving, 4¼ x 3 inches. Published in *Century Magazine*, XXXVII, no. 6, April 1889.

He even quoted several anecdotes about their bravery in skirmishes with the Apaches to "prove the sometimes doubted self-reliance of the negro." The following is the artist's description of the first night's camp after an impossible climb:

> The negro troopers sat about, their black skins shining with perspiration, and took no interest in the matter at hand. They occupied such time in joking and merriment as seemed fitted for growling. They may be tired and they may be hungry, but they do not see fit to augment their misery by finding fault with everybody and everything. In this particular they are charming men with whom to serve. Officers have often confessed to me that when they are on long and monotonous field service and are troubled with a depression of spirits, they have only to go about the campfires of the negro soldier in order to be amused and cheered by the clever absurdities of the men. Personal relations can be much closer between white officers and colored soldiers than in the white regiments without breaking the barriers which are necessary to army discipline.[19]

Without question, these five Black pony-soldiers enjoyed a far greater share of Remington's sympathies than the small bands of Indians they met along the way. *The Sign Language* (Plate 110) was clearly drawn for a White audience that would find the confrontation of races and the communication-gap between them highly amusing; it refers to an encounter with a group of San

Carlos Apaches, who babbled in their own language with many signs and gestures. According to Remington, "great excitement prevailed when it was discovered that I was using a sketch-book, and I was forced to disclose the half-finished visage of one villainous face to their gaze. It was straight-way torn up, and I was requested, with many scowls and grunts, to discontinue that pastime, for Apaches more than any other Indians dislike to have portraits made." That night, he continued, "the 'hi-ya-ya-hi-ya-hi-yo-o-o-o-o' and the beating of the tom-toms came from all parts of the hills, and we sank to sleep with this grewsome [sic] lullaby."[20]

Behind Remington's undisguised dislike and distrust of the Apaches ("miserable wretches," he called them) was the recent memory of Geronimo's raids on White settlements (before his final surrender in September of 1886). The widespread fear that another Apache outbreak from the San Carlos Reservation was imminent made the army very cautious; hence the number of patrols sent out in the broiling sun. Against this background of potential terror, which never materialized, there is something self-consciously funny about the artist's word-picture of himself, saddle-sore and sun-burned, trying to strike up an after-dinner conversation with one of the Indians who had come into camp for a free meal:

> The campfire darts and crackles, the soldiers gather around it, eat, joke, and bring out the greasy pack of cards. The officers gossip of army affairs, while I lie on my blankets, smoking, and trying to establish relations with a very small and very dirty looking Yuma Apache, who sits near me and gazes with sparkling eyes at the strange object which I undoubtedly seem to him.[21]

Remington, for one, was undoubtedly very glad that the army had been able to confine the "dirty looking" Apaches to their assigned reservation. Their poverty was no concern of his; he cared only for the external features of their lives, their clothes, and their faces. If he missed the excitement of an actual battle between the U.S. Cavalry and a band of renegades, that was something he could endlessly recreate in his own paintings in the years to come.

Nothing could be less humorous than the next image (Plate 111). It is a famous photograph, quickly copyrighted in 1891 and often reproduced since then, showing the aftermath of the Battle of Wounded Knee, South Dakota, the last major confrontation of the Indian Wars on the Plains (December 29, 1890).

The photograph seems to set a grim precedent for twentieth-century images of mass executions and mass burials in a common grave that have become all too familiar. As the victorious American troops in their winter uniforms stand around in a semicircle, the frozen Indian corpses are being dumped into a hastily dug pit. For the camera the work has stopped, and the proud "hunters"

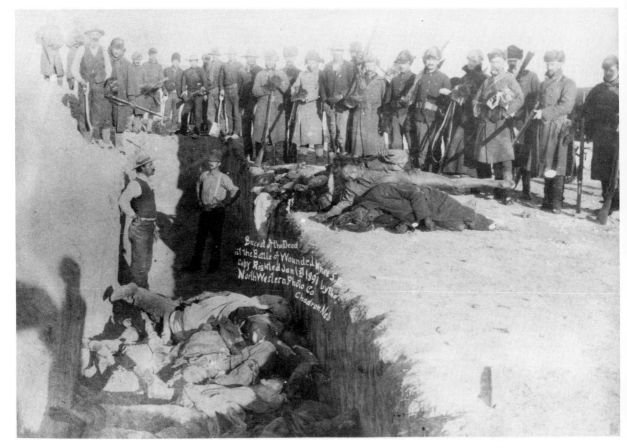

111. G. E. Trager (American Photographer), *The End of the Ghost Dance*, 1891.
Photograph. Nebraska State Historical Society, Lincoln.

with their rifles still in hand pose for this group portrait with their "game" at
their feet. It is New Year's Day, 1891.

The dead number about 200 Sioux—men, women, and children—who were
foolish (or desperate) enough to believe in the Ghost Dance religion of the Pai-
ute prophet, Wovoka. This new messianic cult spread like a prairie fire from
reservation to reservation in 1889–1890, instilling fear in the minds of local
Indian agents and White settlers alike. Originally pacifistic, the religion of-
fered the irresistible promise that an Indian Messiah was coming, that all
White men would suddenly vanish from the surface of the earth forever, and
that a new millenium would then dawn in which all generations of American
Indians, living and dead, would exist together in a perfect world, free of mis-
ery, disease, and death.

To prevent any serious threat to the tenuous peace with the Sioux, especial-
ly after the killing of Sitting Bull by Indian police (December 15, 1890), the
7th Cavalry was summoned in force onto the Pine Ridge Reservation. A band
of Sioux under the leadership of Big Foot had tried to escape into the Badlands,
but they were captured and brought back to Wounded Knee Creek on Decem-
ber 28, 1890. The following day when the shooting started, the men were wear-
ing magic "ghost shirts" which they thought were bullet-proof. Three days
later, after a snowstorm that blanketed the area, a detail was sent back to clean

up the battlefield and look for any survivors in the freezing cold. A photographer went with them to record the remains. The resulting grave-side image looks like the final realization of all those pictorial predictions in American art of the inevitable end of the Indian race.

Since Colonial times White men had occasionally donned Indian garments and war-paint for a specific purpose—the Boston Tea Party of 1773 being the most famous impersonation of this kind. As the Eastern tribes rapidly disappeared or were absorbed into the dominant culture around them, the act of putting on Indian clothes became more and more symbolic, a Romantic expression of a state of mind. For a fictional character like Leather-Stocking, alias Natty Bumppo, semi-Indian garments signified a halfway-world for a White man who resented the very idea of Progress and chose, instead, to live in the dwindling forest like a Redskin. For the real frontier scouts—from Daniel Boone in Kentucky in the 1770s to the mountain men of the Rockies in the 1840s and 50s—Indian clothes and a knowledge of Indian ways were essential. Ironically, their personal survival depended, all too often, on killing without a qualm the Indians with whom they identified and with whom they were friendly at least part of the time.

In the mid-nineteenth century—discounting the number of settlers, especially children, who were abducted in skirmishes along the frontier and then raised (or forced to live) as part of the capturing tribe—the few White men who repeatedly put on full Indian costumes, including war-paint and feathers, were eastern actors treading the boards in one "Indian" melodrama after another. The most popular of these plays was also one of the earliest, *Metamora; or, The Last of the Wampanoags; An Indian Tragedy in Five Acts,* by John Augustus Stone. It was the winning entry in a competition sponsored by Edwin Forrest, the famous leading actor, in 1828. Forrest offered $500 and a part-interest for "the best tragedy, in five acts, of which the hero, or principal character, shall be an aboriginal of this country."[22]

The playwright chose the history of King Philip of Mount Hope as the authentic model for his tragedy about the extinction of the noble savage; and Forrest, playing the title role to the hilt, made it an instant success. From the moment of its first production at the Park Theatre, New York, on December 15th, 1829, this play became a standard "vehicle" for Forrest, remaining in his repertory for forty years. And it was still being preformed by other actors as late as 1887.

For a young portrait and genre painter, like Frederick S. Agate, the chance to do Forrest's portrait in the role of *Metamora* was an opportunity to create a commanding image, one that would leave a suitably strong impression when shown in the annual exhibition of the National Academy of Design (1833). From a later reproduction (Plate 112) it is obvious that Agate wanted to portray the tragic hero at the moment of his most inspirational address which was seconded by the special effects in the background. This speech to his people,

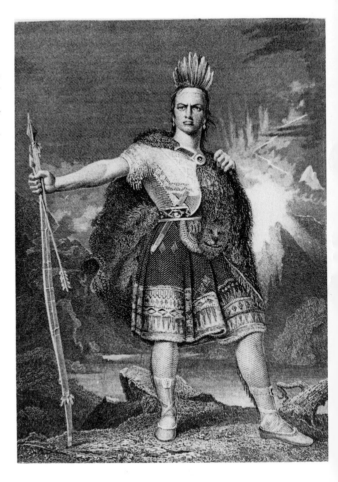

112. Frederick S. Agate (1807–1844), *Metamora* (The Last of the Wampanoags). Engraving, $4^{11}/_{16}$ x $3^{3}/_{8}$ inches. Published in *The Token and Atlantic Souvenir*, Boston, 1842.

rousing them to war, occurred in Act III, Scene 2—An Indian village, deep in the woods:

METAMORA. "When the strangers came from afar off, they were like a little tree; but now they are grown up and their spreading branches threaten to keep the light from you. They ate of your corn and drank of your cup, and now they lift up their arms against you. O my people, the race of the red man has fallen away like the trees of the forest before the axes of the palefaces. The fair places of his father's triumphs hear no more the sound of his footsteps. He moves in the region his proud fathers bequeathed him, not like a lord of the soil, but like a wretch who comes for plunder and for prey. [*Distant thunder and lightning*]. . . .

". . . a mist passed before me, and from the mist the Spirit bent his eyes imploringly on me. I started to my feet and shouted the shrill battle cry of the Wampanoags. The high hills sent back the echo, and rock, hill and ocean, earth and air opened their giant throats and cried with me, "Red man, arouse! Freedom! Revenge or death!" [*Thunder and lightning. All quail but Metamora*] Hark, warriors! The Great Spirit hears me and pours forth his mighty voice with mine. Let your voice in battle be like his, and the flash from your fire weapons as quick to kill."[23]

Sometime in the 1850s or early in the 1860s, Edwin Forrest had himself photographed in his *Metamora* costume by Matthew Brady (Plate 113);

considering the results, though, one may wonder why. Presumably, this image was published as a "public," one of thousands of Imperial-sized, carte-de-visite photos of celebrities, sold to an eager American audience. In contrast to the earlier invocation of the Romantic and indomitable Metamora by Agate, the over-realistic photograph seems like a travesty of what John Augustus Stone had originally intended for the tragic part. The blank wall of Brady's portrait studio adds virtually nothing, but the actor himself seems more grumpy than irreconcilably angry with the evil race of White men. In front of the camera, Forrest's gesture with his right hand appears feeble, at best, and a comic middle age seems to seep through his once heroic costume.

By the last decade of the nineteenth century, the theatrical spirit of *Metamora* must have seemed terribly out of date. Who would go to see such a play performed when there were real-life Indians, even former war chiefs, on display in the traveling "Wild West" shows of the period? After the last outbreaks had been crushed, after the Agency system had taken full effect on every reservation, the magic act of dressing in Indian clothes acquired a new aura of seriousness, even a sense of responsibility, for the few White men who tried it as a way of life.

Only an artist as sensitive and powerful as Thomas Eakins could capture

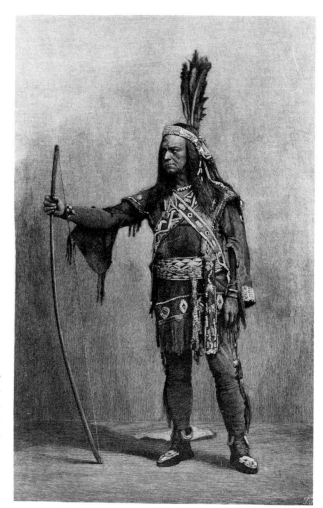

113. Mathew Brady (c. 1823–1896), *Edwin Forrest as Metamora*. Wood engraving (from a photograph) by T. Johnson, 7⅞ x 5 inches. Published in *Century Magazine,* XXXIX, no. 4, February 1890.

or suggest the ramifications of this magic act in paint. His portrait of *Frank Hamilton Cushing* (Plate 115), who liked to call himself "1st War Chief of the Zuñi, U.S. Assistant Ethnologist," is a culmination of the tenuous White man-as-Indian tradition. Marked by a "fin de siècle" sadness, this large portrait will stand as a meditative counterpoint to the countless and mindless "Cowboy and Indian" pictures that proliferated at the end of the century and then spilled over into modern times, especially in the "movies."

Eakins had made one western trip of his own, but it had little to do with Indians. In 1886 he had resigned under pressure from his teaching position at the Pennsylvania Academy of the Fine Arts; as a working vacation and a change of scene, he spent most of the following summer and early fall (three years before Wounded Knee) on a ranch in the Dakota Territory, photographing and sketching the cowboys and their horses. He brought his sketches and negatives back to Philadelphia, along with a cowboy costume, a horse, and an Indian pony named Billy. Other than working on a large landscape of *Cowboys in the Badlands* and posing one of his bearded students in the cowboy outfit for smaller studies, Eakins did little more with this type of subject matter—the type that younger contemporaries were making a career of—until he met Frank Hamilton Cushing about 1894.

On assignment from the recently-formed Bureau of American Ethnology, Smithsonian Institution, Cushing had lived at the Zuñi Pueblo in New Mexico for four and a half years (1879–1884). In the process of gathering field-notes and drawing his own sketches of Zuñi Indian life and customs, Cushing found it expedient to abandon his White man's clothes and accept the substitute articles that were offered to him—beginning with a black silken scarf as a headband in place of his "helmet hat" and a pair of red buckskin mocassins instead of his English walking shoes. Eventually, when he had learned to wear a full Zuñi costume, his ears were pierced in a special ceremony, at the end of which he was given a new name, *Té-na-tsa-li,* or Medicine Flower, because of the simple patent remedies he wisely brought with him from Washington. It was explained by Cushing's adopted father that he was being "named after a magical plant which grew on a single mountain in the west, the flowers of which were the most beautiful in the world, and of many colors, and the roots and juices of which were a panacea for all injuries of the flesh of man."[24]

By far the proudest moment of Cushing's stay at the Zuñi Pueblo was his initiation into the *A-pi-thlan-shi-wa-ni* society, the all-powerful "Priesthood of the Bow," which gave him access to all the other secret societies in addition to a position of leadership and trust (after two years residence). In an early set of three articles for *Century Magazine* (December 1882 to May 1883), the young ethnologist described his experiences in trying to gain membership in this exclusive priesthood as "the most interesting chapter of my Zuñi life."[25] He might have added—"of my entire life."

A decade later, when Cushing came to Philadelphia for medical treatment, he and Thomas Eakins met. Their rapidly growing friendship led to a series of sittings for a large portrait that Eakins painted for the joy of doing it;

there was no commission involved. For his part, the White "Priest of the Bow" was undoubtedly proud to pose in his authentic costume, and so a few photographs were taken first as preparatory studies (Plate 114), either by Eakins or by his friend and former student, Samuel Murray, who shared the same studio at 1330 Chestnut Street. Moreover, it must have been with Cushing's help or direction that a corner of the studio was transformed into the semblance of a kiva in the Zuñi Pueblo, entered by way of a ladder leading down from the "sky-hole" in the roof.

In the final painting (Plate 115) the ethnologist stands in the middle of this space, an altar-like structure to the lower right and a feathered shield, decorated with the image of the Zuñi god of war, hanging from an antler hook on the wall of the kiva behind him to the left. Cushing is holding his badges of office, a beautiful wand of macaw plumes as well as a ceremonial club, and his arms are crossed in a characteristic Indian pose.

By going to the trouble of trying to reproduce all these accouterments as accurately as possible, Eakins matched some of the sincerity with which Cushing entered into the life of the Zuñi Pueblo. The quiet, thoughtful mood of the final image is an answer to the shallow histrionics of the *Metamora* tradition as well as a challenge to the endless pictures of White men *shooting* Indians. More significantly, since Eakins loaned this portrait to the Archaeology Museum of the University of Pennsylvania for a time, it can also be read as a commentary on the importance of ethnological research and the humanistic need for more men like Cushing, endowed with the same courage, wit, and perception, to forget their own prejudices about external appearances and to explore another culture from within over an extended period of time.

As a Black man with light skin, possessing deep religious convictions in addition to an artist's sensitivities, Henry Ossawa Tanner (Plate 116) faced many obstacles at the start of his career. The first difficulty was in obtaining a decent art education. In 1880, at age 21, he applied to the Pennsylvania Academy of the Fine Arts, where Thomas Eakins was the Professor of Painting. He was accepted on the strength of some samples of his work; no one knew what he looked like until he arrived. There was no rule at the Academy "excluding people of color from the schools," but the timid Chairman of the School Committee felt that it was wise to put the matter to a vote in the Antique and Life Classes for Men. None of the students objected—at first.

"The advent of the Nigger," according to Joseph Pennell, who was a pupil at the Academy at exactly the same time (1880–1881), became one of the great excitements of the year, nearly surpassing the frequent faintings of the female models. The following account comes from Pennell's autobiographical *Adventures of an Illustrator* (1925). Tanner is never mentioned by name in this outrageously bigoted passage, but the factual parts of the description seem to fit. The remainder of Pennell's report drips with condescension at best; and, at its worst, it reveals the kind of prejudice and racial insult that Tanner had to endure on this side of the Atlantic:

114. Thomas Eakins (1844–1916), *Frank Hamilton Cushing,* 1895. Photograph, 5⅝ x 4¾ inches. Joseph H. Hirshhorn Museum and Sculpture Garden, Smithsonian Institution, Washington, D.C.

115. Thomas Eakins (1844–1916), *Frank Hamilton Cushing,* 1894–1895. Oil on canvas, 90 x 60 inches. The Thomas Gilcrease Institute of American History and Art, Tulsa, Oklahoma.

He came, he was young, an octoroon, very well dressed, far better than most of us. His wool, if he had any, was cropped so short you could not see it, and he had a nice moustache. He worked at night in the Antique, and last of all, he drew very well. I do not think he stopped long in the Antique—the faintest glimmer of any artistic sense in a student, and he was run into the Life [class by Eakins]. He was quiet and modest, and he "painted too," it seemed, "among his other accomplishments."

We were interested at first, but he soon passed almost unnoticed, though the room was hot. Little by little, however, we were conscious of a change. I can hardly explain, but he seemed to want things; we seemed in the way, and the feeling grew. One night we were walking down Broad Street, he with us, when from a crowd of people of his color, who were walking up the street, came a greeting, "Hullo, George Washington, house yer getin on wid yer white fren's?" Then he began to assert himself and, to cut a long story short, one night his easel was carried out into the middle of Broad Street and, though not painfully crucified, he was firmly tied to it and left there. And this is my only experience of my colored brothers in a white school; but it was enough.[26]

Tanner was obviously caught between his birthright as a Negro and his aspirations as an artist, belonging to neither group completely in America. It is no wonder that he found Paris, the cosmopolitan center of the art world, a far more congenial place in which to work. After living in Atlanta, Georgia, where "he had charge of the Art Department in Clark University for several years," Tanner finally had the opportunity in 1891–1892 of going to Paris and studying at the popular Académie Julian. There, his considerable talent, his warm, though rather quiet personality, and his total dedication to his art could be appreciated without racial bias or prejudgment.

In a letter of 1894 Tanner summarized, using a formal third-person voice, the major events of his career to that point. Understandable pride glows beneath the surface of these soft-spoken words; and all the difficulties of his life were simply omitted from this brief history:

> Henry Ossawa Tanner, the subject of this sketch, is the oldest son of Bishop B. T. Tanner of the African Methodist Episcopal Church. His family removed from Pittsburgh, his birthplace, to Phila., early in his childhood and he has resided there most of the time since that period. Studied at the Pennsylvania Academy of the Fine Arts, afterwards in Paris under Jean-Paul Laurens and Benjamin-Constant. While in Paris at the celebrated "Académie Julian" he received [a] prize for [the] best composition made in a given number of hours, also a prize from the American Art Association in [the] same city. When leaving for America he received a letter of commendation from his masters, Jean-Paul Laurens & Benj.-Constant.[27]

Paris was later to become Tanner's permanent home, but he occasionally felt compelled, it seems, to return to the United States, as he did in 1893–1894 and again in 1902–1904 when Eakins painted his portrait (Plate 116). During the 1893–1894 period, Tanner painted some of his best-remembered works which found permanent homes. *The Banjo Lesson* (Plate 117), for example,

116. Thomas Eakins (1844–1916), *Henry Ossawa Tanner,* c. 1902. Oil on canvas, 24⅛ x 20¼ inches. The Hyde Collection, Glens Falls, New York.

117. Henry Ossawa Tanner (1859–1937), *The Banjo Lesson,* 1893. Oil on canvas, 48 x 35 inches. Hampton Institute, Hampton, Virginia, Gift of Robert Ogden, 1894.

was donated to the Hampton Institute by his patron, Robert Ogden, in 1894. Another canvas, using the same older man as a model and inscribed *The Thankful Poor* (Plate 118), was recently rediscovered in storage at The Pennsylvania School for the Deaf in Philadelphia; it was presented to that institution in 1894 by John T. Morris, one of the trustees.

In addition to these Negro genre subjects—remarkable for their spiritual qualities—Tanner also made another sort of contribution to Black consciousness and to the study of American art at that time. According to his own biographical sketch, "He also read a paper on 'The American Negro in Art' before the World's Congress on Africa in Chicago."[28] Even without knowing exactly what Tanner said at that meeting in Chicago—which was undoubtedly held in connection with the Columbian Exposition of 1893—it is easy enough to tell what he was thinking by looking at his pictures, especially the two reproduced here. Fortunately, as an added guide to his intentions, we do have his own brief description of the work he was doing in 1893–1894:

> Since his return from Europe he has painted many Negro subjects, he feels drawn to such subjects on account of the newness of the field and because of a desire to represent the serious, and pathetic side of life among them, and it is his thought that other things being equal, he who has most sympathy with his subject will obtain the best results. To his mind many of the artists who have represented Negro life have only seen the comic, the ludicrous side of it, and have lacked sympathy with and affection for the warm big heart that dwells within such a rough exterior.[29]

In the clear light of this statement of principles, *The Banjo Lesson* (Plate 117) has to be read as a sobering antidote to sixty years of minstrel shows in America, sixty years of White entertainers in Blackface and Black clothes performing borrowed dances (*Jump Jim Crow*) and borrowed songs in Negro dialect (*My Old Kentucky Home, Carry Me Back to Old Virginny*) for the delight of their audiences. When it was put on public display in Earle's Galleries, Philadelphia, in 1893, a reviewer for the *Daily Evening Telegraph* recognized the profound essence of the picture, and yet he could not free himself completely of years of stereotyped thinking. The minstrel show tradition and images of the comic side of Negro life (see Plate 72) were in his mind as he described the figures in Tanner's work: "An old Uncle Ned, bald and venerable, has a bare-footed little darkey of seven or eight years between his knees, and is earnestly instructing the youngster how to finger the strings of an ancient banjo."[30]

On the more positive side, this same newspaper critic was deeply pleased by the firm modeling of these two figures and the way in which they were enveloped in space by a sense of atmosphere, each occupying his own place and each bearing the stamp of individuality. For special praise, he cited the treatment of hands and faces, and his remarks this time have no trace of condescension: "The hands are especially well drawn, that of the child being a study Mr. Tanner may well be proud of, and the faces are formed with intelligence and expression."[31]

Precisely the same artistic virtues can be found in *The Thankful Poor* (Plate 118) a year later—along with some of the same props. The table in the background of *The Banjo Lesson,* set with a few dinner plates and a water pitcher, has now become the major object in the foreground. The venerable grandfather figure on the left appears to be the same model that Tanner used for *The Banjo Lesson*; his face is partially hidden in shadow, but the light reveals (in the strongest passage of the painting) the way he holds his head, his shoulders, and his hands clasped in prayer before a meager meal. No sound, no plucking at a banjo, disturbs the profound, also melancholy silence of the scene. In this quiet is Tanner's commentary on the White images of Negro family life and religious practices that rarely rose above the anecdotal. In place of picturesque details, *The Thankful Poor* conveys a sense of the real privations of poverty (for those with hardly enough to eat) and the sustaining power of humble prayer. By being so much closer to his subjects, Tanner was able to deliver what he promised. His figures are handled with a degree of sympathy and affection that was far beyond the abilities of most White painters.

118. Henry Ossawa Tanner (1859–1937), *The Thankful Poor,* 1894. Oil on canvas, 45 x 35½ inches. Pennsylvania School for the Deaf, Philadelphia. Photo: Philadelphia Museum of Art.

119. Winslow Homer (1836–1910), *The Gulf Stream,* 1899. Oil on canvas, 28⅛ x 49⅛ inches. The Metropolitan Museum of Art, New York, Wolfe Fund, 1906.

Once a leading delineator "of Negro characteristics," Winslow Homer had contributed little or nothing in terms of images of Blacks since the time of the Centennial. Apparently, he must have felt that virtually all the possibilities he wanted to explore in the United States were already exhausted. Never fond of cities, he had strictly avoided doing urban American scenes since his early days as an illustrator. What is more, after finishing his series of pictures of former slaves in Virginia during Reconstruction, Homer abandoned rural genre scenes of shanties and cotton fields as well. This territory was left open for other artists, like William Aiken Walker, to work over in the 1880s and 90s.

It was in the Bahamas that Homer discovered another world peopled by an English-speaking, yet intriguingly foreign race of Negroes. This new world was well-suited to his basic instincts as a painter. It provided the bright reality of exotic palm trees, warm sunshine, and beautiful, active models, but it also contained occasional touches of Romantic confrontation between man and the more violent forces of Nature. Suites of watercolors were the first products of Homer's winter trips to Nassau and various other islands in the Caribbean, beginning in 1884–1885; but in 1899, just after the Spanish-American War and about fourteen years after the idea first occurred to him, Homer painted *The Gulf Stream* (Plate 119), the most pessimistic and compelling of his West Indian sea-pieces.

The only human form in *The Gulf Stream* is a young Black man, lying dazed and exhausted on the deck of a dismasted and drifting sailboat. This isolated figure could be an American, since the stern of the derelict carries

the name, "ANN [?] / KEY WEST," but the actual port of origin has little significance here. The essential issue at the center of this storytelling scene is the mariner's distance from any shore, let alone a safe harbor. The Black man is still alive after the hurricane which blew him out to sea, along with the sharks, but death is near and seemingly inevitable. On the picture surface he is literally trapped between the menacing sharks in the foreground and the ominous waterspout approaching rapidly from the right. Defeated by the elements that have already wrecked his boat, he does not have the strength left to try to signal the distant ship for help. And even if he were to escape the immediate dangers closing in on him, eventual starvation from lack of food and water seems certain.

When *The Gulf Stream* was exhibited in 1900, some critics, who were more attuned to the soft-focus, pastel vision of the younger American Tonalists, objected to the "unpleasantness" of the subject matter, but others greatly admired "the bold and fateful presentation of cruel fact" which made them think of the most famous canvases in the same vein. According to William Howe Downes's synopsis of the newspaper clippings, "the critic of 'The Sun' discovered that the picture contained more shudders than Géricault's 'Raft of the Medusa,' and other writers drew attention to certain similarities of the subject to Turner's 'Slave Ship.' "[32]

In the final analysis, it seems significant that Homer in 1899 looked far afield to find a semiepic theme, requiring a Black figure. Unlike the *Raft of the Medusa* or *The Slave Ship,* of course, *The Gulf Stream* was never intended to be an ardent attack on the horrors and inhumanities of the African slave trade. More in the manner of Copley's *Watson and the Shark,* it was designed as a thrilling exhibition piece, aimed at a White audience that would find the inclusion of a Black man interesting and exotic. The single figure adrift in *The Gulf Stream* is neither a full epic hero nor a racial stereotype. He simply exists, as any man might—Black or White—stoically awaiting his fate. The dramatic tension between this Black man and the imminent perils of the tropical sea made for exciting storytelling, without the usual residue of Victorian sentimentality. Behind this Caribbean subject, however, one senses a certain avoidance on Homer's part of anything to do with the comparatively uneventful or undramatic lives of most lower- or middle-class Blacks in American society. Henry Ossawa Tanner may have found excellent materials there, but Homer was obviously looking for something on a larger, crowd-pleasing scale.

As a closing summation picture for this book, a fitting image is Frances Benjamin Johnston's photograph of a *Class in American History,* taken at the Hampton Institute, Hampton, Virginia, in 1899–1900 (Plate 120). Where *The Gulf Stream* was certainly intended to operate in the tradition of high art, divorced from the facts of everyday life, this photograph brings us back to the realities of social, economic, and educational concerns among Blacks as well as Indians in the United States at the very end of the nineteenth century.

Frances Johnston was a photographer in Washington, D.C., who seemed

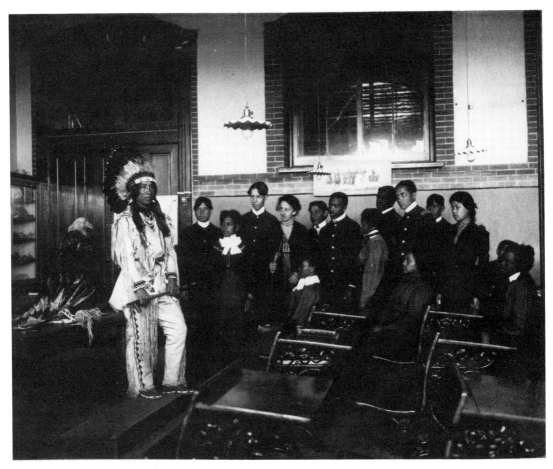

120. Frances Benjamin Johnston (1864–1952), *Class in American History* from *The Hampton Album*, 1899–1900. Platinum print, 7½ x 9½ inches. Collection, The Museum of Modern Art, New York, Gift of Lincoln Kirstein.

to specialize in photoessays on topical subjects. Late in 1899 she was commissioned to do a complete picture-story on the Hampton Institute, a coeducational school for Blacks and Indians, founded just after the Civil War. Positive prints from Miss Johnston's more than one hundred and fifty large glass negatives were included in a display—illustrating the rapid progress and contemporary achievements of the American Negro—at the "Exposition Universelle" in Paris in 1900.

This "Negro exhibit" at the Paris Fair might have been subtitled "Up from Slavery"—to borrow an appropriate and evocative phrase from Hampton Institute's most prominent early graduate, Booker T. Washington. In fact, the display in Paris was under the supervision of T. J. Calloway, a young Black man who had been associated with Booker T. Washington at the Tuskegee Normal and Industrial Institute (founded in 1881) in Alabama. To drive home the "Up from Slavery" point, Frances Johnston took several sympathetic "then" and "now" comparisons in which the distance traveled since the Civil War was made apparent. These introductory pairs of photographs showed "The old-time cabin" versus "A Hampton Graduate's Home" on a comfortable, tree-lined street and "The Old Folks at Home" inside their rude cabin

versus "A Hampton Graduate at home" with his family, seated around a cloth-covered table in a clean and respectable dining-room.

Although the Hampton Institute had a population of almost one thousand students at the turn of the century, not all were Black. Reportedly, there were as many as 135 Indian children also enrolled to take various courses of instruction and to receive vocational training in several practical skills. Because of this mixture, some views of Indian reservation life were also presented in the introductory section of the exhibit to be compared with the progress made by the Indian graduates in the later photographs.

According to Lincoln Kirstein—who found the album of these Hampton photos now in the Museum of Modern Art—race relations within the student body may not have been perfect at all times. The Indian boys had a brick dormitory of their own, called "The Wigwam," and some difficulties might have been caused by the fact that "the average Indian felt himself far superior to the whites, and immeasurably above the Negroes, since they had, themselves, never submitted to slavery, but also had owned large numbers of slaves."[33]

No tensions of this kind show up in any of the classroom photographs, however. In Frances Johnston's carefully posed *Class in American History* (Plate 120), there is, instead, a confrontation between the Black and Indian students on the right and their classmate who is standing on a wooden step on the left, dressed in full tribal costume, next to a stuffed American eagle. This image is not so much a variation on the victor-and-vanquished theme, as traced earlier in this chapter, but a new and telling encounter between the past and the present. *The Hampton Album* as a whole was obviously meant to offer a bright forecast for the future of Indians and Blacks in American society, but the gulf between the pupils and the object of their study in this American History class has a tinge of sadness. The cultural chasm, across which no words pass in the photograph, speaks of a foreign life-style never fully understood in any Eastern classroom and, by 1900, almost irretrievably lost in the headlong process of "civilizing" the continent by either assimilating or exterminating the original inhabitants. No longer in the way of progress, the Indian figure in full regalia has been reduced to an educational curiosity, an interesting display for a Natural History collection in a school or museum.

From all outward appearances in Frances Johnston's photographs, the Indian and especially the Black students at the Hampton Institute in 1899–1900 had thoroughly adopted White clothes and White ways as the key to the future through education. In the American History classroom there is even a reproduction of a Remington-like, gunslinging cowboy or cavalry picture hanging on the wall as a further token of accommodation to the dominant culture beyond the walls of the school. However, instruction at the Hampton Institute and at other Black schools was parallel to, but clearly separate from, White institutions of higher learning, and this obvious segregation would seriously dim the future prospects of even the brightest graduates who were seeking assimilation into White society.

Like other essays on painting and sculpture in the United States, this brief survey of Black and Indian images from 1590 to 1900 is based on the essential premise that a nation's fundamental attitudes and beliefs are inevitably reflected in its works of art. If the highest ideals and aspirations of American society are clearly revealed in the finest pictures and statues, then the less exalted side of our national character—the side involving racial fears, hatreds, and repeated misconceptions—is just as openly expressed on the level of popular prints, genre-like paintings, and other images that appealed to the general public. In the continuing search for what is truly "American" in American art, it should be remembered that racial issues and confrontations were a constant and often a critical concern at the center of our national consciousness. Some American-born painters and sculptors, by succumbing to the lure of Europe or European traditions, were able to escape the bonds of native subject matter. But, for those who wanted to portray the actors and events on the American scene, images of Indians or Black men (or both) were indispensable parts of their repertory as American artists. From the time of John Foster or John Hesselius to the era of Winslow Homer and Thomas Eakins, serious involvement with Black and Indian themes seems to be one of the major characteristics that can be used to define the distinctive nature of American art.

Notes

Introduction

[1] Jacob A. Riis, *How the Other Half Lives; Studies Among the Tenements of New York*, New York, 1890, pp. 148-149.

1. European Interest in the New World

[1] Carolyn Thomas Foreman, *Indians Abroad, 1493-1938*, Norman, Oklahoma, 1943, pp. 23-25.

[2] Louis Hennepin, *A Continuation of the New Discovery of a Vast New Country in America*, London, 1698, pp. 98-99.

2. Colonial Images

[1] Nathaniel Hawthorne, *Mosses from an Old Manse*, New York, 1846, Part II, p. 72.

[2] John Galt, *The Life and Studies of Benjamin West . . . Prior to his Arrival in England*, 2nd ed., London, 1817, pp. 104-106.

[3] Ibid., pp. 132-133.

[4] Letter from Joseph Shippen, dated "Rome, 17th September 1760" and addressed "To Mr. Benjamin West at Leghorn," is in the collection of the Pennsylvania Academy of the Fine Arts, Philadelphia.

[5] William Smith, *An Historical Account of the Expedition against the Ohio Indians*, London, 1766, p. 14.

[6] Ibid., p. 16.

[7] J. Hall Pleasants, *Two Hundred and Fifty Years of Painting in Maryland*, Baltimore, 1945, pp. 16-17.

3. Romantic Thoughts and Feelings

[1] Thomas Clarkson, *A Portraiture of Quakerism*, New York, 1806, I, pp. 271-272.

[2] For a full discussion of *Watson and the Shark*, including reviews from the London press, see Jules D. Prown, *John Singleton Copley*, Cambridge, Mass., 1966, II, pp. 272-275.

[3] Edgar P. Richardson, "'Head of a Negro' by John Singleton Copley," *Art Quarterly*, XV, Winter 1952, pp. 351-352.

[4] *The American Museum*, V, no. 5, May 1789, pp. 429-430.

[5] Thomas Clarkson, *The History of the Rise, Progress, and Accomplishment of the Abolition of the African Slave-Trade by the British Parliament*, London, 1808, II, pp. 191-192.

[6] Franklin's letter is quoted by Robert C. Smith, "Liberty Displaying the Arts and Sciences; A Philadelphia Allegory by Samuel Jennings," *Winterthur Portfolio*, II, 1965, pp. 89-90.

[7] Ibid., pp. 85-89.

[8] Kenneth C. Lindsay, *The Works of John Vanderlyn, From Tammany to the Capitol* (exhibition catalogue), Binghamton, 1970, pp. 133-134.

[9] Isaac Weld, Jr., *Travels through the States of North America*, 2nd edition, London, 1799, II, p. 314.

[10] Trumbull's letter (11 November 1808) is quoted by Theodore Sizer, ed., *The Autobiography of Colonel John Trumbull, Patriot-Artist, 1756-1843*, New Haven, 1953, p. 338.

[11] William Dunlap, *A Trip to Niagara; or, Travellers in America; A Farce*, New York, 1830, p. 32.

[12] Ibid., pp. 52-53.

[13] See Samuel Y. Edgerton, Jr., "The Murder of Jane McCrea: The Tragedy of an American 'Tableau d'Histoire,'" *Art Bulletin*, XLVII, no. 4, December 1965, pp. 481-492.

[14] National Academy of Design, *Catalogue of the Second Annual Exhibition*, New York, 1827, No. 11, pp. 3-4.

[15] Basil Hall, *Travels in North America in the Years 1827 and 1828*, 3rd edition, Edinburgh, 1830, p. xii.

[16] Basil Hall, *Forty Etchings, From Sketches made with the Camera Lucida, in North America, in 1827 and 1828*, Edinburgh, 1829, letterpress for Plate XX, no page number.

[17] Hall, *Travels in North America*, III, pp. 228-229.

[18] Editor, "The Fine Arts," *New-York Mirror*, IX, no. 20, November 19, 1831, p. 155.

[19] *New-York Mirror*, XIV, no. 47, May 20, 1837, p. 375.

[20] See *The Token, and Atlantic Souvenir*, Boston, 1842, pp. 295-296 and 299.

[21] Warren S. Walker, "Elements of Folk Culture in Cooper's Novels," *New York History*, XXXV, no. 4, October 1954, p. 463.

[22] James Fenimore Cooper, *The Pioneers; or, The Sources of the Susque-Hanna; A Descriptive Tale*, New York, 1823, I, p. 236.

[23] *New-York Mirror*, XVI, no. 2, July 7, 1838, p. 15.

[24] *Dunlap Exhibition Catalogue, Stuyvesant Institute*, New York, 1838, p. 18.

[25] Cooper, *The Pioneers*, pp. 242-243.

[26] Ibid., pp. 248-249.

4. The Growing Taste for Realism

[1] George Catlin, *North American Indian Portfolio*, London, 1844, Preface, pp. 3-4.

[2] Catlin's letter, printed in his own *Illustration of the Manners, Customs, and Conditions of the North American Indians*, New York, 1841, pp. 14-16, is quoted at length in John W. McCoubrey, ed., *American Art, 1700-1960*, Englewood Cliffs, N.J., 1965, pp. 93-95.

[3] Catlin, *North American Indian Portfolio*, p. 9.

[4] John Banvard, *Description of Banvard's Panorama of the Mississippi River*, Boston, 1847, p. 15.

[5] John Francis McDermott, *The Lost Panoramas of the Mississippi*, Chicago, 1958, p. 43.

[6] *People's and Howitt's Journal*, VII, May 19, 1849, p. 281.

[7] Ibid., p. 281.

[8] *Description of Banvard's Panorama*, Boston, 1847, p. 32.

[9] Ibid., p. 35.

[10] Dunkin H. Sill, "A Notable Example of Longevity (1737-1852)," *New York Genealogical and Biographical Record*, LVI, no. 1, January 1925, p. 67.

5. The Slavery Issue and the Indian Question

[1] Harriet Beecher Stowe, *Uncle Tom's Cabin; or, Life Among the Lowly*, Boston, 1852, I, Preface, pp. vi–vii.

[2] Ibid., II, p. 61.

[3] Ibid., II, p. 67.

[4] See Robert F. Thompson, "African Influences on the Art of the United States," *Black Studies in the University*, New Haven, 1970, pp. 154–156.

[5] Henry T. Tuckerman, *Book of the Artists*, New York, 1867, p. 470.

[6] As quoted in Chetwood Smith, *Rogers Groups; Thought and Wrought by John Rogers*, Boston, 1934, p. 73.

[7] Rogers Scrapbook, New-York Historical Society Library.

[8] William S. Walsh, *Abraham Lincoln and the London Punch*, New York, 1909, pp. 26-28.

[9] Joel Tyler Headley, *The Great Riots*

of New York, 1712-1873, New York, 1873, reprinted New York, 1971, p. 207.

[10] See *New York Illustrated News*, July 15, 1863, p. 7.

[11] Headley, *The Great Riots*, p. 208.

[12] *Our Daily Fare*, no. 9, June 17, 1864, p. 69.

[13] *Harper's Weekly*, VIII, no. 382, April 23, 1864, p. 260.

[14] As quoted by William Brandon, *The American Heritage Book of Indians*, ed. Alvin M. Josephy, Jr., Marion, 1961, p. 366.

[15] *New York Times*, December 4, 1868, pp. 1-2.

[16] *Harper's Weekly*, XIII, no. 629, January 16, 1869, p. 42.

[17] Ibid., p. 42.

[18] Henry Wadsworth Longfellow, *The Song of Hiawatha*, Boston, 1855, Canto IX.

6. From the Centennial to the Turn of the Century

[1] Centennial Certificate described in full by James D. McCabe, *The Illustrated History of the Centennial Exhibition*, Philadelphia, 1876, pp. 233-234.

[2] Ibid., pp. 232-234.

[3] Ibid., p. 596.

[4] Robert S. Fletcher, *The Centennial Exhibition of 1876; What We Saw, And How We Saw It*, Philadelphia, 1876, p. 71.

[5] T. B. Aldrich, "Among the Studios," *Our Young Folks*, II, no. 7, July 1866, p. 396.

[6] George W. Sheldon, *American Painters*, New York, 1879, p. 28.

[7] Ibid., p. 29.

[8] Editor, "What Shall We Do With Our Indians," *Frank Leslie's Popular Monthly*, II, no. 3, September 1876, p. 263.

[9] Ibid., p. 258.

[10] Ibid., p. 260.

[11] Ibid., p. 266.

[12] Charles Lanman, *A Summer in the Wilderness*, New York, 1847, pp. 15-17.

Quoted by J. F. McDermott, "Charles Deas; Painter of the Frontier," *Art Quarterly*, XIII, 1950, p. 304.

[13] Minna C. Smith, "George de Forest Brush," *International Studio*, XXXIV, no. 134, April 1908, p. xlvii.

[14] Ibid., pp. liii.

[15] Quoted from Eakins' letter to Earl Shinn, January 30, 1875, in the Cadbury Collection, Friends Historical Library, Swarthmore College, Swarthmore, Pennsylvania.

[16] *Frank Leslie's Popular Monthly*, I, 1876, p. 101.

[17] Riis, op. cit., pp. 152-153.

[18] Frederick Remington, "A Scout with the Buffalo-Soldiers," *Century Magazine*, XXXVII, no. 6, April 1889, p. 903.

[19] Ibid., p. 902.

[20] Ibid., p. 908.

[21] Ibid., p. 909.

[22] As quoted by Eugene Richard Page, ed., *Metamora and Other Plays by John Augustus Stone*, Princeton, 1941, p. 4.

[23] Ibid., p. 25.

[24] Frank Hamilton Cushing, "My Adventures in Zuñi," *Century Magazine*, XXV, no. 4, February 1883, p. 511.

[25] *Century Magazine*, XXVI, no. 1, May 1883, p. 29.

[26] Joseph Pennell, *Adventures of an Illustrator*, Boston, 1925, pp. 51-52.

[27] From an undated autobiographical letter by Tanner in the collection of the Pennsylvania School for the Deaf, Philadelphia.

[28] Ibid.

[29] Ibid.

[30] Quoted from the *Philadelphia Daily Evening Telegraph* by Marcia Matthews, *Henry Ossawa Tanner, American Artist*, Chicago, 1969, pp. 70-71.

[31] Ibid., p. 71.

[32] William Howe Downs, *The Life and Works of Winslow Homer*, Boston and New York, 1911, p. 135.

[33] Museum of Modern Art, *The Hampton Album*, New York, 1966, p. 8.

Selected Bibliography

This essay was conceived not as a textbook in itself, but as a companion volume to already existing surveys of American art and American cultural history. For this reason an exhaustive bibliography seemed unnecessary. Those seriously interested in more comprehensive listings for American painting, sculpture, and photography can turn to the useful bibliographies contained in the following standard texts: E. P. Richardson, *Painting in America; The Story of 450 Years* (New York, 1956); Metropolitan Museum of Art (exhibition catalogue), *19th-Century America; Painting and Sculpture* (New York, 1970); Wayne Craven, *Sculpture in America* (New York, 1968); and Beaumont Newhall, *The History of Photography from 1839 to the Present Day,* rev. ed. (New York, 1971). The selected titles listed below have been divided into three categories according to subject matter: Indians, Blacks, and American Art and Artists.

A. Indians

BISSELL, BENJAMIN. *The American Indian in English Literature of the Eighteenth Century.* New Haven, 1925.

BELDEN, B. L. *Indian Peace Medals Issued in the United States.* New York, 1927.

BOND, RICHMOND P. *Queen Anne's American Kings.* Oxford, 1952.

BRANDON, WILLIAM. *The American Heritage Book of Indians.* Alvin M. Josephy, Jr., ed. Marion, 1961.

BROWN, DEE. *Bury My Heart at Wounded Knee.* New York, 1970.

DOCKSTADER, FREDERICK J. *The American Indian Observed.* Exhibition catalogue. New York, 1971.

EWERS, JOHN C. "An Anthropologist Looks at Early Pictures of North American Indians," *New-York Historical Society Quarterly Bulletin,* XXXIII, no. 4, October 1949, pp. 222-234.

———. *Artists of the Old West.* New York, 1965.

FAIRCHILD, HOXIE NEALE. *The Noble Savage; A Study in Romantic Naturalism.* New York, 1928. Reprinted 1961.

FLEMING, E. McCLUNG. "The American Image as Indian Princess, 1765-1783," *Winterthur Portfolio,* II, 1965, pp. 65-81.

———. "From Indian Princess to Greek Goddess; The American Image, 1783-1815," *Winterthur Portfolio,* III, 1967, pp. 37-66.

FORBES, JACK D., ed. *The Indian in America's Past*. Englewood Cliffs, 1964.

FOREMAN, CAROLYN THOMAS. *Indians Abroad, 1493-1938*. Norman, Okla., 1943.

JOSEPHY, ALVIN M., JR. *The Indian Heritage of America*. New York, 1968.

KEISER, ALBERT. *The Indian in American Literature*. New York, 1933.

LE CORBEILLER, CLARE. "Miss America and Her Sisters; Personifications of the Four Parts of the World," *Metropolitan Museum of Art Bulletin*, n.s. XIX, April 1961, pp. 209-223.

LORANT, STEFAN. *The New World; The First Pictures of America*. Rev. ed. New York, 1965.

McCRACKEN, HAROLD. *Portrait of the Old West*. New York, 1952.

MOONEY, JAMES. *The Ghost-Dance Religion and the Sioux Outbreak of 1890*. Abridged ed. Chicago, 1965.

NATIONAL ANTHROPOLOGICAL ARCHIVES, SMITHSONIAN INSTITUTION. *Indian Images; Photographs of North American Indians, 1847-1928*. Exhibition catalogue. Washington, D.C., 1970.

NYE, WILBUR S. *Plains Indian Raiders*. Norman, Okla., 1968.

PEARCE, ROY H. *The Savages of America; A Study of the Indian and the Idea of Civilization*. Baltimore, 1953. Rev. ed., 1965.

RATHBONE, PERRY, ed. *Westward the Way; The Character and Development of the Louisiana Territory as seen by Artists and Writers of the 19th centuy*. St. Louis, 1954.

SMITH, HENRY NASH. *Virgin Land; The American West as Symbol and Myth*. New York, 1950.

TAFT, ROBERT. *Artists and Illustrators of the Old West, 1850-1900*. New York, 1953.

TODD, RUTHVEN. "The Imaginary Indian in Europe," *Art in America*, LX, no. 4, July-August 1972, pp. 40-47.

UNIVERSITY OF PENNSYLVANIA MUSEUM, *The Noble Savage; The American Indian in Art*. Philadelphia, 1958.

WASHBURN, WILCOMB E., ed. *The Indian and the White Man*. Garden City, 1964.

WEITENKAMPF, FRANK. *Early Pictures of North American Indians; A Question of Ethnology*. New York, 1950.

B. Blacks

BEARDSLEY, G. M. H. *The Negro in Greek and Roman Civilization; A Study of the Ethiopian Type*. Baltimore, 1929.

BOWDOIN COLLEGE MUSEUM OF ART. *The Portrayal of the Negro in American Painting*. Exhibition catalogue. Brunswick, Maine, 1964.

BRAWLEY, BENJAMIN. *The Negro in Literature and Art in the United States*, 2nd ed. New York, 1929.

CHASE, JUDITH WRAGG. *Afro-American Art and Craft*. New York, 1971.

DOVER, CEDRIC. *American Negro Art*. New York, 1960.

DYKES, EVA BEATRICE. *The Negro in English Romantic Thought*. Washington, D.C., 1942.

EBONY, Editors of. *Ebony Pictorial History of Black America*. 3 vols. Chicago, 1971.

ELKINS, STANLEY M. *Slavery; A Problem in American Institutional and Intellectual Life*. 2nd ed. Chicago, 1969.

FINE, ELSA HONIG. *The Afro-American Artist; A Search for Identity*. New York, 1973.

FRANKLIN, JOHN HOPE, and the Editors of Time-Life Books. *An Illustrated History of Black Americans*. New York, 1970.

GOSSETT, THOMAS F. *Race; The History of an Idea in America*. New York, 1965.

GROSS, SEYMOUR L., and John Edward Hardy, eds. *Images of the Negro in American Literature*. Chicago, 1966.

HUGHES, LANGSTON, and Milton Meltzer. *Black Magic; A Pictorial History of the Negro in American Entertainment*. Englewood Cliffs, 1967.

————. *A Pictorial History of the Negro in America*. 3rd rev. ed. New York, 1968.

KAPLAN, SIDNEY, and Jules Chametzky, eds. *Black and White in American Culture; An Anthology from 'The Massachusetts Review.'* Amherst, 1969.

LOCKE, ALAIN, ed. *The Negro in Art; A Pictorial Record of the Negro Artist and of the Negro Theme in Art*. Washington, D.C., 1940.

MASTIN, CAROLYN L. *Am I Not A Man and A Brother*. Exhibition catalogue. Wellesley, Mass., 1970.

NELL, WILLIAM C. *The Colored Patriots*

of the American Revolution, With Sketches of Several Distinguished Colored Persons. Boston, 1855.

PATTERSON, LINDSAY. *The Negro in Music and Art.* New York, 1967.

PORTER, JAMES A. *Modern Negro Art.* New York, 1943. Reprint, 1969.

QUARLES, BENJAMIN. *The Negro in the Civil War.* New York, 1968.

SNOWDEN, FRANK M. *Blacks in Antiquity; Ethiopians in the Greco-Roman Experience.* Cambridge, 1970.

TEAGUE, MICHAEL and Zelide Cowan. "Eyeview of the Atlantic Slavetrade; from African barracoon to the American Auction Block," *Art in America,* LIX, no. 1, January-February 1971, pp. 58-67.

THOMPSON, ROBERT F. "African Influences on the Arts of the United States," *Black Studies in the University.* A. Robinson, ed. New Haven, 1969. pp. 122-170.

C. American Art and Artists

Sources already mentioned in the Notes and basic books on particular artists which are easily found in other bibliographies have not been included here.

ALBANY INSTITUTE OF HISTORY AND ART. *Hudson Valley Paintings, 1700-1750.* Exhibition Catalogue by Janet R. MacFarlane. Albany, 1959.

ARVIN, NEWTON. *Longfellow; His Life and Works.* Boston, 1963.

BELOUS, RUSSELL E. and Robert A. Weinstein. *Will Soule, Indian Photographer at Fort Sill, Oklahoma, 1869-1874.* Los Angeles, 1969.

BOLTON, THOMAS and George G. Groce. "John Hesselius, An Account of His Life and the First Catalogue of his Portraits," *Art Quarterly,* II, no. 1, 1939, pp. 76-91.

BOWDITCH, NANCY DOUGLASS. *George de Forest Brush; Recollections of a Joyous Painter.* Peterborough, N.H., 1970.

BRIGHAM, CLARENCE S. *Paul Revere's Engravings.* New York, 1969.

BRINTON, ELLEN STARR. "Benjamin West's Painting of Penn's Treaty with the Indians," *Bulletin of the Friends' Historical Association,* XXX, no. 2, Autumn 1941, pp. 99-189.

BUCK, WILLIAM J. "Lappawinzo and Tishcohan," *Pennsylvania Magazine of History and Biography,* VII, no. 2, 1883, pp. 215-218.

CHAMBERLAIN, GLORIA STAMM. *Studies on John Gadsby Chapman.* Annandale, Virginia, 1963.

COKE, VAN DEREN. *The Painter and the Photograph from Delacroix to Warhol,* Rev. ed. Albuquerque, 1972.

CUSHING, FRANK HAMILTON. "Zuñi Fetiches," *Smithsonian Institution, Bureau of American Ethnology, Second Annual Report* (1800-1882). Washington, D.C., 1883. pp. 9-45.

DARRAH, W. C. *Stereo Views; A History of Stereographs in America.* Gettysburg, Pa., 1964.

DRAPER, BENJAMIN POFF. "American Indians—Barbizon Style; The Collaborative Paintings of Millet and Bodmer," *Antiques,* XLIV, no. 3, September 1943, pp. 108-110.

DRESSER, LOUISA. "Edward Savage, 1761-1817," *Art in America,* XL, no. 4, 1952, pp. 157-212.

FORD, ALICE. *Edward Hicks, Painter of the Peaceable Kingdom.* Philadelphia, 1952.

FRIED, FREDERICK. *Artists in Wood; American Carvers of Cigar-Store Indians, Show Figures, and Circus Wagons.* New York, 1970.

GOODRICH, LLOYD. *Five Paintings from Thomas Nast's Grand Caricaturama.* Exhibition catalogue. New York, 1970.

HALE, RICHARD W. "The Real Reason Why a Grasshopper Was Used for the Faneuil Hall Weather Vane," *Old-Time New England,* XXXI, no. 3, January 1941, pp. 70-71.

HAMILTON, SINCLAIR. *Early American Book Illustrators and Wood Engravers, 1670-1870.* Princeton, 1950.

HENDRICKS, GORDON. *The Photographs of Thomas Eakins.* New York, 1971.

HOLMAN, RICHARD B. "Seventeenth-Century American Prints," *Prints in and of America to 1850; Winterthur Conference Report 1970.* Charlottesville, Va., 1970. pp. 23-52.

HULTON, PAUL H. and David Beers Quinn. *The American Drawings of John White, 1577-1590.* 2 vols. London and Chapel Hill, 1964.

JONES, MATT B. "Early Massachusetts-Bay Colony Seals," *Proceedings of the American Antiquarian Society*, n.s. XLIV, April 1934, pp. 13-44.

KINARD, MARGARET. "Sir Augustus J. Foster and 'The Wild Natives of the Woods,' 1805-1807," *William and Mary Quarterly*, IX, April 1952, pp. 191-214.

LINDQUIST-COCK, ELIZABETH. "Stereoscopic Photography and the Western Paintings of Albert Bierstadt," *Art Quarterly*, XXXIII, no. 4, Winter 1970, pp. 361-378.

LITTLE, NINA FLETCHER. *American Decorative Wall Painting, 1700-1850*. Old Sturbridge, 1952.

LOCKWOOD, LUKE VINCENT. "The St. Mémin Indian Portraits," *New-York Historical Society Quarterly Bulletin*, XII, April 1928, pp. 3-26.

MATTHEWS, MARCIA. *Henry Ossawa Tanner, American Artist*. Chicago, 1969.

NATIONAL PORTRAIT GALLERY, Smithsonian Institution. *Portraits of the American Stage, 1771-1971*. Exhibition catalogue. Washington, D.C., 1971.

PARKE-BERNET GALLERIES, INC. *The Important Collection of Twenty-One Portraits of North American Indians by Charles Bird King*. Sale catalogue. New York, 1970.

PARKER, ARTHUR C. "Sources and Range of Cooper's Indian Lore," *New York History*, XXXV, no. 4, October 1954, pp. 447-467.

PARRY E. C. "Landscape Theater in America," *Art in America*, LIX, no. 6, 1971, pp. 52-61.

———. "Thomas Cole and the Problem of Figure Painting," *American Art Journal*, IV, no. 1, Spring 1972, pp. 66-86.

———, and Maria Chamberlin-Hellman. "Thomas Eakins as an Illustrator, 1878-1881," *American Art Journal*, V, no. 1, Spring 1973, pp. 20-45.

RICHARDSON, EDGAR P. "Gustavus Hesselius," *Art Quarterly*, XII, no. 3, Summer 1949, pp. 220-226.

RUDULPH, MARILOU. "George Cooke and his Paintings," *Georgia Historical Quarterly*, XLIV, no. 2, June 1960, pp. 121-129.

SMITH, DE COST. "Jean Francois Millet's Drawings of American Indians," *Century Magazine*, LXXX, no. 1, May 1910, pp. 78-84.

SWAN, BRADFORD F. "An Indian's an Indian; or, The Several Sources of Paul Revere's Engraved Portrait of King Philip," *Society of Colonial Wars, Rhode Island, Publication No. 44*. Providence, 1959.

SWAN, MABEL M. "On Weather Vanes," *Antiques*, XXIII, no. 2, February 1933, pp. 64-65.

THOMPSON, RALPH. *American Literary Annuals and Gift Books, 1825-1865*. New York, 1936.

TOOLEY, R. V. *Maps and Map-Makers*. London, 1949.

TWAITES, R. G. *France in America, 1497-1763*. New York, 1905.

VAIL, R. W. G. "Sir William Johnson's Indian Testimonial," *New-York Historical Society Quarterly Bulletin*, XXX, no. 4, October 1946, pp. 208-214.

WALKER, T. B., Galleries. *Illustrated Catalogue of Indian Portraits . . . All Painted by Henry H. Cross*. Minneapolis, 1927.

WALLACE, PAUL A. W. "Cooper's Indians," *New York History*, XXXV, no. 4, October 1954, pp. 423-446.

Index

Numbers in italics refer to plate numbers.

Sources of Illustrations

Only those sources not mentioned in the captions are given.

Douglas Armsden—15

Columbia University Libraries—5, 9, 10, 19, 20, 21, 30, 31, 32, 33, 42, 45, 49, 51, 59, 62, 63, 65, 70, 73, 77, 79, 81, 85, 90, 93, 106, 107, 110, 112, 113.

Christopher Focht—40

New-York Historical Society—83

Rare Book Division, New York Public Library, Astor, Lenox and Tilden Foundations—1, 2, 4, 6, 8, 37

Yale University Libraries—26

Arts of the Book Collection—48, 76